ROGER DE PILES' THEORY OF ART

ROGER DE PILES' THEORY OF ART

Thomas Puttfarken

YALE UNIVERSITY PRESS
NEW HAVEN AND LONDON
1985

FOR MICHAEL PODRO

Set in Compugraphic Garamond
by Boldface Typesetters, London EC1
and printed in Great Britain at
the Bath Press, Avon

Library of Congress Catalog Card Number 85–40467
International Standard Book Number 0–300–03356–7

PREFACE

DE PILES was very much a painter's theorist. It was his explicit opposition to the literariness of most of French theory which first caught my attention some ten years ago

Since then, a new interest in the problems discussed here seems to have emerged in a way and on a scale which one could not expect then. Having worked on a relatively limited topic for so long means that it is now virtually impossible for me to recall and to record all the debts I owe to others.

I am extremely grateful to my friends and colleagues in the Department of Art History and Theory at the University of Essex for their encouragement and the patience they have shown over the years; to the Director and staff of the Warburg Institute for their help and hospitality; to Dawn Ades, Michael Baxandall, Sharon Fermor, David Freedberg, Ernst Gombrich, Margaret Iversen, Efthimia Mavromihali, John Nash, Alex Potts, and many others, for having given generously of their time and their knowledge; to numerous generations of students at Essex for having discussed my problems with me; to Maureen Reid and Barry Woodcock for their help with typescripts and photographs; and to Elly for putting up with both me and de Piles.

The dedication on the opposite page is insufficient to acknowledge my greatest debt – and it comes with apologies for the shortcomings and failings of this book.

CONTENTS

INTRODUCTION

THE WRITING of Roger de Piles in both its historical and theoretical respects seems recently to have acquired a pertinence which even a couple of decades ago it would not have had.

On the historical side there have been numerous recent attempts to bring about a major reappraisal of French eighteenth-century art, and to widen our understanding of it beyond that of the Goncourts, which was deeply sensitive but also rather narrow.[1] De Piles died in 1709, but his treatises were read and republished throughout the century. Some sixty years ago, Louis Dimier, the French art historian, referred to him as *le prince des critiques d'art français*, ranking him above Diderot.[2] Many painters of the eighteenth century would have agreed. Although after his death official doctrine quickly watered down some of his more radical ideas, his critical views and his formative influence remained central.

On the theoretical side there now seems to be, at least since Gombrich's *Art and Illusion*,[3] a keener interest than there has been for a long time in those fundamental problems of depiction and the specifically visual effectiveness of representational painting which preoccupied de Piles throughout his critical career.

This book is mainly concerned with three of these problems. First, the problem of liberating the theory of painting from the dominance of literary theory. This dominance characterized the official doctrine of the early academy under Lebrun and had been an almost permanent feature of traditional theory; secondly, the problem of defining the visual interest we have in pictures in contrast to our intellectual, moral or religious interest in the picture's subject-matter; and thirdly, of distinguishing between the way we perceive pictures (and the effect they have on us) and the way we perceive and are affected by the real world around us.

[1] E. and J. Goncourt, *L'Art du XVIIIème siècle*, published in instalments between 1859 and 1875; definitive edition Paris 1927–1928, three volumes. For the most recent attempts to give a different and wider view of the art of the century cf. M. Fried, *Absorption and Theatricality: Painting and Beholder in the Age of Diderot*, Berkeley 1980; N. Bryson, *Word and Image: French Painting of the Ancien Régime*, Cambridge 1981; and P. Conisbee, *Painting in Eighteenth-Century France*, Oxford 1981.

[2] In the preface to L. Mirot, *Roger de Piles*, Paris 1924, p.IV.

[3] E.H. Gombrich, *Art and Illusion. A Study in the Psychology of Pictorial Representation*, New York 1960. Some of the problems discussed by M.H. Pirenne, *Optics, Painting and Photography*, Cambridge 1970, are closely related to those raised by de Piles' theory.

These problems are obviously interrelated. The close connection between painting and literature was emphasized by André Félibien and other members of the early academy in an attempt to elevate painting to a status above that of a purely imitative art and to endow it with a sense of discursive rationality. This position is outlined in my first chapter.

This sense of discursive order, which allowed for the didactic rôle of painting, had been sought in the organization of the picture's subject-matter; and it followed for Félibien, as for his academic followers down to the nineteenth century, that it was the subject-matter and its attendant moral message which gave painting its importance.

Against this view de Piles held that the prime interest of painting was neither discursive nor didactic. It was a visual interest and this was *sui generis*. If a painting did not have this interest, if it did not attract its spectator by its own means and held and absorbed his attention, then it failed (even if it was successful in terms of discursive structure, rational order and moral or other instruction). The literary, moral or social significance of its subject-matter was not, for de Piles, an intrinsic value of painting.

The problems de Piles faced in dealing with these questions were enormous. Of course, painting for him was representational, i.e. imitative, and the more truthfully it imitated its objects the better it was considered to be. Yet if its represented objects and their qualities were not of intrinsic interest in painting, how could painting avoid the ancient accusation of being of interest merely for its feat of imitation, irrespective of what it showed?

Like most of his predecessors, de Piles extolled amazing feats of imitation and even of complete illusion. Yet at the same time he undermined belief in the possibility of exact and straightforward imitation in painting. For him there was only a limited sense of continuity and correspondence between objects and figures in a picture and those in the real world around us. The conditions under which we see a depicted world, painted in material colours on a flat surface surrounded by a limiting frame, are fundamentally different from those under which we see the real world. This limits the illusion of depiction in a number of important ways, but it also gives to painting its powerful, uniquely pictorial effectiveness.

Some of de Piles' thoughts had a continuing effect on eighteenth-century writers, although most theorists of the age of reason were clearly hostile to his notion of the purely visual, i.e. irrational effects of painting. The full force of his argument re-surfaced only in the nineteenth century, in Delacroix' ideas about art. The history of de Piles' theoretical influence in the eighteenth century will be sketched out briefly in the last section of this book.

* * * * *

As I shall concentrate in this study on de Piles' thought and its development rather than on the wider historical circumstances of his life, it may be convenient at this point to give a brief biographical sketch. The known facts have been assembled by Léon Mirot in his short biography of de Piles published in 1924.[4]

[4] L. Mirot, *Roger de Piles. Peintre, Amateur, Critique, Membre de l'Académie de Peinture (1635–1709)*, Paris 1924, with a preface by Louis Dimier.

Roger de Piles was born on 7th October 1635 in Clamecy (Nivernais) into the lower ranks of the provincial nobility. Little is known about his early education until, in about 1650–52, he went to Paris. Here he studied philosophy at the *Collège du Plessis*, then, for three years, theology at the *Sorbonne*.

He also learned to paint, probably with Claude Français (Frère Luc), a student of Simon Vouet.[5] Through him he made friends with François Tortebat, *peintre du roi*, and Charles-Antoine Dufresnoy, whose poem, *De Arte Graphica*, he translated and annotated after the author's death. He also frequented literary circles like that of Gilles Ménage at the Hôtel Rambouillet where he must have met many of the leading participants of the great literary disputes of the time, like the Abbé de Marolles and Chapelain. Throughout his life de Piles seems to have enjoyed the company of poets and critics; Ménage remained a close friend until his death; the friendship with Boileau, of whom he painted a portrait, was responsible for some major changes in the final formulation of de Piles' theory.

With the publication of his annotated translation of Dufresnoy's poem in 1668 he entered the arena of public discussions about the art of painting. With his next work, the *Dialogue sur le coloris* of 1673, he assumed the rôle of leading theorist (outside the academy) among the *rubénistes* in their fight against the dominant *poussinistes* who surrounded the director of the academy, Charles Lebrun. The history of this dispute, and de Piles' rôle in it, has been traced in great detail by Roger Teyssèdre.[6] *Conversations sur la connoissance de la Peinture* appeared in 1677, followed four years later by his *Dissertation sur les ouvrages des plus fameux peintres* (1681), which went through three editions in as many years. By this time he had become a respected, if controversial, *amateur* who advised leading collectors like the Duc de Richelieu on the acquisition of pictures.

His own financial situation had been secure since 1662 when, on the advice of Gilles Ménage, Charles Amelot, Seigneur de Fournay (who was president of the Great Council) had employed him as tutor for his seven-year-old son, Michel. De Piles remained closely and loyally attached to Michel Amelot for the rest of his life, living in the Hôtel Amelot, Place Royal, on a generous pension until a few years before his death.

In 1673 de Piles and Michel went on a Grand Tour of Italy for fourteen months and when, in 1682, the young Amelot became French ambassador in Venice, de Piles accompanied him as secretary. He followed his master in the same capacity to Portugal and Switzerland and in 1705, at the considerable age of seventy, to Madrid, only to be forced home to Paris by his declining health.

While Amelot's ambassadorial missions were not always successful, de Piles' diplomatic activities as secretary seem to have been appreciated at court. Returning from Venice in 1685, he was sent on a delicate secret mission to Germany and Austria where, under the pretext of visiting the main picture

[5] For a brief bibliography about Frère Luc cf. B. Teyssèdre, *Roger de Piles et les débats sur le coloris au siècle de Louis XIV*, Paris 1957, pp.655f.

[6] Teyssèdre, op cit.

galleries, he was to gather intelligence about the German attitude and reaction to the aggressive policies of Louis XIV.

In 1692 he again took on the rôle of secret agent and spy when the King sent him to Holland to investigate and actively to encourage the possibilities of a revolution in both Holland and Britain. Again he travelled as a picture expert, a connoisseur of the arts, advising the King of Poland on the acquisition of paintings. This time his mail to Paris was intercepted and he spent the four years before the peace of Ryswick in 1697 in prison in Holland, despite intensive efforts by Amelot to secure his release. The Dutch thought him sufficiently important to demand, in exchange for his freedom, the release of four Dutch ministers of state and the president of Orange, all imprisoned in France.

During this time of enforced leisure (the prison routine seems to have been very liberal) he tamed birds and composed his *Abrégé de la vie des peintres*, which was published two years after his release, in 1699.

When he returned to Paris the artistic scene had changed considerably. Many of his old friends and adversaries had died, among them Lebrun (in 1690), and the younger generation of artists and critics was no longer seriously involved in the dispute about the relative merits of Poussin and Rubens, of *dessin* and *coloris*.

A major change in the artistic world of Paris occurred in 1699. Hardouin-Mansart was appointed *Surintendant des Bâtiments* and *Protecteur* of the academy. He immediately forced through the election of Charles de la Fosse, a close friend of de Piles', as director of the academy, and the admission of Roger de Piles himself as *Conseiller Honoraire Amateur*. Mansart made it clear to the academy that de Piles' rôle and authority was to be more than that of a normal member: it was through him that the academy should communicate with its protector. When de Piles, within a few months of his election, indicated in a short discourse his intention to lecture on the principles of art, Mansart advised the academy *'de mettre (ce Discours) au nombre des choses qu'elle regarde comme les plus prétieuses'*.[7] Thus de Piles became, for the last decade of his life, the leading and official theorist of the academy. The lectures which he gave regularly over the next years were finally combined and published in his *Cours de Peinture par principes* of 1708, the fullest realization of his theory. De Piles died on 5th April 1709, leaving behind a considerable collection of pictures, drawings and engravings.

[7] A. De Montaiglon, *Procès-Verbaux de l'Académie Royale de Peinture et de Sculpture, 1648–1793*, vol. III, Paris 1880, p.268.

I

FÉLIBIEN AND THE EARLY ACADEMY: *UNITÉ DE SUJET* AND *CONVENANCE*

1. *The Unity of Action in Painting*

IN DISCUSSING the modern pre-occupation with the 'formal unity' of works of art, Ernst Gombrich wrote, in his paper on Raphael's *Madonna della Sedia* : 'The Gentleman on the Grand Tour who had read his Aristotle and his de Piles knew what he meant when he described the *Madonna della Sedia* as a classic work of art and as a harmonious whole'.[1] As far as touring gentlemen of the eighteenth and the nineteenth centuries are concerned, this is probably quite true. De Piles' contemporaries, however, would have been puzzled by this statement. For them the name and the authority of Aristotle were strongly associated with a theory of painting directly opposed to that of de Piles. And the main issue over which de Piles disagreed with this 'Aristotelian' system was the question of what constituted the unity and harmony of pictures.

The 'Aristotelian' position was adopted by the official spokesmen of the young *Académie Royale de Peinture*, – at least until 1699 when de Piles himself became its chief theoretician. But in 1667 when the academy, under the directorship of Lebrun, made the first serious attempt to define the rules of its art – which was its institutional obligation – Aristotle's *Poetics* dominated the discussions. The *conférences* held that year were published two years later by the official historiographer of the academy, André Félibien.[2] He added a preface which is one of the most sophisticated adaptations of literary theory to the art of painting and which remained one of the basic documents for the formulation and development of the concept of unity in the theory of painting. (Félibien fell out of favour shortly afterwards but that had more to do with the academicians' touchiness about the form in which he recounted their arguments than with any theoretical disagreement.)

This programmatic preface will be the first object of our investigation but we

[1] E.H. Gombrich, 'Raphael's Madonna della Sedia', *Norm and Form. Studies in the Art of the Renaissance*, London 1966, pp.64–80, p.76.

[2] A. Félibien, *Conférences de l'Academie Royale de Peinture et de Sculpture*, Paris, 1669. The *Conférences* were included in the six-volume republication of Félibien's *Entretiens sur les Vies et sur les Ouvrages des plus excellens Peintres anciens et modernes*, Trévoux 1725. This is now available in reprint (Farnborough 1967) with an introductory note by Anthony Blunt. Since I quote frequently from both the *Entretiens* and the *Conférences* I hope the reader will find it convenient that all following references to Félibien's works are to the Trévoux edition.

It is only fair to mention that in the *Entretiens*, published between 1666 and 1685 and then republished in two volumes in 1685 and 1688, Félibien takes a more liberal stance than in the official preface to the conferences. For a general discussion of his ideas cf. A. Fontaine, *Les Doctrines d'Art en France, Peintres, Amateurs, Critiques, de Poussin à Diderot*, Paris 1909, pp.41–60.

shall need to amplify it somewhat from the *conférences* themselves, in particular from those passages to which Félibien refers approvingly in his preface. These texts repeatedly allude to dramatic theory, and this presents us with a tiresome problem: we shall have to consult not only Aristotle's *Poetics* but also its French seventeenth-century offspring. The modern reader, like Gombrich's enlightened eighteenth-century gentleman on the Grand Tour, would have no great difficulties in trying to reconcile de Piles and Aristotle. Yet in seventeenth-century France the situation was quite different. This has much to do with the way in which, by the middle of the century, literary critics and poets in France, under the auspices of the *Académie française*, had read and interpreted the *Poetics*. The *doctrine classique* of drama and poetry, as formulated by Chapelain, d'Aubignac, Corneille and others, was the result of long and meticulous discussions of Aristotle.[3] In order to understand the 'Aristotelian' connotations of the conferences of 1667 and of Félibien's preface we have to turn to these literary discussions even if, for us, they may have little affinity to the Aristotelian text on which they were based.

Other material of a different kind should relieve us, from time to time, of the rather abstract and systematic nature of academic discussion: in trying to assess the meaning and the implications of the early Academy's theoretical arguments we also have to consider the kind of painting they had in mind and to which, as a general standard of excellence, their disputes implicitly or explicitly referred. This was, of course, primarily the art of Nicolas Poussin. It would be wrong, I believe, to introduce Poussin's paintings as illustrating certain academic points of view. Like his theoretical letters they were considered by the academicians as statements, as contributions to an argument rather than as illustrations of it.

Poussin's own ideas about painting, as far as they were known to Félibien and his colleagues, are of decisive importance; at the end of this chapter I shall consider one particular notion of unity which Félibien adopted from Poussin and which, in the recent past, has often been seen as transcending the literary origin of early academic theory: this is the notion of pictorial modes.

To draw upon this fairly wide range of evidence to elucidate just one critical term of the period, that of the unity of painting, may seem extravagant. Yet to talk of the unity of painting in seventeenth- and eighteenth-century France is to become engaged with a whole network of critical concepts and almost all the crucial disputes of the period. The first part of this book, therefore, is an attempt to reconstruct those concepts and disputes prior to de Piles' writing, bringing out as far as possible their interconnections. These terms and the disputes which gave definition to them were used and continued by de Piles himself, and we shall have to refer back to them when discussing his theory.

* * * * *

That Félibien and his fellow-academicians should turn to the literary *doctrine classique* for inspiration was not in itself surprising. The impact of literary theory on ideas of painting went back at least to Alberti. Félibien and his

[3] I find that R. Bray, *La Formation de la Doctrine classique en France*, Paris 1927, is still the most comprehensive account of seventeenth-century literary doctrine in France.

colleagues may have thought of their activities as simply updating those traditional theories in the light of the most recent discussions of literature.

There was, however, a more immediate and urgent reason for turning to literary theory: the new academy found itself under constant attack from the *maîtrise*, the craft-organization, whose members envied the privileges enjoyed by members of the new institution.[4] In response to these threats, the new academy aimed to give itself an authority equivalent to that of the *Académie française*, modelling its administration on its literary counterpart and taking on a legislative rôle not only over its members but over the art itself. It attempted to elevate painting to a status equivalent to that of poetry, the status of a liberal art, and it did so in a way far more radical and far more comprehensive than any previous theoreticians of painting.

In this situation it would seem almost inevitable that the first concept of pictorial unity to emerge in the second half of the seventeenth century was that of the unity of pictorial subject-matter, of the story or event to be depicted. For it was that kind of unity which had been central not only to Alberti but also to Aristotle and his followers in the *Académie française*. One could almost say, without too much exaggeration, that most traditional theory of art had been about subject-matter. When, at the beginning of his preface, Félibien states that the painter is not only an *artisan*, a craftsman, but: 'An ingenious and knowledgeable author as he invents and produces ideas which he does not borrow from anyone else'. (Un Auteur ingénieux & sçavant, en ce qu'il invente & produit des pensées qu'il n'emprunte de personne.)[5] he is only repeating, in a typically emphatic way, a long-established view. The invention of subject-matter was the one major part of painting which could be presented as being not only similar to but identical with the corresponding part of poetry. And this was the central issue of Félibien's programmatic preface. His main concern was with what he calls *théorie*, the artist's intellectual or mental mastery of his *sujet*. *Pratique*, the actual execution of the work, was of minor importance, involving as it does manual labour and craftsmanship. What is required of the artist is not primarily manual dexterity or visual acuteness (although these have to be practised) but those qualities which are also seen to be necessary in the poet: *grandeur des pensées* and *connaissances spirituelles*.

The spiritual or intellectual knowledge which the painter needed in order to master his subject-matter is described by Félibien in a way which closely imitates the *doctrine classique*. The central arguments of the literary theory had concerned the definition of the three unities, of action, place and time, and it appears to have been of crucial importance for Félibien to transfer these 'Aristotelian' notions to painting.

The unities of time and place which had been defined by literary critics only after lengthy discussions and fierce dispute had always been somewhat less

[4] On the problematic early history of the academy cf. B. Teyssèdre, *Roger de Piles et les débats sur le coloris au siècle de Louis XIV*, Paris 1957, pp.15–25; and N. Pevsner, *Academies of Art, Past and Present*, London 1940.

[5] Félibien, *Preface* (vol. V), p.311.

important than the unity of action.[6] For Félibien they were of only marginal
interest (although the unity of time has, as we shall see, some importance for
the unity of action). That a picture could represent no more than one place
seemed beyond doubt, and whether a dramatic action should last for twelve or
twenty-four hours was irrelevant for painting with its restriction to one moment
of time. But the unity of action assumes, in Félibien's theory, the status of an
absolute law of central importance for the artist's invention and ordering of his
subject-matter; and although it later came to be modified and simplified it
remained, for at least a century and a half, an essential part of academic doc-
trine.

 The obvious literary origin of this notion of the unity of action has led, in
more recent times, to strong condemnations of its use in the context of painting.[7]
The limitations of early academic theory are clear and they will be discussed later
on in this section. Yet Félibien's – and his fellow-academicians' – arguments
deserve close investigation; they are not only much more complex and intellec-
tually sophisticated than they have been represented in recent accounts, but
they also sparked off – in the writing of Roger de Piles – a critical response
which was much more deeply engrossed in the visual nature of painting than
the responses of modern critics and commentators.

* * * * *

Let us turn first to Félibien's definition of the unity of action in painting as for-
mulated in his preface:

That which in a picture is called the story or the fable is the imitation of some
action which took place in time past, or which could have taken place, involving
a number of persons. But one must carefully observe that one can only have one
single subject in a picture; and even if it involves a great number of figures they
must all be related to the principal figure, in such a way as was shown in the
sixth conference on the picture of the *Manna*.

(Ce qu'on appelle dans un Tableau, l'Histoire ou la Fable, est une imitation de
quelque action qui s'est passée, ou qui a pu se passer entre plusieurs personnes;
mais il faut prendre garde que dans un Tableau il n'y peut avoir qu'un seul
sujet; & bien qu'il soit rempli d'un grand nombre de figures, il faut que toutes
aient rapport à la principale, ainsi qu'on fait voir dans la sixième Conférence sur
le Table de la Mâne.)[8]

The sixth conference of the academy, which had been held on November 5th,
1667, had been devoted to Poussin's *Gathering of the Manna* (Plate 1). Lebrun
himself had delivered the main lecture. In the discussion which followed the

[6] Bray, p.240: 'L'unité d'action s'applique à toute la poésie ... Les unités de temps et de lieu,
 malgré quelques extensions abusives, sont d'abord des règles de la poésie dramatique; elles
 sont, aux yeux de nombreux théoriciens, une application de la règle de la vraisemblance à la re-
 presentation.' On the link between verisimilitude and the unities see below p.51; for the unities
 of time and place in Félibien, cf. *Preface* (vol. V), p.313.
[7] See below, p.6.
[8] Félibien, *Preface* (vol. V), p.313.

lecture some doubts were expressed about the way in which Poussin seemed to have brought together, in his picture, incidents which in the biblical story were presented as separate events; as a result, some of the Israelites surrounding Moses and Aaron are still starving and desperate while others collect the manna and clearly display their joy and relief.[9]

These criticisms were answered by another member of the academy (unnamed) who referred explicitly to the notion of unity of action in literary and dramatic theory:

Someone added to what Monsieur le Brun had just said that if the rules of drama permit a poet to bring together several events which happened at different times in order to create a single action, providing that there was nothing contradictory and that exact verisimilitude was observed, then it is even more just that painters should take that licence, since without it their works would be deprived of something which would make their composition more admirable and which would make us recognize more clearly their author's beautiful genius. In this respect one could not accuse Monsieur Poussin of having included in his picture anything which would impede the unity of action, and which was not probable, as there was nothing which did not contribute to the representation of a single subject.

(Quelqu'un ajoûta à ce que Monsieur le Brun venoit de dire, que si par les regles du Théatre il est permis aux Poëtes de joindre ensemble plusieurs évenemens arrivez en divers tems pour en faire une seule action, pourvû qu'il n'y ait rien qui se contrarie, & que la vrai-semblence y soit exactement observée. Il est encore bien plus juste que les peintres prennent cette licence, puisque sans cela leurs Ouvrages demeureroient privez de ce qui en rend la composition plus admirable, & fait connoître davantage la beauté du génie de leur Auteur. Que dans cette rencontre l'on ne pouvoit pas accuser Monsieur Poussin d'avoir mis dans son Tableau aucune chose qui empêche l'unité d'action, & qui ne soit vraisemblable, ny' ayant rien qui ne concourre à representer un même sujet.)[10]

Félibien, in his preface, sustains the same line of argument:

...in theatrical plays the fable is not perfect unless it has a beginning, a middle, and an end to make us understand the whole subject of the work. In order to provide better instruction for the spectator one can similarly arrange the figures and the whole composition of great works of painting in such a way that one can judge even that which preceded the action represented. That is what Monsieur Poussin has done in his picture of the *Manna*, where one can see the signs of starvation from which the Jewish people had suffered before they received this aid from heaven.

(... dans les pieces de théatre la fable n'est pas dans sa perfection, si elle n'a un commencement, un milieu, & une fin pour faire comprendre tout le sujet de la

[9] Félibien, *Conférences* (vol. V), pp.400–428. On Poussin's *Gathering of the Manna*, cf. A. Blunt, *The Paintings of Nicolas Poussin. A Critical Catalogue*, London 1966, no. 21; p.18.

[10] Félibien, *Conférences* (vol. V), pp.426/427.

piece; l'on peut aussi dans de grands Ouvrages de Peinture pour instruire mieux ceux qui le verront, en disposer les figures & toute l'ordonnance, de telle sorte qu'on puisse juger de ce qui aura même précedé l'action que l'on represente; c'est ce que M. Poussin a fait dans son Tableau de la Mâne, où l'on voit des marques de la faim que le peuple Juif avoit soufferte avant qu'il eut reçu ce secours du Ciel.)[11]

I have quoted these texts *in extenso* because we shall have to refer back to them later. These passages have recently been subjected to a rather negative reading. R.W. Lee, in his essay on *Ut Pictura Poesis*, quoted them as evidence of what he considered to be an improper way of transferring a critical concept from its place in dramatic theory to the discussion of painting. By comparing Lee's rather rigid reading with the texts themselves we may arrive at a clearer understanding of what Félibien and his colleagues were saying.

For Lee the dramatic unity of action depends on the division of the plot into beginning, middle and end, i.e. on the temporal or sequential organization of the whole, and this, in his view, could not reasonably be adapted to the spatial art of painting:

To the dramatist the unity of action is invaluable as a principle of criticism, for it points to a standard of abstemious concentration, and warns against the inclusion of the casual and unrelated in an art in which the succession of events in time must move consistently to an inevitable end. But for painting . . . it could have, in the Aristotelian sense, no meaning, for the counterpart in painting of Aristotle's unity of action – the representation of an event in such a way that all pictorial events would be simultaneously functional to the expression of a single dramatic action – could of necessity (such was the requirement of the medium) include only a single moment of time. Once this is understood, it becomes clear that any attempt to apply to painting the principle of the unity of action in the manner in which Aristotle applied it to drama, is aesthetically fallacious.[12]

Félibien and the anonymous participant of the sixth conference could have countered this argument in several ways.

In the first instance, they could have argued that Aristotle, in the *Poetics*, considers the unity of action in a number of ways of which the differentiation of the plot into beginning, middle, and end is only one. They would probably admit that in the sense of a strictly controlled dramatic development, or of a complete narrative sequence, this aspect of the notion of unity was not fully commensurate with the conditions of painting. French critics would have been more interested in other implications of Aristotle's unity: firstly in the relation of the major action to minor actions, and secondly in the causal rather than the merely temporal differentiation of the plot.

Let us turn briefly to the *Poetics*. The unity of the fable in Aristotle consists in it being the imitation of one main action. This one action must have – in

[11] Félibien, *Preface* (vol. V), p.313.

[12] R.W. Lee, 'Ut Pictura poesis: The humanistic theory of painting', *The Art Bulletin*, XXII, 1940, pp.197–269; pp.258/9.

order to be a whole – a beginning, a middle, and an end. The minor actions or incidents must be related to this main action in such a way that 'the whole will be disjoined and dislocated if any of them is transported or removed.'[13] The underlying idea of 'organic unity', expressed by Aristotle in the analogy between the unified action and the living creature,[14] seems to have been alien to seventeenth-century theory, but it shows quite clearly that his demand for sequential differentiation into beginning, middle and end reflects only the specific conditions of the unity of action in dramatic poetry. There the relation of the parts to each other and to the whole was normally one of succession. The same could not be said of the analogous living creature, and there would be no reason, then, why Félibien and the academicians should not adapt the notion of unity to painting, where unity of action is a matter of the reciprocal relevance of the parts of a work and their relevance to the underlying theme. But if we recognize *this* notion of unity as central (which Lee seems to have missed) we do not even have to pay the price of disregarding the factor of sequence.

We must be very careful not to misrepresent Félibien; distinguishing between beginning, middle and end in the context of Poussin's *Gathering of the Manna* is not to be understood as a necessary implication of the concept of unity, but as a possibility – *'pour instruire mieux ceux qui le verront'* – to extend the one moment of the depicted action by showing *'des marques de la faim'*, signs of starvation from which all the Israelites had suffered before.[15] Félibien is not asking for the full depiction of earlier or later stages of the story, but for signs and indications of what went before. Had he claimed that the unity of action in Poussin's painting depended on this more limited sense of the extension of time, Lee's criticism would have more force.

It is true that Félibien himself refers to the differentiation of the plot as an analogy for the ordering of a pictorial composition. Yet it is safe to assume that he was sufficiently well acquainted with Aristotle's writings to know that distinguishing beginning, middle, and end was not just a means of general dramatic concentration but also one basic condition of our rational understanding, for without it there would be no causality, no way of explaining effects by referring to their causes.[16]

As Félibien introduces the analogy between Aristotle's differentiation of the plot into beginning, middle, and end and the painter's ordering of his subject-matter for a clearly didactic purpose ('to make us understand the whole subject of the work') we can be fairly sure that he is not suggesting that we transfer to painting the whole notion of dramatic development. What he is aiming at is an equivalence in painting of the causal stringency of Aristotle's plot. In Poussin's *Gathering of the Manna* this has been achieved; the delight and relief of the Israelites is understandable in relation to its causes: their previous state of starvation and despair, as indicated in the group on the left, the intervention of God, to whom Moses draws their and our attention, and then the gathering of the Manna itself.

[13] Aristotle, *Poetics*, chap. 8, 1451a.
[14] Aristotle, *Poetics*, chap. 7, 1450b; chap 23, 1459a.
[15] Félibien, *Preface* (vol. V), p.313.
[16] Compare, for instance, Aristotle, *Metaphysics*, Bk. II, 2, (2a), 994a.

To extend the one moment of pictorial representation to include previous causes of which the main action is the effect is permissible only in so far as it does not disturb the unity. The anonymous critic makes this point absolutely clear. He does not argue – as Lee claims – that the unity of action in painting consisted in the simultaneous representation of a temporal sequence of events. In his opinion, this is a licence, acceptable in both poetry and painting provided that manifest contradictions were avoided, so that the principle of *vraisemblance* was upheld, and nothing included that would disrupt the unity of the subject. Yet if these conditions were met, and if the artist succeeded in tying his figures and actions together in causal relationships, then this would be, in Félibien's view, the perfection of the unity of action in painting.

2. *The Simultaneity and Sequence of Visual Perception*

Félibien and his colleagues could have proceeded with a second line of argument to justify their interest in the sequential (temporal or causal) ordering of pictorial subject-matter. They could have claimed that Lee's distinction between the temporal art of drama – and literature in general – and the spatial art of painting was too rigid and narrow, and they could have referred to the actual text of Lebrun's lecture on Poussin's *Gathering of the Manna* as recorded by Félibien.[17]

Lee's view echoes a long and well-established tradition; it is almost a commonplace in sixteenth- and seventeenth-century *paragone* literature. For Leonardo the simultaneity of pictorial representation as opposed to the succession of events in literature was an essential argument for the superiority of painting, which could present its objects immediately and directly to the spectator's eyes.[18] Lebrun himself referred to this distinction between the art of language and that of painting during the discussion following his lecture:

The historian makes himself clear by the arrangement of words and the sequence of discourse which produce an image of the things he wants to say and which represent successively any action he likes. The painter, however, has only one moment in which he has to take the object he wants to depict....

(Un Historien se fait entendre par un arrangement de paroles & une suite de discours qui forme une image de choses qu'il veut dire, & represente successivement telle action qu'il lui plaît. Mais le Peintre n'ayant qu'un instant dans lequel il doit prendre la chose qu'il veut figurer...)

But Lebrun reverses Leonardo's argument; in his view this is a serious limitation imposed upon the painter by his medium, and the artist is not only justified but may be even obliged to attempt to overcome this restriction:

He sometimes has to combine many previous incidents to make us understand the subject he puts before us; without it his work would offer as little instruction to those who looked at it as the historian who, instead of telling his whole story, would just tell its end.

[17] Félibien, *Conférences* (vol. V), pp.400–428.
[18] Leonardo da Vinci, *Das Buch von der Malerei*, ed. H. Ludwig, Vienna 1882, Bk. I, pp.36ff.

(Il est quelquefois nécessaire qu'il joigne ensemble beaucoup d'incidens qui ayent precedé, afin de faire comprendre le sujet qu'il expose, sans quoi ceux qui verroient son Ouvrage ne seroient pas mieux instruits, que si cet Historien au lieu de raconter tout le sujet de son Histoire se contentoit d'en dire seulement la fin.)[19]

Defending Poussin, Lebrun here distinguishes between the successive moments of action and the necessary simultaneity of its pictorial representation. His own lecture on the painting of the *Manna* implies another and more relevant distinction, which was to become an essential part of French artistic theory in general and of the further development of the concept of unity in particular – the distinction between the simultaneity of the presence of objects in a painting and the possibility of the spectator's successive perception of these objects. Because the painting, looked at synoptically, does not conflict with the sense of a single moment it does not follow that the spectator, in his detailed attention, has to perceive all its parts simultaneously or, indeed, as occurring simultaneously.

To look at a painting like Poussin's *Manna* means for Lebrun (as for Félibien)[20] to establish a sequence of closely attentive and interrelated observations. It is clearly part of his intention that this sequence, which is meant to be reflected in the sequence of his discourse, is not just one of visual order. Although the first part of his lecture is devoted to the general disposition of the picture,[21] it would be wrong to assume that this was the overall and simultaneous effect of the whole work with all its parts; and the mistake would be on a matter of real importance.

Lebrun's notion of perception is not one directed toward visual effects but toward objects endowed with meaning. The general disposition he refers to is the setting of the scene, the landscape, which with its mountains, its woods and rocks, is a perfect representation of a desert. Within this setting, the groups and figures present themselves to Lebrun in a clear and meaningful sequence. The first group to attract his attention is the one on the left. These are the 'still' suffering Israelites (indicating the previous plight of the Jewish people), grouped around what is clearly and by all accounts the most impressive figure of the composition: that of a young mother offering her breast to an old woman. Lebrun briefly describes each figure of this group, their activities, costumes and draperies.

He then leads on to the second group of the foreground, on the right-hand side of the picture; this group, corresponding to the one on the left, represents the second stage of the action, the contrasted reactions of the Israelites to the miraculous fall of Manna.

Lebrun's sense of an implicit separation and sequence within the picture is surely governing his description. It is only after a detailed account of the second group has been given that our attention is finally drawn to the main protagonists of the action:

[19] Félibien, *Conférences* (vol. V), pp.424/425.
[20] Félibien, *Préface* (vol. V), p.307.
[21] Félibien, *Conférences* (vol. V), p.402.

The two parts of this picture, to the right and to the left, form two groups of figures which leave the centre free and open for our eyes to discover, further in the background, Moses and Aaron.

(Les deux parties de ce Tableau qui sont à droit & à gauche, forment deux groupes de figures qui laissent le milieu ouvert & libre à la vue pour découvrir plus avant Moîse & Aaron.)[22]

Lebrun rounds off his survey of the picture by leading us into the background, where we find among hills and mountains the camp of the Israelites.

*　　*　　*　　*　　*

It could be argued that the temporal sequence implicit in Lebrun's description should be understood simply as a result of the inevitable succession of language and discourse; that in describing a painting (any painting) we have to use language in a way comparable to that of the historian, *'par un arrangement de paroles, & une suite de discours'*; and finally that, while in the case of the historian the sequence of language could be understood as suitable for (or even as corresponding to) the sequence of events described, the same could not be said in the case of descriptions of pictures. Paintings, as Lee would claim, have neither a beginning nor an end.

Yet to argue in this way would mean to deny any sense of validity to the specific mental habits and critical attitudes of the French academicians. Poussin himself had repeatedly demanded that his paintings be attentively *read*, not simply looked at.[23] And in the formulation of Félibien and Lebrun, the sequential structure and order of this attentive and instructed reading is brought out quite explicitly. The fact that it would take us more than one instant to take in all the parts and details of an action depicted in a painting means that the painter is expected to give clear guidance for our reading of his composition; he has to establish order in the sequence of our perceptions (Diderot's demand that a painting should have a *ligne de liaison*, one main compositional line along which the spectator is led, will be referred to in the last chapter; it is the logical consequence of the implications of Lebrun's lecture).[24]

If the artist has a complete understanding of his subject, and if he orders his work accordingly, then, according to Félibien, the spectator, in the process of reading it, should find both his ideas and his perceptions of the work's beauties well-ordered:

When we look at a painting all the notions we have of those elements which

[22] *Ibid.*, p.405.

[23] See, for example, Poussin's letter to Stella, *Entretien VIII* (vol. IV), p.26, describing the variety of emotions and feelings, ages and temperaments etc. depicted in the *Manna* – 'choses, comme je crois, qui ne déplairont pas à ceux qui les sçauront lire.' Blunt realized that 'this idea of reading the picture is fundamental in Poussin's conception of painting' (*Nicolas Poussin*, London, New York 1967, p.223); for a semiotic approach to the 'reading' of Poussin's work cf. L. Marin, 'La Lecture du Tableau d'après Poussin', *Cahiers de l'Association Internationale des Etudes Françaises*, 24, 1972, pp.251–266.

[24] See below, p.133.

can help to make it perfect emerge one after another without any confusion and enable us to discover the beauties of the work as we look at it.

(En Voyant un Tableau, toutes les notions que l'on a des parties qui peuvent servir à le rendre parfait, viennent sans confusion les unes après les autres, & en découvrant les beautez à mesure qu'on le regarde.)[25]

That our vision needs to be guided by the composition of the picture was to become a commonplace in academic doctrine; it is a condition of our understanding of the picture's subject, and hence an integral part of the doctrine of the unity of action, that our view must be led from one figure to another, and from one group to another, and must not be allowed to wander aimlessly around. This point is made clear by Lebrun:

He [Lebrun] said that what he refers to as the parts [of the picture] are all the separate figures in different places of the painting which divide our vision and enable it in some way to move around these figures, and to consider the different planes and the different situations of all the bodies, and the bodies themselves as different from each other.

That the groups are formed by an assemblage of several figures joined together which do not at all divide the main subject but, on the contrary, help to bind it together and to detain our vision so that it would not constantly wander around in the large expanse of the landscape.

(Il dit que ce qu'il appelle parties, sont toutes les figures separées en divers endroits de ce Tableau, lesquelles partagent la vuë, lui donnent moyen en quelque façon de se promener autour de ces figures, & de considerer les divers plans & les différentes situations de tous les corps, & les corps mêmes differents les uns des autres.

Que les groupes sont formez de l'assemblage de plusieurs figures qui ne separent point le sujet principal, mais au contraire qui servent à le lier & à arrêter la vuë; en sorte qu'elle n'est pas toûjours errante dans une grande étenduë de Pais.)[26]

Lebrun never goes as far as directly equating the sequence of our perception of a picture with the sequence of events depicted in that picture (and nor did Félibien). Yet the structure of his lecture would have provided an answer for those artists who were seeking to overcome the temporal limitations of their art and to approximate the work of the dramatic poets. If, as seems to be the case in Poussin's picture, we can be made to look first at those figures which enact the first stage of the story, and then at those groups which represent the later stages, then the ordered sequence of our visual perception on the one hand and our understanding of a temporal development of the action on the other would, so to speak, go hand in hand, and could be seen as mutually enforcing and enriching. Our successive perception of all the elements simultaneously present in a picture can arrange and transform them into a temporal sequence which,

[25] Félibien, *Preface* (vol. V), p.307.
[26] Félibien, *Conférences* (vol. V), pp.406/407.

though different in specificity, pace, and extension from the sequence of the action, can be suggestive of the consequentiality of a well-ordered dramatic plot.

3. Causality and Sequence of Thought

I have pointed out, in the first section, that Félibien would have understood the notion of unity of action, first of all, as a condition of rational understanding, as relating effects to causes, actions to their beginnings. In the second section, we have seen Lebrun pointing to a way in which painting could overcome a limitation of painting as compared to the 'art of language'.

Lebrun's comparison between painting and language is no longer informed by the arguments of the ancient *paragone* literature. Its aim is to relate painting to our understanding and our rationality in a way comparable to the relation language is normally seen as having with our rationality. This had been implicit in the attempt to define painting in the terms of dramatic theory but, later, rational rather than dramatic sequence becomes focal.

Let us turn to the description of a painting by Poussin by one of the most eminent *hommes de lettres* of the generation following Félibien. The painting is Poussin's *Landscape with a Snake* (Plate 2), now in the National Gallery, London, which is the object of one of the *Dialogues des Morts* by Fénelon, published in 1712,[27] and composed while this great theologian and educational writer, who had become a member of the *Académie française* in 1693, was in charge of educating the grandchildren of Louis XIV.

As we are not concerned here with Fénelon's educational view of history which dominates the *Dialogues des Morts*, we shall concentrate solely on his description of Poussin's painting; in a fictitious conversation with Leonardo da Vinci the French master is made to give a detailed account of his own composition, and he does this in a way which is very close to the ideas and aims of the early academicians and of Félibien.

Like Lebrun's lecture on the *Manna*, the description starts with the left hand side of the picture. Here we see what is, in terms of our emotional involvement, the strongest scene of the action: a man who had come to fetch water from a spring and who has been seized by a monstrous serpent.[28]

Leonardo does not know the picture, and even an exact description of the man killed by the snake does not do much to arouse his interest in what he regards as an isolated event: 'If you don't show us other objects this is just a rather bleak picture'. (Si vous ne nous présentez point d'autres objets, voilà un tableau bien triste.)[29] It is only with the introduction of the second scene or episode, the fleeing man on the right, and with a sense of sequence or mutual interaction between the two scenes, that his interest becomes firmly engaged. And

[27] Fénelon, *Dialogues des Morts*, quoted here from *Œuvres choisis: Dialogues sur l'éloquence*, Paris s.d., pp.352–452. For the *Landscape with a Snake*, cf. A. Blunt, *The Paintings of Nicolas Poussin. A Critical Catalogue*, London 1966, no. 209, pp.143f. Also Blunt, *Nicolas Poussin*, pp.286ff.

[28] Fénelon, *op. cit.*, p.425.

[29] *Loc. cit.*

his interest is now comparable to that aroused by classical drama; Leonardo senses: 'A certain pleasure similar to that the spectators of ancient tragedies enjoyed, where everything inspired terror or pity'. (Un certain plaisir semblable à ceux que goûtoient les spectateurs de ces anciennes tragédies où tout inspiroit la terreur et la pitié.)[30] In attitude, gesture and expression this second object of our reading is conceived as an effect caused by the first and initial object:

He notices the snake around the dead man, he stops suddenly; one of his feet remains suspended; he raises one arm, the other one is dropped; but both hands are open, indicating surprise and horror.

(Il aperçoit le serpent autour de l'homme mort, il s'arrête soudainement; un de ses pieds demeure suspendu: il lève un bras en haut, l'autre tombe en bas; mais les deux mains s'ouvrent, elles marquent la surprise et l'horreur.)[31]

Fénelon's next step takes us to the centre of the painting and also further back into the landscape – again in a sequence similar to that by which Lebrun led us to the figures of Moses and Aaron in the *Manna*. But there we were presented with the cause of the change of fortune we had witnessed in the two foreground groups. Here, in the *Landscape with a Snake*, we find something different: the relation between cause and effect, which provided the link for the first two objects of Fénelon's description, is used for a second time. A woman, sitting by the wayside, watches the man fleeing; although she cannot see the cause of his terror and panic, the sight of him surprises and frightens her. The cause of her excitement is the effect the snake and the dead body have on the man she does see:

The sight of the frightened man produces in her a rebound of terror. Of these two expressions of fear one could say what is often said about expressions of pain: great ones are quiet, small ones lament.

(La vue de cet homme effrayé fait en elle un contre-coup de terreur. Ces deux frayeurs sont, comme on dit, ce que les douleurs doivent être: les grandes se taisent, les petites se plaignent.)[32]

The possibility of reading a painting, starting with an initial main action, as a sequence of dependent elements, must have been tempting for Fénelon, the poet and man of letters. The linearity of a sequence like this was exactly that quality which – according to French seventeenth-century grammarians – distinguished the French language from others, being the fundamental basis of its logicality and *clarté* :

The natural order requires that in each proposition the noun, which expresses its subject, should be placed first; if it is accompanied by an adjective, that this adjective should follow it closely; that the attribute should be placed after the verb which links the subject with the attribute.

[30] *Ibid.*, p.426.
[31] *Loc. cit.*
[32] *Loc. cit.*

(L'ordre naturel demande donc que dans toute proposition le nom qui en exprime le sujet soit placé le premier; s'il est accompagné d'un Adjectif, que cet Adjectif le suivre de près; que l'attribut soit mis après le verbe qui fait liaison du sujet avec l'attribut.)[33]

In later chapters we shall have to return to the work from which this quotation has been taken, Bernard Lamy's *La Rhétorique, ou l'Art de Parler* of 1675.[34] Lamy did not regard this construction of sentences as conventional; he saw it as an imitation of the natural process of the workings of the mind: 'First one thinks about the subject of a proposition ... and so the subject occupies the first place'. (On pense d'abord au sujet d'une proposition ... ainsi le sujet occupe la première place.)[35] It was because of this linear sequence of dependencies both in thought and in speech that, in Lamy's opinion, the French language and mind were superior even to Latin and Greek. These ancient languages were not based on logical consistency and linearity, but on the notion that the whole content of a sentence had to be simultaneously present in our mind before we could formulate or understand it. In Latin there is no difference (or only one of emphasis) between *Hominem fecit Deus* and *Deus fecit hominem*; the sentence has to be conceived simultaneously as a whole, for only then can we understand the mutual relations between its parts:

One has a conception which is like an image consisting of several features linked to each other in order to express it. It would therefore seem appropriate to present that image all at once, so that one could consider all its mutually related features with a single glance.

(On a une conception qui est comme une image faite de plusieurs traits qui se lient pour l'exprimer. Il semble donc qu'il est à propos de presenter cette image toute entière afin qu'on considere d'une seule veue tous ses traits liez les uns avec les autres.)[36]

In Latin we need to know the whole sentence in order to understand it, and so there will be a *retardement* of our understanding before the sentence is finished. In French, however, the meaning of the sentence is continually communicated through the natural and irreversible sequence of its parts: *Dieu a fait l'homme* is an imitation both in thought and in speech of the natural sequence of cause and effect.

Whether Félibien was as aware of these linguistic implications as Fénelon must have been, we do not know. I have suggested, in the first section, that his reading of Aristotle's differentiation of the plot into beginning, middle, and end was informed not so much by notions of narrative continuity, but by an interest in rational thought and logical consequentiality. One would like to think, therefore, that the fact that his description of the *Landscape with a Snake* proceeds in

[33] B. Lamy, *La Rhétorique, ou l'Art de Parler*, quoted here from the fourth edition, Amsterdam 1694, p.48.
[34] See below, chap. III.
[35] Lamy, *loc. cit.*
[36] Lamy, p.50.

exactly the same sequence as Fénelon's was not merely coincidental, although he simply lists the different parts of the action:

That dead body, lying by the edge of a spring and surrounded by a serpent; that man who flees with expressions of fear in his face; that sitting woman who is surprised to see him running and being so terrified.

(Ce corps mort & étendu au bord d'une fontaine, & entouré d'un serpent; cet home qui fuit avec la frayeur sur le visage; cette femme assisse, & éttonnée de le voir courir & si epouvanté.)[37]

The sequence of the snake with the dead body, the fleeing man, and the surprised woman is as irreversible as the sequence of subject-verb-object in the French language. And perhaps the very fact that the notion of the 'image' was invoked to illustrate the lack of logical consequence and consistency in other languages, made it even more tempting for Poussin's friends and admirers in France to detect in his paintings exactly those qualities of linearity, logicality and *clarté* which, being normally considered as beyond the reach and the limits of painting, were thought of as the hall-marks of French *esprit* and thinking and which were seen as the basic conditions of our understanding and our rational ordering of the world. If painting could be presented as displaying these qualities then what was true for speech and discourse would equally be true for the art of painting: ' . . . that order and beauty are almost the same thing'. (. . . que l'ordre & la beauté sont presqu'une même chose.)[38]

4. *The Unity of Action and the Problem of Episodes*

The separation of figures and groups in Poussin's paintings, which made it possible for Lebrun and Fénelon to 'read' them as sequences of events or of causes and effects, may serve as an introduction to another controversial aspect of the unity of action in painting: the use of the dramatic term 'episodes' to describe minor figures or groups or subsidiary actions in a painting. This seems to have been a commonly accepted use in the later half of the seventeenth century; yet for Lee it is another 'absurd' transgression of the limits set *a priori* for pictorial theory in pursuing an analogy with drama.

The anonymous critic of the sixth lecture was so overcome with the analogy between drama and Poussin's *Manna* that he made a rather daring comparison of Poussin's foreground figures with dramatic episodes leading to *peripeteia* :

That is why we see that these groups of figures, involved in different actions, are like so many episodes, which bring about what is called *peripeteia* and make us understand the change of fortune of the Israelites as they leave a state of extreme misery and enter into a happier state.

(C'est pourquoi l'on voit que ces groupes de figures qui font diverses actions, sont comme autant d'Episodes qui servent à ce que l'on nomme Peripeties, &

[37] Félibien, *Entretien VIII* (vol. IV), p.150.
[38] Lamy, p.8.

de moyens pour faire connoître le changement arrivé aux Israëlites quand ils sortent d'une extrême misere & qu'ils rentrent dans un état plus hereux.)[39]

This may be an extreme way of interpreting in dramatic terms the temporal implications of Poussin's painting (and the sequence of Lebrun's reading of it), but it is by no means absurd. Even when we look at paintings which are less suggestive of a dramatic development than the *Manna* we may feel justified to refer to their parts as episodes.

This has much to do with the reason for which the early academicians introduced the term into their discussions; it could help to elucidate, within the general unity of action, the relationships of minor to major figures, of subsidiary actions to the main action. And to borrow the term from dramatic theory would seem wholly appropriate; even in drama the relation between the episodes is not just one of their temporal arrangement. No less essential was the relative weight or importance accorded to each part of the fable. It was with respect to the relation of the more important elements to the less that Mambrun, one of the leading literary theoreticians of the time, could postulate that the episodes in drama should be like the members of a body.[40]

Félibien, in his preface, uses the same analogy when he talks of those particular figures:

Which are only there to accompany the main figure . . . and which have a true connection with the figure which serves as the body of the work of which the others are like the members.

(Qui ne sont que pour accompagner la principale . . . & qui ayent un rapport honneste à la figure qui sert comme de corps à l'ouvrage dont les autres sont commes les membres.)[41]

Yet even the French dramatists and literary critics considered the episodes with certain misgivings, to say the least. In Aristotle's *Poetics* episodes are simply the constituent parts of an action; and the action which the plot presents can be either probable and necessary, in which case the episodes are in accord with the principle of unity, or it can be without probability or necessity, in which case episodes, and the plot of which they are part, lack the required consequentiality.[42] This second kind of plot or action is what Aristotle calls 'episodic'.

The seventeenth-century critics read this in a somewhat different way. They distinguished very rigidly between the main action of the drama and episodes which formed subsidiary actions. As the unity of the plot was considered to depend on its being the imitation of one action, episodes appeared to be detrimental to the unity of a work and therefore altogether undesirable.

[39] Félibien, *Conférences* (vol. V), p.426.
[40] P. Mambrun, *Dissertatio peripatetica de epico carmine*, Paris 1652; cf. Bray, p.250. To define an order of language by reference to the human body was never understood as contradictory, see, e.g. Aristotle (above, p.7) and Quintilian, *Institutio Oratoria*, VII, x, 7, advising the orator to make the structure of his speech as regular as that of the human body (cf. P. France, *Rhetoric and Truth in France, Descartes to Diderot*, Oxford 1972, p.10).
[41] Félibien, *Preface* (vol. V) p.316.
[42] Aristotle, *Poetics*, chap 9, 1451b.

Other readings of Aristotle were more liberal, and the question was finally resolved by, so to speak, splitting the concept of unity into two. Mambrun, for instance, makes a distinction between action and plot which is only superficially based on Aristotle. For Aristotle, action and plot are very closely related: when he talks about the ordering and structuring of tragedy he is more likely to use the term 'plot', and when he is concerned with the material on which the dramatist draws, he talks, in general, about the action. Mambrun turns this distinction into the neat phrase: 'The action is the work of the hero, the plot that of the poet'. (L'action est l'oeuvre du héros, la fable celle du poète.)[43] In his view – and this became part of the *doctrine classique* – there should be only one action, which must not be complex but simple, that is, without episodes. Mambrun seems to assume that what constitutes one action is self-evident; and the unity of action is then to be understood quite literally as a numerical limitation. The fable or plot, however:

Is the action augmented by episodes. It is the plot, and not the action, which is complex ... And the plot, too, has its unity which consists in the necessary or probable dependence of its parts.

(C'est l'action augmentée des épisodes. C'est elle, et non l'action, qui est complex ... Elle a, elle aussi, son unité, qui consiste en la dépendance nécessaire ou vraisemblable de ses parties.)[44]

Episodes, in this account, are not integral or constituent parts of the action; the poet includes them in his plot in order to give it variety and richness and generally to sustain and guide the interest and the attention of his audience. It is normally in this sense that the term is applied to painting (although one should note that the anonymous critic's comments on the *Manna* seem to be closer to Aristotle's original definition). Painters, like poets, are warned not to be excessive in their use of subsidiary actions and to ensure that they are properly related to the main theme. As Félibien puts it in his preface:

If you want to give variety to your subject by adding some separate actions, you must take care that your actions are not too many nor too low, even if they have some connection with the story you paint.

(Que si l'on veut varier son sujet par quelques actions particulieres, il faut prendre garde que ces actions ne soient pas en trop grand nombre ou trop basses, quoi qu'elles aient quelque rapport à l'histoire qu'on peint.)[45]

* * * * *

Most theorists of painting since Alberti have tried to define the correct balance between variety and restraint. It may seem that Félibien has rather little to add to this perennial discussion; the passage just quoted, although probably more on the restrictive side, is rather vague and general, and the same seems to be true

[43] Cf. Bray, p.247.
[44] Bray, *loc. cit.*
[45] Félibien, Preface (vol. V), p.316.

of a similar passage from his *Entretiens*, where he advises the artist to take care: 'That there are neither too many nor too few figures for the subject he treats'. ('S'il n'y a point trop ou trop peu de figures pour le Sujet qu'il traite.)[46]

Yet if we bear in mind that for Félibien the ideal of painting had been realized in the art of Poussin, and if we also remember that he saw his theories as a continuation of the great painter's thoughts on art, then we may be able to give more substance to an important element of his theory of unity.

Before we look at one or two more paintings by Poussin which may help to elucidate the problem, let us turn first to the discussions which took place in the *Accademia di San Luca* in Rome during the 'thirties of the seventeenth century as these are often referred to as having influenced the young Poussin. The actual text of these disputes seems to have been lost, yet from what we know it appears that they were concerned with problems very closely related to ours.[47]

The central problem was posed as the question whether the rules of tragedy or those of epic poetry had to be considered as being binding for painting. The argument was largely concerned with the number of figures, subsidiary actions and episodes which the artist could legitimately include in his picture. Andrea Sacchi, the leader of the 'classicists', held the view that tragedy, as the highest *genre* of drama, had to be imitated in every respect, including the restriction of the number of figures in a picture to those essential to its subject. Pietro da Cortona, Sacchi's opponent in these discussions, agreed that a painting should have only one main subject, but he argued that this subject could and should be adorned by numerous episodes and subsidiary figures, so as to endow the composition with magnificence and variety. It would probably be true to say that for both painters, and their respective followers, this was not so much an issue of theoretical speculation aiming at eternal rules, but rather an attempt to justify their own art, to prove the excellence and superiority of their own compositions in contrast to those of their opponents. The difference between the 'classically' simple and restrained compositions by Sacchi and Cortona's exuberant 'baroque' decorations, manifested most clearly in their ceiling frescoes in the Palazzo Barberini, required some kind of programmatic explanation.

This discussion is of interest in our context as Poussin had for some time been a close associate of Sacchi's in Rome.[48] Furthermore, modern critics have found among Poussin's paintings perfect examples of 'classical' unification and restraint of the kind Sacchi advocated. And finally, there is possibly a direct link between Sacchi's ideas and Félibien's theories, depending on the trust we put in

[46] Félibien, *Entretien IV* (vol. II), p.379. Cf. also *Entretien VIII* (vol. IV), p.90: '...faire en sorte que dans la representation d'une histoire, il n'y ait ni trop, ni trop peu de figures'.

[47] On the dispute in the *Accademia di San Luca* during the presidency of Cortona (probably in 1636) cf. M. Missirini, *Memorie per servire alla Storia della Romana Accademia di San Luca*, Rome 1823, pp.111–113; A. Blunt, 'Poussin's Notes on Painting', *Journal of the Warburg Institute*, I, 1937–38, pp.346f; D. Mahon, 'Poussin au carrefour des années trente', *Nicholas Poussin, Actes du Colloque Poussin*, 1960, pp.251ff, in part. pp.257/258; D. Mahon, 'Poussiniana. Afterthoughts arising from the Exhibition', *Gazette des Beaux-Arts*, 1962, vol. 60, pp.1–138, in part. pp. 96–101; A. Blunt, *Nicolas Poussin*, p.221.

[48] On Poussin's association with Sacchi, as reported by Passeri, cf. D. Mahon, 'Poussiniana', p.64; A. Blunt, *Nicolas Poussin*, p.57.

Félibien's claim that his opinions on art were influenced by Poussin's own thought.

Let us first look at one of Poussin's paintings which has recently been interpreted as evidence of Sacchi's influence on the French painter, the *Massacre of the Innocents* (Plate 3) in Chantilly, probably painted in the late 'twenties. Wittkower and others saw this as an extreme consequence of Sacchi's principles: 'His French rationalism and discipline carried Poussin even further than Sacchi'.[49] Whereas earlier representations of the subject normally indulged in tumultuous scenes, involving large numbers of figures, Poussin restricted his composition to what Anthony Blunt has called an almost Racinian concentration:[50] just one mother, one child, and one soldier, with a second mother, mourning over her dead child, in the background. There is no doubt that Poussin's composition – compared, for instance, with Rubens' almost contemporaneous version in Munich (Plate 4)[51] – is an example of extreme restraint and simplification.

The linking of Sacchi and Racine, of Italian and French 'Aristotelianism', in modern references to the picture is of particular interest in our context; the more dogmatic and rigid members of the *Académie française* would surely have agreed with Sacchi's demand that the number of figures in a picture, as the number of persons in a dramatic action, should be limited to what was essential to the subject.

But whether Poussin's picture is really evidence of 'the stiffening of the theoretical position', as Wittkower thought,[52] is another matter. As other paintings of roughly the same period, like the *Plague at Ashdod* (Plate 5), the *Crossing of the Red Sea*, or the *Rape of the Sabine Women*,[53] include large numbers of figures, numerous episodes, subsidiary actions, which on the surface seem to be more in tune with Cortona's 'baroque' ideas, the *Massacre* would seem to be rather untypical.

It would not even be a wholly convincing strategy to assign to the picture the status of a self-consciously programmatic statement. Those literal statements we have by Poussin (admittedly of a later date) point in a rather different direction. The famous letter to Paul Fréart de Chantelou outlining his theory of the modes, which was written in 1647, the year when Félibien arrived in Rome, gives a clear indication that restricting or even reducing the number of figures in a painting was not considered by Poussin as in itself an artistic achievement. Although it is possible that we are dealing here with what one might best describe as a business letter, it would seem that the following passage deserves at least as much serious consideration as the whole passage on the modes:

And why, after sending you the first of your pictures composed of only sixteen or eighteen figures – so that I could have made the others with the same number

[49] R. Wittkower, *Art and Architecture in Italy 1600–1750*, second edition, London 1965, p.172.
[50] Blunt, *Nicolas Poussin*, p.90.
[51] Munich, Alte Pinakothek, no. 572.
[52] Wittkower, *loc. cit*.
[53] Blunt, *The Paintings of Nicolas Poussin*, nos. 32, 20, 179.

or fewer in order to bring such a labour to an end – why did I enrich them with no thought except to obtain your goodwill?'

(Pourquoy esse que après vous auoir enuoyé le premier de vos tableaux composé de saize ou dishuit figures seullement et que je pouuois faire les autres du mesme nonbre ou plustost les diminuer pour venir plustost afin d'une si longue fatigue je les ei enrichis de plus sans penser à aucun interrest autre que à gagner vostre beinueillanse.)[54]

The small number of figures – *only* sixteen or eighteen or even less – is referred to in this letter not with the positive meaning of classical simplification, but in a negative sense as a means of easing the artist's workload. And one has to add that most of Poussin's narrative paintings, including the early ones, show him to have been the hard-working and conscientious painter which he was presenting himself to Chantelou as being.

Why then is the *Massacre of the Innocents* composed in the way it is, with the absolute minimum of figures required? If we looked at it in the light of Sacchi's reported views it would remain an isolated and unrepresentative case in the *œuvre* of Poussin. If we apply to it Félibien's rule that the artist should take care that there were neither too many nor too few figures for the subject to be depicted, we may find that the picture is not untypical at all; it simply represents one extreme of a range of possible interpretations of subjects for paintings. That Poussin reduced the *Massacre* to just one group of three figures would then have to be understood not in the light of a general rule of dramatic restraint, of 'abstemious concentration', but as a consequence of the particular character of this subject.

It is possible that Poussin became aware of the need to restrict the number of figures and groups in this picture after he had painted an earlier version of the same subject, the painting now in the Petit Palais (Plate 6).[55] It shows three groups of figures, each of them engaged in almost exactly the same action: a soldier trying to kill a baby despite the mother's desperate attempts to save her child. The biblical story of the murder of the innocents seems to require a large number of figures, but it does not seem to allow for much variety in the

[54] (Ch. Jouanny, ed.) *Correspondance de Nicolas Poussin* (Archives de l'Art français, nouv. per. vol. 5), Paris 1911, no. 156, pp.370–375; p.371f. The 'Racinian concentration' (Blunt) was controversial even among the early academicians; cf. the seventh conference on Poussin's *Healing of the Blind*, where it was argued that historical accuracy or *convenance* required a large multitude of people following Christ. The counter-argument did not invoke dramatic concentration but claimed that the multitude was hidden behind the architecture: (*Conférences* (vol. V), pp.442–444. Also cf. *Entretien VIII* (vol. IV), p.18, on Poussin's *Capture of Jerusalem*; the second version exceeded the first one by being 'beaucoup plus rempli de figures, & traité d'une manière encore plus sçavante'. On Félibien's visit to Italy and his meetings with Poussin, see Y. Delaporte, 'André Félibien en Italie (1647–1648)', *Gazette des Beaux-Arts*, 1958, I, pp.193–214.

[55] Blunt, *The Paintings of Nicolas Poussin*, no. 66, pp.46 f. It is worth mentioning in this context that painters of battle-pieces – and the version in the Petit Palais would almost seem to fall into this category – were considered inferior by the Academy even to portrait painters (cf. Félibien, *Entretien IX*, vol. IV, pp.180/181) – the reason being that they did not depict a central and unified action in the Aristotelian sense.

expression of individual *affetti* and emotions, nor for the subordination of episodes or subsidiary actions under one main action.

The three groups of the Petit-Palais version are well arranged and clearly recognisable, but in terms of their dramatic meaning they are simply repetitions of the same basic type. Their relation to each other is not that of parts of a body in the sense required by Mambrun and Félibien for episodes and main action, and we cannot read them in any temporal or causal sequence so that one part could be considered as leading to or depending upon another. In Félibien's terms, which might have been those of Poussin himself, there are too many figures conveying the same message rather than adding to it or enlarging upon it.

In this sense, the restriction of the Chantilly version to only one group could easily have been the result of Poussin's awareness of the shortcomings of the earlier painting. He now realised that the whole range of actions and emotions involved in the subject – the soldiers' determination to kill, the horror of the mothers trying in vain to protect their children – could be and had to be expressed in just one group, if the picture was not going to be repetitious or, in dramatic terms, episodic. As the inclusion of the cause of the main action, Herod ordering the massacre, would have stretched the action beyond any acceptable limits, any additional group would simply have repeated the subject without adding anything essential to it. The only subsidiary figure (or episode) admitted is that of the second mother in the background, and her presence *is* explicable in terms of a temporal or causal development: she indicates the result or end to which the main action will lead, – in her arms she carries her murdered child.

<p style="text-align:center">* * * * *</p>

Looked at in this way, the rigid concentration of the Chantilly *Massacre* would seem to be perfectly in line with Félibien's view that the number of figures of a composition depended on the artist's interpretation of his subject. If we left the matter here, it would look as if it was implied that the restraint of Poussin's composition was of a somewhat negative kind, as simply reflecting the limited potential of the subject in respect of variety and consequentiality; and we could rightly be accused of underrating Poussin's power of invention.

We would also fail to notice that the picture's unusual concentration is very intimately related to another and equally unusual feature, its monumental scale. As an apparently extrinsic factor, the size of a picture is easily neglected though it is of obvious consequence both for the way in which the artist works out his composition, and the way it makes its impression on the spectator.[56] Seventeenth-century artists and critics were far more aware of these implications of a painting's size than we are today. Without its monumental scale and its almost life-size figures, a composition like the *Massacre* would probably have been described in much the same way in which Fénelon addressed the isolated left hand group from the *Landscape with the Snake*: '*Voilà un tableau bien triste*'.[57]

[56] I have discussed some of these problems in more detail in my Dr. phil. dissertation (Hamburg 1971), *Masstabsfragen. Über die Unterschiede zwischen grossen und kleinen Bildern*.

[57] See above, p.12.

That we are justified in relating the picture's extreme concentration to its scale is indicated by Félibien, although in a somewhat oblique way and *ex contrario*. According to him, the abundance of detail and figures in most of Poussin's compositions is closely connected to the small or medium format of his paintings. When talking about some early works, including the *Plague at Ashdod*, Félibien comments on the popularity of these medium-sized 'cabinet-pictures'; although commissions like these meant that Poussin had to work within somewhat narrow limits:

They offered him enough space to realize his noble conceptions, and to display, in small formats, grand and learned compositions.

(Mais qui lui donnoient . . . assez de lieu pour faire paroître ses nobles conceptions, & pour étaler dans de petits espaces, de grandes & sçavantes dispositions.)[58]

Félibien implies that this was not entirely of Poussin's own choice; it was the result of the Italians awarding all major commissions to their compatriots so that French painters in Rome had to be content with *des tableaux de cabinet*.

Stories of artists who managed to overcome the limitations of a small format are among the *topoi* of ancient literature on art. Pliny, for instance, tells the story of Timanthes who succeeded in representing even the giant Polyphemus in a small painting.[59] Deprived of the opportunities of large scale compositions, Poussin's art is seen by Félibien in the same way as Timanthes' was by Pliny — transcending the limitations of scale within which it had to manifest itself:

He found in pictures of a medium size a field sufficiently vast to show his knowledge; and he has not produced any in which we could not notice an infinite number of different beauties.

([Il] trouvoit dans des Tableaux d'une mediocre grandeur un champ assez vaste pour faire paroître son sçavoir: aussi n'en a-t-il point fait où l'on ne puisse remarquer une infinité de differentes beautez.)[60]

The finest example of this infinite variety, displayed despite the *mediocre grandeur* of the painting is, according to Félibien, *The Gathering of the Manna*: ' . . . which other work could be shown, in which there was such a great number of beautiful parts to be seen?'. (. . . quel autre ouvrage pourroit-on faire voir, où il y eût un aussi grand nombre de belles parties à considerer?)[61]

We would not do justice to Félibien if we saw his views simply in the light of the tradition of Pliny's *Künstlerlegenden*. Poussin's achievement of having brought together, on a small scale, an infinite variety of beautiful objects is of a rather different kind from that of Timanthes.

[58] *Entretien VIII*, p.21. French critics generally seem to have been somewhat defensive about the size of Poussin's pictures; cf. for example, Roland Fréart de Chambray, *Idée de la perfection de la peinture*, Paris 1662, pp.85–90. He is talking about Giulio Romano's *Sleeping Polyphemus* and Timanthes (see n.59), but is clearly thinking of Poussin: 'Un petit Tableau peut devenir quelquefois un grand chef-d'oeuvre, selon l'Idée du Peintre en est relevée . . . ' (p.89).

[59] Pliny, *Natural History*, XXXV, 74.

[60] Félibien, *Entretien VIII* (vol. IV), p.120.

[61] Félibien, *Entretien VIII* (vol. IV), p.144.

It is not part of our investigation to discuss in detail the different demands and possibilities of large scale and small scale paintings. The contrast between the *Massacre* and the *Manna*, however, brings out clearly one difference which I believe to be of crucial interest for us: the two works elicit quite different responses from the spectator. The almost life-size figures of the *Massacre* impress themselves upon us with a sense of an immediate presence and actuality; the concentration on one monumental group gives us the illusion of witnessing the cruel drama in an almost physical sense.

The much smaller figures of cabinet-pictures like the *Manna* have none of this immediate impact; it is not just that they seem to be more distant (being so much smaller), but they appear to belong to an altogether different kind of reality.[62] We have to find our way, so to speak, into the picture, we have to project the figures into their spatial settings, their surroundings, explore the depth of the picture in order to place the figures and groups in relation to each other; in short, we become more aware of projecting and exploring an image than we are in the case of large scale pictures and life-size figures. We cannot help being attentive to what is happening in the *Massacre*, but it requires some effort to attend to the events of the *Manna*.

It may seem as if we had strayed a long way from the notion of unity of action as defined in Félibien's preface and during the conferences. Yet the comparison between these two pictures may help us to appreciate the urgency and the complexity of this notion. Poussin's demand that his paintings should be *read* (even if we understood this simply in a rather vague and metaphorical way) does obviously make more sense when applied to the *Manna* than it does in the context of the *Massacre*. It is the smaller paintings which require more variety and richness of detail in order to arouse our interest; *l'infinité de differentes beautez*, to which Félibien refers, are 'episodes' in Mambrun's sense, meant to attract our attention and to engage our minds. Yet the more numerous they are, the more they need to be ordered and structured to sustain our interest.

Simply to include as many beautiful elements as possible in a small picture would not count, by Félibien's standards, as an artistic achievement. It is the overall sense of order and consequentiality (Félibien's unity of action or subject) which keeps our attention engaged, relating one element to the next in a meaningful sequence. The more beautiful details and episodes such a sequence contained within its overall sense of unity, the more it would engross and absorb the spectator's attention (and make him forget the small format of the picture in front of his eyes). If we want to define more precisely Félibien's attitude to the problem of action and episodes we could, rather than rely on the generally dogmatic statement from the preface, quote directly from Aristotle himself:

'The longer the story, consistently with its being comprehensible as a whole, the finer it is by reason of its magnitude'.[63]

And we could add – in the spirit of Félibien – that Poussin had truly overcome

[62] See Puttfarken (as in note 56).
[63] Aristotle, *Poetics*, chap 7, 1451a.

the limitations of the small scale by achieving this controlled magnitude in cabinet-pictures rather than in expansive decorations.

5. *Fitness and Propriety: The Problem of Judgment*

It would be wrong to assume that all of Poussin's narrative paintings could be read as temporal or causal sequences. Both the *Gathering of the Manna* and the *Landscape with a Snake* are extreme examples of the sense of consequentiality implied in Félibien's unity of action or subject. Other subjects required different kinds of order. Félibien's analysis of the *Rebecca* (Plate 7) and Fénelon's description of the *Phocion*[65] are further examples of the way in which French critics successfully transformed the simultaneous presence of the picture into the linear sequence of a literary account.

We may sometimes think of these interpretations as inadequate or insufficient as far as the specifically visual nature of painting is concerned (a point to which we shall return shortly). But one has to agree that they account in a clear and comprehensive manner for the different actions and episodes, the settings and landscapes, and most of the other details of the pictures. We may no longer share the literary culture of which these accounts were part and which defined their priorities, but I think we have to admit that there is a correlation between the descriptions and the pictures described which seems somewhat closer than what most modern criticism has achieved.

The general governing principle of pictorial unity covering all kinds of subject and all kinds of order (and thus, as extreme cases, temporal and causal sequences) is, according to Félibien, that of *convenance*. For lack of a better word we shall have to translate it as 'fitness', including the notion of appropriateness and dependence between the parts and the whole of a work (in contemporary literary terms *la dépendance nécessaire ou vraisemblable des parties*).[66]

The rule of *convenance* extends over all those parts of painting which Félibien calls 'theoretical' (as opposed to the practical arrangement and execution of the work). In this sense it depends on the artist's knowledge and erudition, which should be the same in the painter as in the poet, the historian or the critic. The overall task of ordering, of establishing *convenance* throughout and of overall unity, is that of *composition*, and this, for Félibien, is an entirely intellectual activity as distinct from the practice of *ordonnance*, *dessin* and *coloris*: 'It is entirely liberal, and one can master it without being a Painter'. (Qui est toute libre & que l'on peut sçavoir sans etre Peintre.)[67]

Appropriateness and dependence, in the sense used by Félibien, are then not to be understood as primarily visual qualities, in the sense of a painting's balance,

[64] *Entretien VIII* (vol. IV), pp.101–115.

[65] Fénelon, *Dialogues des Morts*, pp.417–424 (the dialogue is between Parrhasius and Poussin).

[66] Bray, p.247.

[67] Félibien, *Entretien I* (vol. I), p.92; also *Preface* (vol. V), p.309: 'Il est donc vrai qu'il y a un Art tout particulier qui est detaché de la matiere & de la main de l'Artisan, par lequel il doit d'abord former ses Tableaux dans son esprit...' On the similarity of painter and poet cf. *Entretien III*, (vol. III), p.185: 'Il faut que le Peintre faisant l'office d'un Poëte muet, expose dans la noble invention d'un beau sujet, toutes les parties d'un Poëme bien entendu'.

equilibrium and overall visual effect. They are to be understood as qualities of the subject rather than the distinctly visual character. They relate to the literal and literary connections between persons and objects, which in their entirety constitute the fable or the subject. It is because of this understanding of composition as an intellectual achievement that the learned connoisseur, in Félibien's view, can read the painting and form a judgment without being a painter. His judgment will depend on the fitness of all the parts and details of the composition in respect of the nature of the subject.

Closely related to the notion of *convenance* or fitness are two other notions, *bienséance* and *vraisemblance*. *Bienséance*, as used by Félibien, covers the traditional concept of *decorum* and can best be translated as 'appropriateness':

Which has to be maintained in respect of different ages, sexes, countries, of different professions, morals, passions, and of the fashions of each nation to dress.

(Qu'il faut conserver à l'égard des âges, & des sexes, des païs, & des differentes professions, des moeurs, des passions, & des manieres de se vêtir propres à chaque nation.)[68]

Vraisemblance, or verisimilitude, overlaps to such an extent with *convenance* that it is at times difficult to distinguish between the two. Veronese's *Supper at Emmaus* is lacking in *vraisemblance* because the artist has neglected the elementary rules of *convenance* : 'As the disposition of the place and all the people surrounding Our Lord are not fit for that event'. (Parce que la disposition du lieu & toutes les personnes qui environnent Nôtre Seigneur ne conviennent point à cette action.)[69]

These three notions had considerably exercised the minds of the members of the *Académie française* in whose literary disputes they figure as prominently as the three unities, to which they are closely related. In one important aspect Félibien's use of them differs from contemporary literary criticism, and this difference underlines the limitations of his theory.

Ten years before Félibien published his *Conférences*, the literary critic Nicole wrote: 'Reason will teach us the general rule that a thing is beautiful if it has *convenance* with its own nature and with ours'. (La raison nous apprendra pour règle générale qu'une chose est belle lorsqu'elle a de la convenance avec sa propre nature et avec la nôtre.)[70] *Convenance*, *vraisemblance*, and *bienséance* in literary theory refer not only to the nature of the subject but also to the nature, the knowledge and the conventions of the audience, the public. The standard against which they were to be judged was set not by exact historical or literary knowledge, but by the *sens commun*, or public opinion. The notion of probability has had critical priority over historical reality and truth even in Aristotle, defining an area of poetic invention and freedom; in seventeenth-century France it is the

[68] Félibien, *Preface*, p.317.
[69] *Preface*, pp.314/315.
[70] P. Nicole, *Traité de la vraie et de la fausse beauté dans les ouvrages de l'esprit et particulierement dans l'épigramme* (Latin text 1659, French translation by Richelet 1698, p.171); cf. Bray, p.216.

sens commun, les moeurs et les sentiments des spectateurs, which determine what counts as probable and what does not.[71]

This was not without its problems; the major dilemma was what Bray, following Nicole, has described as the perpetual conflict between *bienséances internes* and *bienséances externes*.[72] *Bienséances internes* correspond rather exactly to Félibien's notion of *convenance* or fitness; *bienséances externes*, in this context, could perhaps be translated as propriety (rather than as appropriateness, as I suggested for Félibien's use of the term). The requirement that actions and characters had to be consistent and in accordance with their own nature and with historical reality and *decorum* or *costume* was generally accepted, but it was not always reconcilable with the requirements of the *sens commun*, in particular with the demand that everything should be adjusted to the contemporary public's standards of knowledge, morals, and taste.

There is very little to be found in Félibien's preface or in the conferences which would indicate that the early academicians shared this respect of their literary colleagues for the general public and its judgments.[73] Fitness, appropriateness, and probability were, for them, of overriding importance, and were discussed with erudite learning and detailed references to historical, art historical, and literary sources.

One very obvious reason for this difference is that there was no general public for painting. While theatrical performances were well attended both by *la cour et la ville*[74] there was no institutionalised framework within which an artist could submit his work to the general public. It is not before the eighteenth century that Salon exhibitions became a regular feature of artistic life in France.[75] So without being subjected to the pressures and the verdicts of a real general public (which they probably would have considered to be ignorant and incapable of sound judgment) they saw only themselves as true and competent judges in matters of their own art:

As the Academy is full of learned men there are no beauties in a work which are not noticed, nor any mistakes, small as they may be, which are not pointed out.

(L'Académie étant remplie de sçavans hommes, il n'y a point de beautez dans

[71] 'La mesure à garder, c'est que le public ne se doute de rien', Bray, p.255; taken from G. Lanson, *Corneille*, sixth edition, Paris 1922, p.69.

[72] Bray, p.216: for Nicole see note 63 above.

[73] Two typical statements can be found in the *Preface*, on p.317, where *bienséance* is referred to as 'une des plus nécessaires [parties] pour instruire les ignorans & l'une des plus agréables aux yeux des personnes sçavantes'; and on p.314, where Félibien demands 'que la vrai-semblance se trouve par tout comme une partie très-necessaire & qui frappe l'esprit de tout le monde'. The literary origin of these passages is clear, yet neither of them makes any concessions to the general public comparable to those which the *Académie française* advocated (as indicated by Bray, p.227 and p.224f: 'Les bienséances externes sont la mesure des bienséances internes. Le réalisme historique est limité par les connaissance historiques du public et par ses ignorances').

[74] Cf. E. Auerbach, *Das Französische Publikum des siebzehnten Jahrhunderts*, Munich 1933.

[75] On the history of academic exhibitions in France see G.F. Koch, *Die Kunstausstellung. Ihre Geschichte von den Anfängen bis zum Ausgang des 18. Jahrhunderts*, Berlin 1867, pp.127 ff.

un ouvrage qu'on ne remarque, ni aussi de défauts pour petits qu'ils soient qu'on ne fasse voir.)[76]

Judgments thus established were considered not only to be useful for the practising artist but also exemplary for a somewhat wider, though still rather limited, public, the *amateurs des Beaux Arts*. In their attempt to keep up the ideal of the *pictor doctus* or the *peintre philosophe* the painters were far less prepared to compromise in matters of historical truth, accurate interpretation of textual sources etc., than their literary colleagues.

* * * * *

Lack of concern for a wider, less educated public which would have found little interest in the extensive and detailed reading of a picture's subject-matter, had its repercussions on Félibien's theory. His insistence on the rationally coherent and unified treatment of a *sujet* meant that less erudite but perhaps more generally attractive aspects of painting remained largely neglected.

His literary colleagues were more circumspect and tried not only to strike a balance between erudition and simpler pleasures, but to use the public appeal of the theatre to achieve the more serious end of drama, that of instructing and improving its audience. To accept, and respond to, the public's judgment in matters of historical, social, or moral respects was, for them, a matter of furthering the didactic end of their art.

Critics like the Abbé d'Aubignac, who considered the theatre as a school of the people, *l'Ecole du Peuple*,[77] saw the poet's task as a two-fold one: as far as the invention and the structuring of the action was concerned, the poet had to adhere strictly to the truth and the *bienséances internes* of his subject without regard for the public; the spectators had to be taken into account only when the poet came to consider and arrange his work in terms of its actual performance or *représentation*.[78]

In a passage which anticipates Félibien's distinction between *théorie* and *pratique*, the Abbé d'Aubignac used the comparison with painting to illustrate the two ways of looking at the poet's work:

One can consider a picture in two ways: firstly like a painting, in so far as it is the work of the painter's hand, where there are only colours but no things, shadows but no bodies, artificial lights, false elevations . . . ; secondly, in so far as it contains an object painted, whether it is real or supposedly so, which has clearly defined settings, natural qualities, consistent actions, and all its circumstances according to order and reason.

(On peut considerer (un Tableau) en deux façons; la premiere comme une peinture, c'est-à-dire, autant que c'est l'ouvrage de la main du Peintre, où il n'y a

[76] Félibien, *Preface* (vol. V), p.304. How seriously discussions about the *bienséances internes* were taken by the academicians is demonstrated by the seventh conference, on Poussin's *Healing of the Blind*, (vol. V), pp.429 ff.

[77] François Hédelin d'Aubignac, *La Pratique du Théatre* (1st edition 1657) quoted here from ed. Amsterdam 1715, vol. I, p.5.

[78] *Ibid.*, pp.27 ff, chapter on *Des Spectateurs & Comment le Poëte les doit considerer*.

que des couleurs, & non pas des choses; des ombres, & non pas des corps, des jours artificiels, de fausses élevations... La seconde autant qu'il contient une chose qui est peinte, soit véritable ou supposée telle, dont les lieux sont certains, les qualitez naturelles, les actions indubitables, & toutes les circonstances selon l'ordre & la raison.)[79]

D'Aubignac makes this distinction between the two sides of art, not in order to give intellectual superiority to one of them, but to alert the poet to the importance of both. Without the practical execution, the performance, his work might still be of interest to *sçavants hommes*, to the learned community. Yet it would fail to affect the uneducated, the lower classes,[80] those who are influenced not by reasoning but by their senses. The senses, in this context, are not considered in opposition to reason, but as a means by which the theatre can be established as *l'Ecole du Peuple*: 'Reason can only conquer them by using means which affect the senses'. (La raison ne les peut vaincre, que par des moiens qui tombent sous les sens.)[81]

Accordingly, most of the concepts that make up the *Doctrine classique* of French drama are concerned with both sides; they relate to the poet's mental conception of his subject as well as to the performance, the practical execution. *Bienséances internes* and *externes*, and *vraisemblance* (which refers both to historical probability and to the expectations and convictions of the contemporary public) are obvious examples. The three unities, too, operate on both sides; their function is not only that of concentrating and ordering the plot; they are also means of achieving verisimilitude, almost in the sense of sensory illusion. The unities of time and place are meant to adjust the performance on the stage as far as possible to the actual time and place of the public.[82]

From the point of view of historical knowledge, general erudition, and reasoned instruction all this would appear as a weak compromise. Yet for d'Aubignac and his fellow dramatists and critics it meant that the didactic content of a work could and should be transmitted by the specific means and in the distinct medium of drama, that of an audible and visible performance.

Even if we allow for the fact that Félibien and his colleagues did not yet have to include a wider, uneducated public into their considerations, we have to accept that his preface, in which he attempts to sketch out a comprehensive theory, neglects the specifically visual nature of the art of painting. The actual arrangement of forms and figures, drawing, and colouring are all treated as inferior parts, inevitable for the realization of the work but not of decisive importance. They are not accounted for as the very means through which we perceive and comprehend the subject or theme. As the central interest of painting is defined in terms shared with other arts the specific sensual, the visual qualities and effects of it are seen as almost incidental.

This is particular obvious in Félibien's treatment of *ordonnance*, the

[79] *Ibid.*, p.28.
[80] *Ibid.*, p.4; d'Aubignac explicitly refers to 'ceux qui sont du dernier ordre, & des plus basses conditions d'un Etat'.
[81] *Ibid.*, p.5.
[82] Cf. Bray, pp.253–288.

arrangement of figures and forms on the canvas. This one would expect to be the visual counterpart of *composition*, the mental ordering of the subject; and if we are right in defining the unity of the subject as that sense of order which would allow, or even compel, us to read and to understand the subject, as it were, step by step, then we would expect the *ordonnance*, the visual arrangement of the picture, to display a corresponding sense of unity which would guide and direct our vision from one object to the next. This, as we remember, was implied in Lebrun's description of Poussin's *Manna*. Yet Félibien, unlike his literary colleagues, explicitly refuses to establish rules for *ordonnance*. It is, for him, a natural talent and his only advice is, that artists should avoid confusion.[83]

Félibien's whole approach in the preface is clearly dominated by his interest in subject-matter,[84] and this interest precedes, in the process of examining a picture, any interest in the actual pictorial treatment and the specific visual effects of the work. Rather than being seen as bringing about the subject, as presenting it to our eyes, as determining the particular way in which we see and understand it, the practical parts of painting are considered as a consequence of the subject: the spectator's attention to *ordonnance*, *dessin*, and *coloris* is confined to simply checking their *convenance* with the nature of the subject.[85]

6. *The Modes in Poussin's and Félibien's Theory of Art*

The one important element that remains to be examined in Félibien's theory is that of the pictorial modes, partly because they seem to present us with a further notion of unity in painting, and partly because they could be seen (and have been seen in the recent literature) to cover exactly the functions of a visual order introducing and guiding us toward an understanding of the picture's subject-matter. Félibien relies heavily on Poussin, who had explained his ideas about the modes in 1647 to Paul Fréart de Chantelou, his friend and patron.[86]

[83] Cf. *Preface* (vol. V), pp.305 and 319/320, where *ordonnance* is described as 'un don tout particulier de la nature'.

[84] The most dogmatic and potentially controversial offspring of this interest was the strict hierarchy of *genres*, from still-life at the bottom end to religious history painting at the top (cf. *Preface*, pp.310/311).

[85] See, e.g. *Preface*, p.320.

[86] *Correspondance de Nicolas Poussin*, no. 156, pp.370–375; the text is now available, with an English translation, in Blunt, *Nicolas Poussin*, pp.367–370. The modern literature on Poussin's *modes* is considerable and still growing. See, e.g. Ch. Sterling, *Exposition Nicolas Poussin*, Paris 1960, pp.260 f; G. Kauffmann, *Poussin-Studien*, Berlin 1960, pp.64 ff: R. Zeitler, *Poussinstudien I*, Uppsala 1963 (manuscript, copy in the Warburg Institute, London) pp.15 ff; W. Messerer, 'Die "Modi" im Werk von Poussin', *Festschrift Luitpold Dussler*, Deutscher Kunstverlag 1972, pp.335–356; A. Blunt, *Nicolas Poussin*, London, New York 1967, pp.225–227. A rather more sceptical (and, in my view, more appropriate) view is that of D. Mahon, 'Poussiniana', pp.121–128, who refers to 'the so-called theory of modes which was foisted on him (Poussin) by Félibien and Lebrun during the process of canonization which followed his death, and which it is even now all too easy to treat with a seriousness and respect which is totally disproportionate'. I must add to this list the very interesting book by O. Bätschmann, *Dialectik der Malerei von Nicolas Poussin*, Zurich, Munich 1982, which I discovered too late to include in my discussion.

Both Félibien and Lebrun enlarged upon the modes with enthusiasm, and in the following century the term became part of the jargon of art criticism and theory. Antoine Coypel, one of Lebrun's successors as Director of the Academy, formulated, in 1721, what is perhaps the best-known definition of the modes in painting:

Each picture must have a mode which characterizes it. Its harmony will be now sharp and now sweet, now sad and now cheerful, according to the different nature of the subject one wants to represent. In this one can follow the enchanting art of music . . . What musicians call *modes* or *dessins* are graceful, strong or terrible. The same applies to pictures. What should move the heart by passing through the ears should also move it by passing through the eyes. The first impression of a picture must determine its character . . .

(Chaque tableau doit avoir un mode qui le caractérise. L'harmonie en sera tantôt aigre et tantôt douce, tantôt triste et tantôt gaie, selon les différents caractères des sujets que l'on voudra representer. On peut suivre en cela l'art enchanteur de la musique . . . Ce que les musiciens appellent modes ou dessins sont gracieux, forts ou terribles. Mêmes principes dans un tableau. Ce qui doit émouvoir le coeur en passant par l'oreille doit l'émouvoir aussi en passant par les yeux. Le coup d'œil d'un tableau doit déterminer son caractère . . .)[87]

The 'mode' of a picture, according to this definition, is the unified and immediate visual effect of the whole work on the spectator, affecting his 'heart', his emotional state; as it 'characterizes' the picture, in the sense of expressing the quality of the subject, it would seem to prepare us by purely sensual, specifically visual means for a subsequent detailed reading and understanding of the subject-matter.

This seems to be the meaning attributed by most modern critics to Poussin's and Félibien's notions of the modes; with Coypel's definition attached to them, the modes appear as a surprisingly modern concept in the otherwise academically dull context of seventeenth-century theory. Ian Bialostocki, for instance, in his excellent essay on the history of the modes in painting, implicitly assumed that Coypel's definition of modes as visual effects *au premier coup d'œil* was applicable also to Poussin.[88] And he consequently concluded that the mode of a picture had to be expressed not only by the movements and actions of the figures, and their proportions, but also 'and that is perhaps the most interesting aspect, by the formal artistic means'.[89]

Anthony Blunt shares this view: 'The idea of applying the principles of the Modes to painting is highly original, because, according to the earlier writers on the arts, the means of conveying a mood or an emotion had been by gesture, whereas Poussin maintains that it can be done by the actual style of the painting, that is, by almost abstract means'.[90] To underline the pioneering originality

[87] A. Coypel, *Sur l'esthétique du peintre*, 1721, from H. Jouin, *Conférences de l'Académie Royale de Peinture et de Sculpture*, Paris 1883, pp.230 ff.
[88] I. Bialostocki, 'Das Modusproblem in den bildenden Künsten', *Zeitschrift für Kunstgeschichte*, 24, 1961, pp.128–141; p.135.
[89] Bialostocki, p.136.
[90] Blunt, *Nicolas Poussin*, p.226.

of Poussin's thoughts, Blunt refers to Delacroix, who, in the nineteenth century, developed similar ideas.

Most modern critics who have tried to identify the modes of particular paintings by Poussin are generally in agreement with Bialostocki and Blunt. They predominantly use what we may call, in a modern sense, formal analysis, by describing a composition using abstract terms like horizontal or vertical, which they consider as 'expressive forms'.[91] One problem of this approach is that the generally agreed definition of 'mode', as opposed to style or manner, implies that it is deliberately and consciously chosen to fit the respective subject; the terminology of 'formal analysis', however, is a quite recent addition to art historical writing, and is more useful in describing pictorial effects which previous artists may have felt vaguely, but which they did not consciously calculate.[92]

Neither Félibien nor Poussin give any clear indication that they were concerned with the formal, almost abstract means of painting (and it would be vain to speculate to what extent they were consciously aware of them). Poussin refers to the poet who adapts the choice of words and versification to the character of the subject, but he does not specify the analogous parts of painting.[93] Félibien, in a vague passage, mentions symmetry and proportion as constituting the beauty of the painting with which the modal effect could be achieved.[94] This is such an obvious commonplace of traditional literature on art that it would be quite wrong to read it in terms of modern, abstract 'expressive forms'.

* * * * *

The argument that formal and abstract means were to express the mode of a work (or at least to contribute to it) is closely related to Coypel's statement that the modes should make their effect *au coup d'œil*, immediately and spontaneously. Again, there is very little in either Poussin or Félibien to support Coypel's view (and we shall see later that Coypel is not at all referring to their theory but to that of de Piles). Poussin even reproached Chantelou, in the same letter in which he gave his account of the modes, for having been precipitous in his judgment of Poussin's picture, for not having taken sufficient time to examine it closely: had he done so, his first unfavourable impression would have been reversed.[95]

Yet it seems that the assumptions of modern critics, according to which the modes should include formal means of expression and make their impact immediately and spontaneously, are fully supported, or even necessarily required, by the model from which Poussin borrowed the concept in the first place: that of music and musical theory. Music seems to be abstract, and seems to affect us spontaneously, without involving our rational faculties.

[91] Bialostocki, pp.135 f.
[92] For a criticism of the more absurd results of 'formal analysis', as developed mainly in German art history since Riegl and Wölfflin, see Gombrich, 'Raphael's *Madonna della Sedia*' (as in note 1).
[93] Cf. Blunt, *Nicolas Poussin*, p.370.
[94] Félibien, *Preface*, p.324.
[95] Cf. Blunt, *Nicolas Poussin*, p.368.

Poussin's passages on the modes are based, as Anthony Blunt has pointed out,[96] on Giuseppe Zarlino's *Istituzioni Harmoniche* of 1558. Yet the definition of different musical modes (the Dorian mode, the Ionic mode, the Phrygian mode, and so on) goes back to classical antiquity. What had kept the musicians' interest in the modes alive was the fact that classical authors, including Plato and Boethius, had attributed to them spontaneous, profound effects with truly miraculous powers. Both Poussin and Félibien duly refer to the examples recorded by ancient sources, to Pythagoras (and others) who used the modes to cure illnesses, to the flute-player who induced in Alexander the Great a state of the utmost rage, and others.[97]

According to the musical theory of the ancients the immediate impact of the modes, and their complete power over our emotions, our moral composure and whole personality, resulted from man being a microcosm, an image of the universe with its cosmic harmonies. This microcosm could be directly affected by music (as *musica artificialis*) which was considered as a similar copy of the cosmic universal music and harmony (as *musica mundana* or *coelestis*).[98] This direct affection bypassed reason and rational control, which in Plato's view made the musical modes a dangerous threat to the education of his citizens; most of the modes were to be banned from his ideal state because of their corrupting influence on morals and character, while some, with a more manly effect, like the Dorian and the Phrygian, had to be used under strict control for clearly defined purposes.[99]

How seriously sixteenth-century musicians took these speculative foundations of ancient musical theory is difficult to tell; by the seventeenth century notions like harmony, symmetry and proportion generally seem to have lost any relation to ideas of cosmic harmonies. Without this cosmic relationship, however, it was difficult to explain the profound effects, and sixteenth- and seventeenth-century musicians, particularly in France, faced insurmountable problems in their attempts to recreate or reconstruct the legendary modes of antiquity.

Fortunately, for them, there was another classical tradition of music from which they could draw inspiration, that of music as an imitation of human actions, emotions and feelings, and in Aristotle's view (as expressed in the *Poetics*) that was exactly why it could arouse the same states of mind in the audience.[100] This was much safer ground for seventeenth century Aristotelians, particularly if one considered that for the ancients music included not only melody and rhythm, but also singing, involving a text as a major element of the music. The message of the text could be happy or sad, light-hearted or

[96] Cf. P. Alfassa, 'L'origine de la lettre de Poussin sur les modes d'après un travail recent', *Bulletin de la Société de l'Histoire de l'Art Français*, 1933, pp.369/370.

[97] Félibien, *Preface* (vol. V), pp.323/324; see also Poussin, in Blunt, *Nicolas Poussin*, pp.369/370.

[98] Cf., for example, G. Pietzsch, *Die Klassification der Musik von Boethius bis Ugolino von Orvieto*, Halle 1929, and H. Hübschen, 'Der Harmoniebegriff im Mittelalter', *Studium Generale*, 19, 1966 pp.548–554. I am grateful to Professor Volker Scherliess who discussed these musical problems with me.

[99] Plato, *The Republic*, 3, X.

[100] Aristotle, *Poetics*, chap. I, 1447a.

morally elevating, and melody and rhythm could be used to support and re-enforce the nature or 'mode' of the message, the subject-matter.[101]

This approach to musical modes may not be particularly appealing to modern critics. Since it makes the emotional and expressive qualities of the 'abstract' or purely musical elements appear rather negligible compared with the importance conveyed by the text, it does not generally correspond to our own, modern, experience of music (except, perhaps, of operas and *Lieder*). But it did put music very much on an equal footing with dramatic poetry, in the sense in which our listening to music, like our watching a dramatic performance, could be described as a mimetic process.

* * * * *

With this model in mind let us turn again to Poussin's and Félibien's discussion of the modes in painting. Despite the references to ancient literary sources, Félibien was not particularly enthusiastic about seeing the profound and miraculous effects of the classical modes emulated in painting. This he makes clear in his eighth *Entretien*, devoted to the life and art of Poussin. His interlocutor, Pymandre, recalls the story of Eric II, King of Denmark, who is said to have been so incensed by martial music that he immediately killed four members of his entourage. The debt of this legend to that of Alexander and the flute-player is obvious. Félibien agrees with Pymandre's comment:

It would be dangerous . . . if painting had the same force to move our passions as music; excellent painters would be able to produce considerable disorder.

(Il seroit dangereux . . . que la Peinture eût autant de force que la Musique pour émouvoir les passions; les excellens Peintres seroient en état de faire bien des desordres.)[102]

This was certainly not the aim of painting as a rational and even philosophical art, and Félibien adds:

I also believe it was not the intention of Poussin to put those who looked at his pictures in such a great danger. However, if one considers well the majority of things he has produced, one will find that he has observed exactly the rules I have talked to you about, and one will see in his works the signs of his determination to make them conform in every thing to the subjects which he treated.

(Je crois aussi que ce n'étoit pas l'intention du Poussin de mettre ceux qui verroient ses tableaux, dans un si grand peril. Cependant, si l'on considere bien la plûpart des choses qu'il a faites, on trouvera qu'il observoit exactement les maximes dont je viens de vous parler, & l'on verra dans ses ouvrages, de marques de son application à les rendre conformes en toutes choses aux sujets qu'il traitoit.)[103].

[101] This point is discussed in more detail in J.C. Allard, *Studies in Theories of Painting and Music in Sixteenth and Seventeenth Century France* (M. Phil. dissertation, University of Essex, 1977).

[102] Félibien, *Entretien VIII* (vol. IV), p.57.

[103] *Entretien VIII*, p.59.

Félibien's attitude to the profound effects of ancient musical modes appears, in this passage, somewhat less than serious; transferring the modes to painting should certainly not undermine the supremacy of subject-matter and, implicitly, of reason and understanding. Like Poussin's reproach of Chantelou for having yielded too quickly to the first impression of a picture, Félibien's comment does not confirm the assumptions of modern critics that pictorial modes should make their impact immediately and by formal and abstract means.

If we are right in arguing that musical modes in an Aristotelian sense could engage us in a sequential way, by involving our emotions as we listen to, and understand, the text of the music (accompanied by an appropriate melody and rhythm), then we could come to a different interpretation of Félibien's and Poussin's ideas about pictorial modes. And this interpretation, though less exciting than other recent accounts, seems to me to be much more in line with the aims and interests of early academic theory.

The modal effect of a painting, in this sense, would not have to be immediate, *au coup d'œil* in Coypel's terms, and independent of our rational understanding of the subject-matter. It would accompany, and follow naturally from, our 'reading' of a picture and from our understanding of the subject: each figure we look at should express, by the traditional means of action, movement, gesture, facial expression etc., the same or a similar emotion, the emotion of the main *sujet*. As we look from one figure to another, sharing in a Horacian or Albertian way their feelings – which should be, according to the *unité de sujet*, closely related and dependent upon each other – then we would build up a strong emotional state of mind, we would become affected by and involved in the mode of the picture.[104]

It is in this sense that Félibien's comments on Poussin's modes should be read:

The expression of his subject is so generally spread out that there is everywhere either happiness or sadness, fury or sweetness according to the nature of his story.

(L'expression de son sujet y est généralement répandü qu'il y a par tout de la joye ou de la tristesse, de la colere ou de la douceur selon la nature de son histoire.)[105]

Par tout here does not mean an abstract overall effect, but the expression of each individual figure or object: 'There is no part (in the picture) which does not express the quality of his subject'. (Il n'y a point de partie qui n'exprime la qualité de son sujet.)[106]

The one 'abstract' element Félibien includes in his discussion is the 'beautiful

[104] This seems to be how the academicians interpreted the modes; cf. the seventh conference on Poussin's *Healing of the Blind*: 'On voit que le Peintre a aussi repandu dans son Tableau un certain caractere d'allegresse, & une beauté de jour que fait une expression generale de ce qu'il veut figurer par son action particuliere; et cette joye qu'il communique si bien à toutes ses figures est la cause de celle qu'on reçoit en les voyant', (vol. V, p.445).

[105] Félibien, *Preface*, p.323.

[106] *Preface*, p.326.

harmony of colours'. This follows in a wholly traditional way[107] from the analogy with music, and is quickly brought under rational control by *convenance*:

... as in Music the ears are not pleased unless there is a just harmony of different voices, so in Painting the sight is not agreeably satisfied unless there is a beautiful harmony of colours and an exact *convenance* of all the parts with those next to them.

(... comme dans la Musique l'oreille ne se trouve charmé que par un juste accord de différentes voix; de même dans la Peinture la vûë n'est agréablement satisfaite que par la belle harmonie des couleurs, & la juste convenance de toutes les parties les unes auprès des autres.)[108]

There is no indication that Félibien considered colour as an abstract compositional element in its own right; the reference to *convenance* among parts next to each other suggests firmly that he saw colour, and its expressive force, as being attached to figures and objects.

In discussing Poussin's modes, Félibien almost invariably referred to the expressive force of figures:

And so Mr Poussin represented his figures with more or less strong actions, and with more or less lively colours, according to the subjects he was treating.

(Ainsi M. Poussin representoit ses Figures avec des actions plus ou moins fortes, & des couleurs plus ou moins vives, selon les sujets qu'il traitoit.)[109])

And he finally spelt out explicitly that he saw the *affetti* of the figures, their expressions of feelings and emotions, as conveying the modal effect of a work in a traditionally mimetic way:

He gave to his figures the power to express those feelings he wanted and to make his subject inspire these feelings in the soul of those who watched it.

(Il a donné à ses Figures la force d'exprimer tels sentimens qu'il a voulu, & de faire que son sujet les inspire dans l'ame de ceux qui le voyoient.)[110]

With this interpretation of Poussin's modes we can avoid a number of problems posed by other approaches. The clear priority given in almost all of

107 Cf. e.g. below chap. IV, p.102 and n.54.
108 *Preface*, p.323.
109 *Preface*, p.327.
110 *Preface*, p.326. I cannot, here, discuss in detail some further arguments of Félibien which blur rather than clarify the issue: he describes the traditional styles of the Italian schools as 'modes', and he even uses the term to refer to the *manière* of individual artists. This confusion of style, manner, and mode is resolved, so to speak, in Poussin, who mastered them all and used them for the purposes of his particular subjects. We would call this historical ecclecticism, yet for Félibien it was an important argument for what Mahon has called the canonization of Poussin. While Italian critics like Bellori extolled Annibale Carraci as the 'healer' of the old *disegno-colore* rift (having combined, in his art, the essential elements of both the North-Italian and the Florentine-Roman styles), Félibien now implies that the solution is not to be found in a fusion of two or more styles but in their clear distinction and separation, in a hierarchy of *modes* corresponding to the hierarchy of *genres* or subjects. And Poussin would appear as the supreme master of both hierarchies.

Poussin's and Félibien's remarks to reason and understanding can be main-
tained even in their theory of the modes, with no overwhelming weight being
put on the 'merely' visual character, the 'practical' side of painting in Félibien's
terms. The effectiveness of a mode can be seen as being closely related to our
attentive reading of a picture and its subject-matter; as we move from figure to
figure, and from group to group, registering or even reconstructing their unity
of action, our emotive responses deepen and we become increasingly engrossed
and absorbed in the feelings and passions of the people involved in the action.

We can now, finally, tackle a problem about the modes in Poussin's work
which Félibien himself evaded. This problem arises from the fact that Félibien
transformed Poussin's casual letter to Chantelou into a general rule of painting;
he consequently had to maintain that Poussin observed the rule of the modes in
almost all his works; and that meant that each painting should have a clearly
identifiable mode which had to be that of the main action.

Some of Poussin's works can be read in such a way. One has to agree with
Félibien that the *Plague at Ashdod* is a *sujet triste & lugubre*,[111] and little seems
to be wrong with identifying the *Rebecca* as a painting in the Ionic mode.[112] Yet
for some of Poussin's major paintings, including, unfortunately, those which
Félibien used to illustrate his theory of the unity of action, it is rather more diffi-
cult to identify one single mode. Subjects like the *Manna* or the *Healing of the
Blind*[113] involve a 'change of fortune' and, consequently, a drastic change of
mood and expression; it would be impossible to subsume both the starving
Israelites and those which have been rescued by the manna under one single
mode. Félibien simply mentions the emotional impact of what he considers to
be the main group, – one of languor and misery.[114] If this was to be the general
mode, how would we reconcile it with the expressions of joy and relief of the
other group or the sense of confidence inspired by Moses and Aaron?

Changes of mood and expressions are an important feature in quite a number
of Poussin's paintings. The emotional impact of the *Landscape with a Snake*, for
instance, depends to a large extent on the contrast between the quiet, peaceful
landscape and the frightening incident, which starts the chain-reaction of
horror and surprise. The *Landscape with Hercules and Cacus* (Plate 8) displays
a similar contrast of moods: the gigantic figures of the fighting heroes disrupt
the arcadian peace of the landscape underneath in a way which defies attempts
to identify in the painting one single mode.[115]

Félibien's theoretical problem was that his complex notion of the unity of
action or subject was not really reconcilable with the simple, single modes of the
speculative classical tradition. Yet if we understand the modes as working in an
Aristotelian, mimetic way (and that is strongly implied by most of what Félibien
has to say about them), then that problem would disappear. We could define the
'unity' of a mode along the same lines as Félibien's unity of action: it allows for

111 Félibien, *Preface*, p.327.
112 *Preface*, p.328.
113 This picture was discussed during the seventh conference (vol. V), pp.429–466.
114 *Preface*, p.326.
115 The same would apply to several other paintings, like the *Polyphemus* or the *Orion*, cf.
 Blunt, *The Paintings of Nicolas Poussin*, nos. 175 and 169.

diversity of expressions, even for contrasts, as long as these divergent effects are held together, like the different episodes and parts of the aciton, by a sense of relationships, of mutual dependence, and hence, in the final account, by our understanding of the subject.

Félibien's theory of the modes, seen in this way, is little more than a systematic ordering of traditional terms like *affetti*, empathy, and *decorum*, with a view to establishing unity in our emotive responses in the same way in which the unity of action was meant to establish unity for our understanding and reading of a work.

But we must not mistake the emotional unity of the modes (at this stage of their history) for a visual unity in the sense of the overall arrangement of the formal elements of a picture. Poussin's and Félibien's ideas have little to do with the attempts of later critics and artists to define the expressive force of a visual array of forms and colours irrespective of a picture's subject-matter. Blunt's suggestion that Poussin should be seen as a predecessor of Delacroix is not helpful; the kind of visual unity Delacroix had in mind was quite different from the emotional unity of Poussin's compositions. As far as their visual unity was concerned, Delacroix found Poussin's paintings quite deficient:

It seems that all his figures are unrelated to each other and appear to be cut out; that is why there are these gaps and the lack of unity, of fusion, of effect, which we do find in Lesueur and all the colorists.

(Il semble que toutes ses figures sont sans lien les unes avec les autres et semblent découpées; de là ces lacunes et cette absence d'unité, de fondu, d'effet, qui se trouvent dans Lesueur et dans tous les coloristes.)[116]

[116] A. Joubin (ed.), *Journal de Eugène Delacroix*, Paris 1932, vol. I, p.439, 6 June 1851.

II

ROGER DE PILES: PAINTING AS A VISUAL ART – 'ILLUSION' AND 'ATTRACTION'

IT WAS ROGER de Piles who introduced into French theory the concept of *l'unité d'objet*, of the unity and order of the picture's visual effect. This is meant as an alternative and correction of Félibien's notion of the *unité de sujet*; but so central a concept is it that it has implications for all the elements of academic doctrine. Most traditional terms survive in de Piles' system, but with their significance redefined.

Referring to de Piles' 'system' might be misleading unless one bears in mind the different nature and the assumed status of his theory compared with that of the early academicians. For most of his life, de Piles was a freelance *amateur* and liberal critic advising like-minded patrons, collectors and artists. In his writings he attacked the rigid rules of Lebrun's academy against which he defended the art of Holland and Flanders (and of Rubens in particular). When, in 1699, the academy was finally forced to accept him as a member, he instantly announced his intention to lecture on the principles of art noticing that, as the academy since its foundation had not produced many artists who were equal to the great masters of the past, solid and infallible rules were required. Yet the lectures he subsequently delivered to the academy and the *Cours de Peinture par Principes*, which resulted from these lectures, show the same broad-minded and liberal attitude as his earlier publications. De Piles did not see his rôle as that of a *législateur*; the *Cours de Peinture* is simply presented as advice to young artists, and as a contribution to a wider discussion of the theory of art.[1]

* * * * *

In the following chapters on de Piles' theory I have not aimed to give a comprehensive account of his thought but to bring out those aspects of it which seem to me to be of a wider interest for theoretical discussions of painting and which I believe to have been of considerable influence. His involvement in the disputes

[1] R. de Piles, *Cours de Peinture par Principes*, Paris 1708, further editions 1766 and 1791, (quoted in the following pages as *CdP*)p.26, English translation *The Principles of Painting*, by 'a painter', London 1743, p.15f: 'I write, in a word, for young pupils, who may have set out in a right path, and for all those, who, after acquiring some tincture of design and colouring, have impartially examined the best works, and are docile enough to embrace those truths which may be hinted to them'. De Piles gave notice of his intention to give a series of lectures on the principles of painting on 6th July 1699, cf. A. de Montaiglon, *Procès-Verbaux de l'Académie des Beaux Arts*, Nouvelles Archives de l'Art Française, 3 ème serie, 1909, III, pp.269–274: *Discours de M. de Piles: De la nécessité d'établir des principes et des moyens d'y parvenir*.

between *Rubénistes* and *Poussinistes* has been analysed in great detail by Bernard Teyssèdre.[2]

Of the following four chapters on de Piles' theory the first one will deal briefly with his definition of painting as an art of visual imitation and with what appear to be its rather paradoxical consequences: the requirement that a picture should be on the one hand 'illusionistic' – to the extent of deceiving the spectator – and on the other be attractive as a distinctive kind of artefact.

The next chapter is devoted to an analogy between painting and rhetoric on which de Piles insists repeatedly; it covers most of his theory and offers an intellectual model of how to reconcile the apparently conflicting consequences of his initial definition of painting.

This, I hope, will give us what I call the intellectual genesis of those two new concepts which de Piles introduces into the discussion of painting: the *unité d'objet* of a picture's overall composition, and its effect of *enthousiasme* on the spectator. In our experience of pictorial unity and enthusiasm de Piles sees illusion and attraction not only as reconciled but as reciprocally supporting and enforcing. The aim of the last two chapters is to elucidate the meaning of *l'unité d'objet* and see it in relation to modern theories of visual perception, and then to examine the notion of *enthousiasme*.

1. De Piles' Definition of Painting

At the end of the last chapter I have pointed to the differences between Félibien's and Coypel's ideas about pictorial modes. It would be wrong to assume that these differences could be explained simply in terms of a development or a progression from an earlier to a later stage of discussion. When Coypel defined the modes as the overall expression of the subject's character affecting the spectator *au premier coup d'œil*, he based his arguments on a text published more than fifty years earlier: De Piles' *Remarques sur l'Art de Peinture de Dufresnoy* of 1668.

Preceeding Félibien's edition of the *Conférences* by one year, the *Art of Painting* in de Piles' translation and with his comments remained perhaps the most popular treatise on painting for most of the eighteenth century.[3]

[2] B. Teyssèdre, *Roger de Piles et les débats sur le coloris au siècle de Louis XIV*, Paris 1957; critical review by C. Goldstein, *The Art Bulletin*, XLIX, 1967, pp.264–268. For the life of de Piles, cf. L. Mirot, *Roger de Piles*, Paris 1924. A general and not very accurate account of his theories is given by A. Fontaine, *Les Doctrines d'art en France*, Paris 1909. Specific problems in de Piles have been investigated by three former students of mine at Essex: R. Bramich, *Roger de Piles, the Abbé Dubos, and the Comte de Caylus: Theories of Composition and the Judgement of Paintings*, M.A. dissertation, Essex University, 1974. J.C. Allard, *Studies in Theories of Painting and Music in Sixteenth and Seventeenth Century France*, M. Phil. diss., Essex University 1977; and 'Mechanism, Music and Painting in Seventeenth Century France'; *Journal of Aesthetics and Art Criticism*, Spring 1982; E. Mavromihali, *Pictorial Unity in Turner and Roger de Piles' Theory of Art*, M.A. diss., Essex University, 1981.

[3] See above, chapter I, note 90, for Coypel. Ch.-A. Dufresnoy's poem *De Arte Graphica* was published after the author's death by de Piles as *L'Art de Peinture de Charles-Alphonse du Fresnoy, traduit en françois, avec des remarques necessaires et tres-amples* (by de Piles), Paris 1668; further editions in 1673, 1684, 1688, 1751, 1760 etc. Ch. N. Cochin, as secretary, read from it to the academy in 1769; cf. Montaiglon, *Procès-Verbaux*, VIII, pp.18ff. This was

De Piles does not use the term *mode*. He refers, however, to pictorial effects similar to those produced by music, which we would feel immediately and spontaneously:

This Œconomy (of the *Tout Ensemble*) produces the same effect in relation to the Eyes, as a Consort of Musick to the Ears.

There is one thing of great consequence to be observ'd in the Œconomy of the whole work, which is, that at the first sight we may be given to understand the quality of the subject: and that the Picture at the first Glance of the Eye, may inspire us with the principal passion of it: for Example if the subject which you have undertaken to treat be of joy, 'tis necessary that every thing which enters into your Picture should contribute to that Passion, so that the Beholders shall immediately be moved with it. If the Subject be mournfull, let every thing in it have a stroke of sadness; and so of the other Passions and Qualities of the Subjects.

(Cette Œconomie (du Tout-ensemble) produit le même effet pour les yeux, qu'un Concert de Musique pour les oreilles.

Il y a une chose de très-grande conséquence à observer dans l'Œconomie de tout l'ouvrage, c'est que d'abord l'on reconnoisse la qualité du Sujet, & que le Tableau du premier coup d'œil en inspire la Passion principale: par example, si le sujet que vous avez entrepris de traiter, est de joye, il faut que tout ce qui entrera dans vostre Tableau contribue à cette Passion, en sorte que ceux qui le verront en soient aussi tost touchez. Si c'est un Sujet lugubre, tout y ressentira la tristesse; & ainsi des autres Passions & qualitez des Sujets.)[4]

The *Œconomie du Tout-ensemble* in de Piles' terminology is in fact the actual arrangement of forms and colours, of light and shade on the canvas producing a visual effect *au premier coup d'œil*.

This passage of de Piles' would establish, at least in theory, that link between the immediate sensuous effect of a picture's overall composition and our sequential rational understanding of the subject which Félibien's theory did not seem to provide: the mere sight of a painting should inspire in us that passion which should dominate and inform the figures and objects and the whole action of the picture.

I argued in the last chapter that Félibien's definition of the *modes* was little more than a version of the traditional theory of *decorum* and *convenance*. De Piles' assumption, on the other hand, that the formal – the merely visual arrangement of a composition – could and should express passions and inspire emotions, seems to be something new. It certainly appeared to be new to most writers even of the following century. Previously, from Alberti and Leonardo to Félibien and Lebrun, theorists and artists had maintained that the highest and

followed, in subsequent meetings, by readings from de Piles' notes on the poem. English translations, by Dryden, London 1695, further editions 1716, 1750, 1769; by Wright, London 1728; by Wills, London 1754; by Mason, with comments by Reynolds replacing de Piles' *Remarques*, York 1783; by Churchey, London 1789.

[4] *Remarques* (in *L'Art de Peinture de Ch.-A. du Fresnoy*), p.135; translation (by Dryden), p.114.

most difficult achievement of the painter was successfully to represent inner emotions by movements, gestures, and attitudes of the human body, and by facial expression. De Piles here seems to attribute the same expressive power even to those elements of a composition which hitherto had been dismissed, in most theoretical discussions of painting as mere practice. This struck at the basis of traditional theory.

Most writers who followed de Piles' argument understood it as offering an opportunity to extend the principle of *decorum* or *convenance* beyond the qualities of figures and objects depicted in a painting to its overall visual effect.[5] The demand that a painting's overall effect should be appropriate to the character of the subject-matter, the action depicted, became a commonplace in eighteenth-century art theory.

This seems to be an entirely legitimate interpretation of de Piles' passage. Yet if this is what de Piles meant in 1668, then his later writings indicate a decisive change of attitude. We can only guess at the reasons for this change. To some extent they seem to be based on the visual experience of pictures, to some extent on the logical pressure of other components of his theory.

To demand that a painting's overall effect should be appropriate to the character of the subject matter is not the same as claiming that it can, *au premier coup d'œil*, inspire the dominant passion or emotion of the picture. De Piles, in his later life, would have insisted on the difference. This difference between the immediate impact of the overall effect and the appropriateness of the overall effect to the subject would later have been insisted on by de Piles in the following way: the first visual effect may be appropriate to the *sujet*, but it is likely to be too general, insufficiently precise to inspire a particular, clearly definable emotion or passion. The problem has become only too familiar in modern art where we often find our spontaneous visual experience of a work limited or corrected by its title.[6]

This first difference would have led, in de Piles' view, to argue that in this way the notion of appropriateness or *convenance* would endow the subject matter with critical superiority; de Piles was not prepared to let the importance he attached to the immediate visual effect be diminished by reducing it to a level where it could only be discussed in terms of propriety, i.e. as a function of subject-matter. For this could only mean that the immediate visual effect of a painting would not in itself be successful but only in relation to, and after our understanding of, the particular action depicted. Since most of de Piles' theory hinges on the importance of the immediate visual effect we should not be surprised to find that in his later writings he departs from the statement in the *Remarques* in two crucial respects: he now sees the expressive force of the immediate visual effect of a picture as different in kind from the passions and emotions of the subject-matter; and he re-defines the relationship between the two in order to endow the visual effect with that critical superiority which in theories of *decorum* had been attached to subject-matter.

[5] See my article, 'David's *Brutus* and Theories of Pictorial unity in France', *Art History*, IV, 1981, pp.290–304.

[6] On the problem of expression in our visual experience of paintings, see E.H. Gombrich, *Art and Illusion*, chapter XI, 'From Representation to Expression', pp.304–329.

Before we follow these arguments in more detail we have to look at some of the basic assumptions and ideas which de Piles brought into them. This is not helped by the fact that, unlike Félibien, he was at his worst when he tried to be most systematic. His *Balance des Peintres*, for instance, although highly acclaimed in the eighteenth century,[7] is now considered his most notorious contribution to criticism.[8] It is an attempt to assess the achievements of the major artists since Raphael in very much the same way in which teachers would assess their pupils' class-papers: by awarding marks out of twenty for each composition, design or drawing, colour, and expression. Only Rubens and Raphael qualify for a high mark with sixty-five out of the maximum of eighty; Poussin has to be content with only fifty-three, an Michelangelo looks like a total failure with a mere thirty-seven out of eighty.

But de Piles makes it quite clear that he is not too serious about the whole exercise. The *Balance* is a playful *divertissement*, and other judges are free to reach entirely different results.[9] The one important point is his insistence on the equal status of his four parts of painting: he does not distinguish between the 'practical', as inferior, and the 'theoretical', as superior in the way that Félibien had done.

* * * * *

The basic theoretical difference between Félibien and de Piles is not so much about the respective status of *dessin* and *couleur*, or of Poussin and Rubens, but about the fundamental question as to what constitutes a proper theory of painting. While Félibien stresses the similarities between painting and poetry, de Piles sets out to investigate those parts which are proper to painting only. He wants to define painting not according to its *genre*, its genus, but according to its *différence*, its species. His definition of painting is that of a visual art: 'Which, on a flat superficies, imitates all visible objects'. (Qui sur une superficie plate imite tous les objets visibles).[10] This simple definition serves as the

[7] Cf., for example, Abbé Dubos, *Réflexions critiques sur la Poésie et sur la Peinture*, Paris 1770 (7th edition; 1st ed. 1719), I, p.284. To the *Cours de Peinture* of 1708 the *Balance* is added as a modest appendix; in 1743, the English editor thought it worthwhile to advertise the inclusion of the *Balance of Painters* by listing it as a sub-title on the title-page of *The Principles*, adding that it was 'of singular use to those who would form an idea of the value of paintings and pictures'.

[8] Delacroix seems to have been one of the first to object to the schoolmasterly system of de Piles' *Balance*, cf. his *Œuvres littéraires*, I, Paris 1923, pp.30f. Gombrich, *Norm and Form*, p.76 refers to it as a 'notorious aberration'; and Schlosser finds it necessary to defend de Piles: 'Il de Piles non deve esser giudicato alla stregua della sua famigerata Balance des Peintres, per quanto essa abbia più di tutto fatto noto il suo nome...' (J. Schlosser Magnino, *La Letteratura Artistica*, 3rd edition, Florence, Vienna 1964) p. 633.

[9] *CdP*, 489/490: 'Les jugemens sont trop differens sur cette matiere, pour croire qu'on ait tout seul raison. Tout ce que je demande en ceci c'est qu'on me donne la liberté d'exposer ce que je pense, comme je la laisse aux autres de conserver l'idée qu'ils pourroient avoir toute differente de la mienne.'

[10] *CdP*, p.313, transl. 190; cf. also *CdP*, p.3: 'L'essence & la définition de la peinture, est l'imitation des objets visibles par le moyen de forme & des couleurs'; and de Piles' *Abregé de la Vie des Peintres*, p.3: 'Un Art, qui par le moyen du dessin & de la couleur, imite sur une superficie plate tous les objets visibles'.

starting point for his last treatise, the *Cours de peinture par principes* of 1708.[11]

The problems of his position emerge immediately we ask on which parts of painting its 'difference' was to be based. According to de Piles these are colour and disposition – *coloris* and *l'œconomie de tout l'ouvrage*.

Colour, at this stage of our investigation, presents no serious problems; de Piles holds the view that objects are only visible insofar as they have colour, and since painting has been defined as the art of imitating visible objects it follows that colour is an essential part of pictorial imitation:

The painter therefore who is a perfect imitator of nature ... ought to make colouring his chief object, since he only considers nature as she is imitable; and she is only imitable by him, as she is visible; and she is only visible, as she is coloured. For this reason, we may consider colouring as the *difference* in painting, and design as its *kind*.[12]

So, tho' the perfect idea of the painter depends on design and colouring jointly, yet he must form a special idea of his art only by colouring, since, by this difference, which makes him a perfect imitator of nature, we distinguish him from those as have only design for their object, and whose art cannot come up to this perfect imitation which painting leads to.

(Le Peintre qui est un parfait imitateur de la Nature ... doit donc considerer la couleur comme son objet principal, puisqu'il ne regarde cette même Nature que comme imitable, qu'elle ne lui est imitable, que parce qu'elle est visible, & qu'elle n'est visible que parce qu'elle est colorée. Il me semble donc qu'on peut regarder le coloris comme la difference de la peinture, & le Dessein, comme son genre ...

Ainso quoique l'idée parfaite du Peintre dépende du Dessein & du coloris tout ensemble, it faut se la former spécialement par le coloris; d'autant que par cette difference qui le rend un parfait imitateur de la Nature, on le démêle d'entre ceux qui n'ont que le Dessein pour objet, & dont l'Art ne peut arriver à cette parfaite imitation où conduit la Peinture.)[13]

It is much more difficult, however, to see why disposition or *l'œconomie du tout-ensemble* should be an essential part of painting for it does not seem to be derived from the definition of painting as imitation. But for de Piles it is a part

[11] In a general sense, this definition is not new; we could quote similar statements from Alberti to Félibien and Testelin. What is new, however, is that de Piles uses the term definition in a strictly logical sense, which reduces all those aspects and qualities not covered by it to the status of non-essential ones.

[12] The informed English translator here added the note: 'Alluding to the logical terms *genus* and *differentia*'.

[13] *CdP*, pp.311–313; transl. pp.189/190. We could, again, quote several generally similar statements from earlier sources as, for example, from Lomazzo 'Procurerà dunque con ogni studio il pittore d'essere valente coloritore, poichè in questo consiste l'ultima perfezione dell'arte. E per questa particolarità che ha in se la pittura, cioè di dimonstrare all'occhio le cose con colore simile, ella se fa differente da tutte le altre arte, e massime dalla scultura', (G.P. Lomazzo, *Trattato dell'Arte della Pittura, Scultura ed Architettura*, Rome 1844; [1st ed. Milan 1584]; pp.36f). Yet read in context, none of these earlier sources has the same logical stringency and consequentiality as de Piles' formulation.

which belongs uniquely to the painter while all the other parts either derive from the depicted objects or are rules which have been borrowed from literature, from medicine, from mathematics or from other 'arts'.[14]

If we looked at the quarrel between *Rubénistes* and *Poussinistes* only as a dispute about the relative status of colour and drawing we could easily overlook the important rôle of disposition or order in de Piles' theory. *Dessin*, and its Italian counterpart, *Disegno*, traditionally had a twofold meaning. On a practical level it could refer to drawing, outline, or contour, on a more theoretical level *design* could be almost synonymous with invention or *idea*, with the planning and idealizing of the painter's subject matter.[15] In academic terminology this would include *disposition*, as the mental or intellectual ordering of the *sujet*.

De Piles explicitly attacks the dual connotations of *dessin*:

In painting, this word has but two significations: First, it means the thought of a picture, which the painter puts either on paper or cloth, in order to judge of what he is contriving; and in this manner we may design, not only a sketch, but a work well connected as to lights and shades, or, even a small picture well coloured ... Secondly, we call design the just measures, proportions, and outlines, supposed to be in visible objects, which, having no other existence than in the extremities of those bodies, do actually reside in the mind ... after the painter has formed his figure, his lines are of no further use, and must no longer appear'.

(Par rapport à la Peinture, le mot de Dessein n'a que deux significations. Premierement, l'on appelle Dessein la pensée d'un Tableau laquelle met sur du papier ou sur de la toile, pour juger de l'ouvrage qu'il medite; & de cette maniere l'on peut appeller du nom de Dessein non-seulement un esquisse, mais encore un ouvrage bien entendu de lumieres & d'ombres, ou même un petit

[14] Cf. *Remarques*, pp.132/133: 'Voicy le plus important Precepte de tous ceux de la Peinture. Il appartient proprement au Peintre seul, & tous les autres sont empruntez, de belles Lettres, de la Medicine, des Mathematiques, ou enfin des autres Arts: car il suffit d'avoir de l'esprit & des Lettres, pour faire une tres-belle Invention: Pour dessiner, il faut de l'Anatomie: un Mathematicien mettra fort bien les bâtimens & les autres choses en Perspective, & les autres Arts apporteront de leur côté ce qui est necessaire pour la matiere d'un beau Tableau: Mais pour l'œconomie du Tout-ensemble, il n'y a que le Peintre seul qui l'entende; parce que la fin du Peintre est de tromper agreablement les yeux: ce qu'il ne fera jamais si cette Partie lui manque.' See also de Piles, *Conversations sur la Connoissance de la Peinture*, Paris 1677, pp.228ff, where he talks about Rubens: 'De toutes les parties de la Peinture, celle qui a le plus contribúe à l'effet & au brilliant de ses Ouvrages a esté la disposition des objets: car les lumieres & les couleurs ne serviroient pas de beaucoup si les corps n'estoient placez & disposez pour les recevoir avantageusement; & cette disposition ne se trouve pas seulement dans les objets particuliers, mais encore dans les groupes & dans le tout-ensemble de l'ouvrage.'

[15] See E. Panofsky, *Idea. A Concept in Art Theory*, transl. by J.J.S. Peake, Columbia 1968, pp.73ff and 223ff; also W. Kemp, 'Disegno. Beiträge zur Geschichte des Begriffs zwischen 1547 und 1607', *Marburger Jahrbuch für Kunstwissenschaft*, 19, pp.219–240. For Lebrun's notion of *dessin théorique*, including invention and disposition, see Teyssèdre *Roger de Piles*, p.475. In his *Entretien* IV, (vol. II), p.280, Félibien refers to both meanings of *dessein*, yet in a much more moderate and less speculative way than the Italian tradition of *disegno*: 'Avant que d'arrêter quelque histoire, un Peintre dit qu'il en a formé le dessein dans son esprit'; and Félibien, like de Piles, seems much happier with using *dessein* simply for drawing.

Tableau bien colorié . . . 2°. L'on appelle Dessein les justes mesures, les propor-
tions & les contours que l'on peut dire imaginaires des objects visibles, qui
n'ayant point de consistence que l'extrêmité même des corps, resident veri-
tablement & réllement dans l'esprit . . . les lignes dont le Peintre s'est servi pour
former sa figure (ne doivent plus paroître)).[16]

De Piles accepts only the second meaning of *dessin* as described by him. The
first meaning he considers so wide as to make the term useless:

. . . in such case design would no longer be a part of painting, but the whole of it;
since it would contain not only lights and shades, but also colouring, and even
invention . . . By what name would (these gentlemen) call that part of design,
which furnishes the objects that compose an history? And what name must be
given to that other part of design, which disposes the colours, lights, and shades?

(. . . Le Dessein ne seroit plus une des parties de la Peinture: mais . . . il en seroit
le tout, puisqu'il contiendroit non-seulement les lumieres & les ombres, mais
aussi le coloris, & l'invention même: & pour lors il faudroit . . . demander à
ceux qui sont de l'opinion que je viens de rapporter, comme ils voudroient que
l'on appellât la partie du Dessein laquelle trouve les objets qui composent une
Histoire; & comment ils voudroient encore qu'on nommât cette autre partie du
Dessein qui distribue les couleurs, les lumieres & les ombres.)[17]

The dismissal of *dessin* in its wider sense still leaves it, in its narrow sense of
outline or proportion, as one of the essential parts of painting. Yet compared
with the new status of colour as the crucial means of imitation it can hardly
retain its traditional status as the single most important part of the art. The
main beneficiary of the whole manoeuvre, however, is the notion of *disposition*.
It is now endowed with that sense of ordering and overall control of the artist's
work which had previously been the prerogative of *dessin* in its wider meaning.

De Piles' argument is not entirely honest; he omits from his wider, and unac-
ceptable, definition of *dessin* its intellectual nature and its idealising power. The
examples he refers to are exactly those which Félibien, and other idealists,
would have found rather offensive in this context: Rubens' oil-sketches and
Titian's pen drawings. Yet this deliberate misrepresentation of the case of
dessin points to one rather crucial difference between traditional theories of
painting, such as Félibien's, and the approach of de Piles. For Félibien, as we
have seen, the artist had to accomplish the mental or intellectual ordering of his
subject-matter before he started with the less significant practical arrangement
of figures and objects in the picture. According to de Piles what the artist should
have in his mind, before he started to work, was not just a proper conception
of his *sujet*, but a visual image of his work, of the whole painting he wanted to
produce.[18]

[16] *CdP*, pp.322/323; trans. pp.196/197.

[17] *CdP*, pp.325/326: transl. p.198.

[18] Compare *Remarques*, p.133f: 'Il faut donc tellement prévoir les choses, que vostre Tableau
soit peint dans vôtre teste avant que de l'estre sur la toile'. This refers to the *Oeconomie du
Tout-ensemble*. Cf. also *Remarques* pp.229f.

The change of meaning of *disposition* from Félibien to de Piles has, as we shall see later on, important consequences. It is transformed from a careful, almost rational ordering of subject-matter to an immediate, spontaneous vision.

* * * * *

To set up rules for such 'visionary' art is a problematic task; and that is true even for de Piles who, as we have seen, was rather modest about his rôle as *legislateur*. His insistence on both overall *disposition* and *coloris* as the two most important parts of painting would have presented even the most visually gifted aspiring young artists with an almost insurmountable problem. From de Piles' definition of painting as an art of imitating all visible objects, it follows that the end of painting must be to deceive and seduce our eyes.[19] *Tromperie*, deception or illusion, plays an important part in his theory; yet while it is easy to see the necessity of colour for pictorial illusion, it is rather more difficult to reconcile the rôle of disposition, of visual order, with a merely illusionistic effect of a picture.

We tend to think of order or disposition as something detrimental to actual illusion, as something which enforces our awareness of the painting as artefact.[20] Bernard Teyssèdre, in his detailed study of de Piles' quarrel with the Academy, even referred to those *deux termes antagonistes*, each of which de Piles had defined in an uncompromising way.[21] De Piles, however, does not see these terms as contradictory or mutually limiting; illusion and order, according to his definition, are mutually reinforcing, and if we distinguish between literary extravagance and actual argument we find that their relationship is one of the most interesting elements of his whole theory of painting.

2. *Illusion and the* Traité du Vrai

The modern English reader may not find the contradiction between illusion and order as compelling as I have just assumed. Illusion, in English, can refer to two rather different things: either to the belief that something we see is something which it is not; or to having our interest in or interpretation of something controlled by the consistency and skill of its presentation, as when we speak of an actor on stage sustaining an illusion; we do not mean by this that we really mistake him for the character he is acting. What we mean is that by the consistency of his performance he enables us to suspend our disbelief. In the first case almost any kind of noticeable order would be detrimental to the illusion. In the second case, however, illusion may actually depend on some kind of order or coherence of which we may have to be aware in order to approve of it and to submit to the effect.

[19] *Remarques*, p.133: 'La fin du Peintre est de tromper agreablement les yeux'; *Conversations*, p.101; 'Le Peintre ... est obligé non seulement de plaire aux yeux comme le Sculpteur; mais encore de les tromper dans tout ce qu'il represente'; *CdP*, p.3: 'Il faut donc conclure, que plus la Peinture imite fortement & fidelement la nature, plus elle nous conduit rapidement & directement vers sa fin, qui est de séduire nos yeux.'

[20] Gombrich, *Norm and Form*, p.74, talks of 'two mutually limiting demands – that of lifelikeness and that of arrangement'.

[21] Teyssèdre, *Roger de Piles*, p.536.

Yet this distinction was not as easily available for de Piles as it is now for us. The notions of deception or *tromperie* clearly approximate to our first sense of illusion. But what his thought is reaching for seems much closer – but not the same as – the second kind of illusion; de Piles would maintain that the hold of painting over our minds was in some fundamental ways different from the hold of the actor.

De Piles' insistence on illusion is almost as notorious as his *Balance des Peintres*. Throughout the *Cours de Peinture* we are led to believe that illusion and truthful imitation were almost synonymous or, to be more precise, that the former was a necessary result of the latter. Whether the painter achieves his end of deceiving our eyes or not determines the success of his work, for it is the illusion created by a painting which: 'Strikes and attracts every one, the ignorant, the lovers of painting, judges, and even painters themselves.' (Frappe & attire tout le monde, les ignorans, les amateurs de Peinture, les connaisseurs, & les Peintres mêmes.)[22]. De Piles refers to the classical examples of perfect imitation and illusion, such as Zeuxis' grapes,[23] and he even adds a modern version to these traditional *Künstlerlegenden*: a portrait of Rembrandt's maid, which the artist had placed inside a window in order to deceive his neighbours. The success was complete, the *tromperie* was not discovered for several days. De Piles had a personal interest in this story: he had seen this picture on one of his trips to Holland and had bought it for his own collection.[24]

Perhaps more disturbing than these exercises in literary exaggeration is the unequivocal praise accorded to the coloured wax-figure compositions of the Sicilian Abbé Zumbo, which de Piles describes in loving detail at the end of his *Cours de Peinture* (Plate 9). By using wax of different colours, the Abbé had managed to overcome the limitations of sculpture:

As this happy genius was very sensible, that colouring would be of infinite advantage to set off his work, ... he has accordingly coloured it, and by this means made both the carnations and draperies appear with greater truth.

(Ce génie heureux a bien senti que la couleur releveroit infiniment son Ouvrage ... il s'est servi du Coloris, pour mettre le vrai dans ses carnations & dans ses draperies.)[25]

We could dismiss this as a misapplication of pictorial concerns to a work of sculpture, and we shall see later on how de Piles exploits the comparison with sculpture to extol the achievements of painting. The point here is to underline the importance he seems to attach to complete and truthful imitation in works of visual art.

There are many more examples we could quote in support of de Piles'

[22] *CdP*, pp.3f; trans. p.2.

[23] *CdP*, p.443; trans. p.267; see also *CdP*, p.41; transl. p.25 on Appelles.

[24] *CdP*, p.10; transl. p.6. According to H. Gerson, *Rembrandt Paintings*, London 1968, de Piles' picture 'was no more than a school picture. It hangs today in Woburn Abbey having been acquired in 1742, at the de Piles auction, by an ancestor of the present Duke of Bedford'.

[25] *CdP*, p.474; transl. pp.284/285. For a less serious explanation of de Piles' eulogy of Zumbo's groups, see Teyssèdre, *Roger de Piles*, pp.514f.

'illusionism'. Simply to disregard them as literary exercises in the tradition of
Pliny and Renaissance writers seems dishonest, but as we relate the notions of
imitation and illusion to other aspects of de Piles' theory we find that they relate
to a rather more complex artistic procedure than duplicating real objects and
figures. Although the visual effect of paintings provides the focus of all de
Piles' arguments his notion of imitation and illusion owes a considerable
amount to literary and, in particular, rhetorical models – so much so, indeed,
that we may, in the end, legitimately doubt not only whether he thought that
Zeuxis' and Rembrandt's illusionistic achievements were possible, but whether
they were at all desirable.

<p style="text-align:center">* * * * *</p>

'True and faithful imitation' is treated, on a rather theoretical level, in a sepa-
rate chapter of the *Cours de Peinture* to which de Piles himself refers as the
Traité du Vrai.[26] It serves as an introduction to the whole treatise and is presented
as being of central importance for the whole system: 'For all the parts of painting
are no further valuable than they bear this character of truth.' (Car toutes les par-
ties de la Peinture ne valent qu'autant qu'elles portent le caractere de ce vrai.)[27]

The main interest of the *Traité du Vrai* is provided by the way in which de
Piles adopts and reformulates ideas and notions from two different sources: the
one is the seventeenth-century theory of idealism as exemplified in Bellori's
L'Idea del Pittore, published only shortly before in 1672.[28] From this de Piles
borrows the distinction between different levels of truth, although the impor-
tance he attaches to each of them is in almost reverse order. The second source
is the literary theory of *vraisemblance* which, in its application to theatrical per-
formance, covers the notions of illusion and imitation. It can thus help us, to
some extent, to elucidate the meaning which these terms may have had for de
Piles.

There are three different kinds of truth in painting. The first one is the simple
and primary truth which consists in the simple imitation of natural objects as
we see them:

In all natural things, this simple truth discovers the way by which the painter
may gain his end; which is such a strong and lively imitation of nature, that it
may seem possible for the figures to come out of the picture, as it were, in order
to talk with those who look at them.

(Ce Vrai Simple trouve dans toutes sortes de naturels les moyens de conduire le
Peintre à sa fin, qui est une sensible & vive imitation de la Nature, en sorte que
les figures semblent, pour ainsi dire, pouvoir se détacher du Tableau, pour
entrer en conversation avec ceux qui les regardent.)[29]

[26] *CdP*, pp.29–43, transl. pp.17–26.
[27] *CdP*, p.21; transl. pp.12/13.
[28] As introduction to G.P. Bellori, *Le Vite de 'Pittori, Scultori ed Architetti moderni*, Rome
 1672. The *Idea* is most easily available, with an English translation, in E. Panofsky, *Idea*,
 Appendix II, pp.154–172. That de Piles was familiar with Bellori's writings is clear from the
 preface to the *Abrégé* of 1699.
[29] *CdP*, pp.31/32; transl. p.19.

The second truth is the *Vrai Ideal*:

A choice of various perfections, not meeting in any single copy, but taken from several, and commonly from those of the antique.

(Un choix de diverses perfections qui ne se trouvent jamais dans un seul modele, mais qui se tirent de plusieurs & ordinairement de l'Antique).[30]

The third truth, finally, is a combination of the first two and constitutes the perfection of painting:

The third truth, as a compound of the other two, gives the last hand to art, and the perfect imitation of fine nature. It carries so beautiful a probability, as often appears to be more true than truth itself....

(Le troisième Vrai qui est composé du Vrai Simple & du Vrai Ideal fait par cette jonction le dernier achevement de l'Art, & la parfaite imitation de la belle Nature. C'est ce beau Vraisemblable qui paroît souvent plus vrai que la verité même...)[31]

The distinction between *vrai simple ou natural* and *vrai ideal* recalls Bellori's distinction between naturalism and idealism. And in perfect agreement with traditional Italian categorizations, de Piles considers the Venetian school of painting to be that of naturalism, the Roman school that of the *vrai ideal*. In terms similar to Bellori's, de Piles criticizes the 'bad habit, which painters call *manner*'; (la mauvaise habitude que les Peintres appellent Maniere).[32] This refers to artists who depend entirely on *pratique & habitude* and who neglect the study and imitation of nature.

Yet this is about as far as the agreement between the two theorists goes. For Bellori, and other like-minded idealists, the intellectual idea was the highest aim of the artist, i.e. in the last instance the instruction of the spectator. Artistic truth is to be found only by surpassing nature and by approaching the ideal:

Thus the Idea constitutes the perfection of natural beauty and unites the truth with the verisimilitude of what appears to the eye.

(Cosi l'Idea costituisce il perfetto della bellezza naturale e unisce il vero al verisimile delle cose sottoposte all'occhio.)[33]

The similarity of terms used by both writers should not mislead us: for de Piles, idealization is far less important than natural imitation. For Bellori, the *vero* is superior to the *verisimile*. De Piles reverses the order of precedence: even in the combination of the first two truths, in the *vrai composé*, the decisively forceful element is the *vrai simple*, simple and truthful imitation:

By the aforesaid conjunction, the primary truth seizes the spectator, salves many neglicencies, and produces its effect the first, without our attending to it.

[30] *CdP*, p.32; transl. p.19.
[31] *CdP*, p.34; transl. p.20.
[32] *CdP*, p.40; transl. p.24. In *Remarques*, p.160 he had attacked those painters 'qui peignent toutes choses de Pratique' as 'les Libertins de Peinture'.
[33] Quoted from Panofsky, *Idea*, pp.156/157.

(Dans cette jonction le premier Vrai saisit le Spectateur, sauve plusieurs négligences, & se fait sentir le premier sans qu'on y pense.)[34]

Simple truth can subsist by itself, it can even achieve the final end of painting, whereas ideal truth, on its own, can do neither:

It is such as does not carry the painter to the end of his art, but leaves him short of it; and the only assistance he can expect to come to the end of his career, must proceed from the simple truth.

(Par [le Vrai Ideal] le Peintre ne pouvant arriver à la fin de son Art, est contraint de demeurer en chemin, & l'unique secours qu'il doit attendre pour l'aider à remplir sa carriere doit venir du Vrai Simple.)[35]

Bellori's *vero*, of course, is *bellezza*, ideal beauty, and that is roughly the same as what Dufresnoy meant in his *De Arte Graphica* when he referred to the most important part of the art of painting: *Nosse quid in rebus Natura creavit ad Artem pulchrius*.[36] De Piles, however, even in his early comments on Dufresnoy's poem, does not talk about *bellezza* or *pulchritudo*, the higher, intelligible beauty which can only be grasped by the mind or the intellect; he talks about *ornemens*, the lower kinds of beauty which appeal to the senses.[37]

In 1668 this might have been considered a rather unacceptable licence on the part of the translator. In 1708, when de Piles published his *Cours de Peinture*, he found that public opinion was wholly on his side: 'Beauty, say they, is nothing real; every one judges it according to his own taste, and 'tis nothing but what pleases'. (Le Beau, dit-on, n'est rien de réel, chacun en juge selon son goût; en un mot, que le Beau n'est autre chose que ce qui plaît.)[38] *Ornement*, for de Piles, is not as it was in traditional theory, an accidental quality of objects which the painter found in real nature, and of which *pulchritudo* was the ideal perfection. The beauty of objects, whether accidental or ideal, is now replaced by the *bel effet* of the overall composition, of the arrangement and harmonious distribution of light, shade, and colour. This effect is anything but accidental; we shall see in a later chapter that it is the result of the very science of painting, in the context of which it is intimately related to imitation and *tromperie*. This is not yet spelled out in the *Traité du Vrai*; its main purpose is a tactical one: to dispose, in a discreet way, of the academic theory of idealism.[39] What the reader is asked to notice at this stage is that idealization is desirable but by no means essential for painting.

* * * * *

34 *CdP*, p.34; transl. p.20.
35 *CdP*, p, pp.33/34; transl. p.20.
36 *L'Art de Peinture*, p.9, vers 38; translated by de Piles, p.8, as 'de sçavoir connoistre ce que la nature a fait de plus beau & de plus convenable à cet Art'.
37 *Pulchrum* in Dufresnoy's verse 47 is translated by de Piles as *bienséance* & *ornemens* (pp.9–11).
38 *CdP*, p.135; transl. p.84.
39 This was recognised by A. Lombard, *L'Abbé Du Bos. Un initiateur de la pensée moderne (1670–1742)*, Paris 1913, p.213: 'De Piles... voyait dans l'imitation une réaction contre le "beau idéal" qui éloignait de la nature'.

Most of de Piles' contemporary French readers would probably have associated the *Traité du Vrai* less with Bellori and more with French literary doctrine. De Piles may have borrowed the distinction between different kinds of truth from Bellori but the concepts of *le vrai* and *vraisemblance* were probably more easily available through literary theory. *Vraisemblance*, verisimilitude or probability, was, according to d'Aubignac, the foundation of all dramatic art.[40] Since it is in this context, as in that of de Piles' theory, closely related to notions of imitation and illusion, a brief discussion of its literary implications may throw some light on the meaning which all three terms had for our author. Given the complexity and sophistication of the *doctrine classique*, however, the following account cannot claim to be more than a crude and somewhat superficial outline of some of its principles.

The literary concept of *vraisemblance* is as wide and comprehensive as that of *bienséance* with which it is, as we saw in the first chapter, closely associated. It can be applied to three different things: first to the action, to the construction of the plot; secondly, to the *mores*, the customs and habits of the persons involved, the participants of the action, and in this sense, verisimilitude is part of the theory of *bienséance* or *decorum*; and finally to the representation, the performance; in this sense it is one of the foundations of the three unities of drama.[41]

The meaning and range of *vraisemblance* in relation to *vérité* changes according to its application: as a quality of the fable or plot, it is a much wider concept than simple truth. It is the basic condition of artistic invention and freedom. It enables the artist to go beyond the particular interest of historical fact and to endow his work with general meaning. This is all strictly in line with Aristotle's *Poetics*.[42] Yet the general meaning of the plot is subject to the approval of the French public and its *opinion commune*: it is the public whose judgement determines whether it is *vraisemblable*, probable, or not. This has rather limiting consequences as far as *mores* and *bienséances* are concerned: the poet is advised to substitute for the historical reality of his figures and stories that of the contemporary public with its *mores*, habits and moral standards.[43] And applied to the theatrical performance, the principle of *vraisemblance* is even more restricting; the unities are meant to bring the time and place of the action as close as possible to the time and place of the performance, i.e. of the audience attending it.

Vraisemblance in all three applications is considered a basic condition of the audience's *foi* or *créance*, its faith or belief, and thus of the moral and generally didactic effect of the work. The third kind of verisimilitude, that of performance or *représentation* is more or less identical with illusion.

But what does illusion mean in seventeenth-century theatrical theory and practice? According to classical tradition, poetry, as we all know, has to achieve two ends: it must both please and instruct. The didactic effect of the theatre is

[40] D'Aubignac, *La pratique du théâtre*, II, chapter 2, p.65.
[41] Cf. Bray, *La Doctrine Classique*, p.192.
[42] *Poetics*, chap. 9, 1451[b].
[43] 'Tout écrivain qui invente une fable, dont les actions humaines font le sujet, ne doit représenter ses personnages, ni les faire agir que conformément aux moeurs et à la créance de son siècle' (Bray, p.225; from Chapelain, *De la lecture des vieux romans*, 1647).

achieved by the purgation of our passions, and that depends on our *foi* or *créance*, i.e. on *vraisemblance* in all its three applications.

Where there is no belief, there is no attention or affection either, and without affection there are no emotions or passions and hence no purgation, which is one end and aim of poetry:

L'esprit n'est point ému de ce qu'il ne croit pas.[44]

Plaisir, on the other hand, presupposes that we do not confound theatrical performance and actual reality, that we are aware that the actors are actors and not real kings and princes.[45] If we took the representation of a tragedy for a real tragic event its effect on us would, of course, not be pleasing at all. Chapelain's statement that imitation in dramatic poetry should be 'so perfect that there would appear no difference between the thing imitated and that which imitates' (si parfaite qu'il ne paraisse aucune différence entre la chose imitée et celle qui imite),[46] was accepted by d'Aubignac and others with the apparently paradoxical provision that the imitation must always be recognizable as imitation.

Yet it is paradoxical only for the modern reader. In much the same way in which de Piles saw no contradiction in insisting on both visual illusion and overall order, seventeenth-century literary critics had no problems in reconciling pleasure and instruction. The problematic notion in both cases is that of illusion; and in dramatic terminology neither *foi* nor *illusion* seem to refer to a state of delusion.

Foi in respect of the first two kinds of *vraisemblance* means simply our acceptance of the plot and its implications as reasonable and acceptable; and even illusion, being the result of the third kind of *vraisemblance*, that of the performance or representation, does not involve actual deception, but refers to 'the visual trickery of a well-wrought stage presentation'[47] and its effects on our senses. There is still a strict distinction being made in the seventeenth century between the 'eyes of our body' and the 'eyes of our mind'; and while our physical senses could be 'deceived' by a theatrical illusion, the eyes of our mind would still maintain their rational control over what was to be considered as real and acceptable by reason and common-sense.

Rational control over 'illusion' in this sense is not only a basic condition of the pleasure we derive from the performance, by assuring us at any time that what we are witnessing is not, in fact, a real event; it is also a necessary requirement for our understanding the point, the didactic or instructive purpose of the play. Illusion, leading to the stirring of our emotions and passions, which may, by way of empathy or affection, lead to catharsis, is our immediate response to what is only a particular event taking place on the stage. Our rational control,

[44] N. Boileau, *L'Art poetique*, quoted from *Œuvres de Nicolas Boileau Despréaux*, nouv. ed. revenuë & augmentée, Paris 1713, vol. III, p.50.

[45] Cf. d'Aubignac, II, chap. 2, p.68.

[46] Quoted from Bray, p.149. D'Aubignac's response was that unless we knew that the performance 'n'est qu'une feinte, & un déguisement', we would be unable to judge its beauties and mistakes (II, chap. 2, p.68).

[47] Ch. Hogsett, 'Jean Baptiste Dubos on art as illusion', *Studies on Voltaire and the Eighteenth Century*, vol. LXIII, 1970, pp.147–164; p.152.

our awareness of the drama as a work of art, however, leads us beyond the particular event towards a consideration of the more general applicability of its message and thus, in a more generally applicable way, towards the purgation of our emotions and passions. Sensuous *vraisemblance* and illusion, seen from this angle, are means to support the effects which the higher, more intellectual kinds of *vraisemblance* (in the form of a consistent plot and of acceptable *mores*) are supposed to have on our mind.

<p style="text-align:center">* * * * *</p>

To some extent de Piles uses the distinction between illusion and rational control in the same way as literary theorists. He describes the effects which Rubens' *Fall of the Damned* (Plate 10), then in the collection of the Duc de Richelieu,[48] has on the ignorant and on *connaisseurs* in very much the same terms in which d'Aubignac explained the reactions of a man who has never seen a theatre or even heard of it, as being different from those of the normal, educated public.[49] The ignorant would be deceived by Rubens' painting to the extent that they would be forced to turn away: 'Being unable to bear its terrible effect, since they actually seem to be seeing the real damned ones;' (Parce qu'ils n'en peuvent souffrir l'effet terrible, & qu'il leur semble effectivement voir de veritables damnes).[50]

Connoisseurs, on the other hand, although similarly terrified in the beginning, would praise the work:

By soon transforming their terror into admiration, and by becoming extasized, as it were, at the sight of this incomparable work, having previously examined each of its parts, and the effect of the whole.

(En changeant aussi'tost cette terreur en admiration, & en s'extasiant, pour ainsi parler, à la veuë de cet Ouvrage incomparable, après en avoir examiné chaque partie, & l'effet du Tout-ensemble).[51]

The pleasure of the informed spectator seems to be caused, to some extent, by the same relation between, on the one hand, sensuous illusion and the resulting emotional involvement and affection and, on the other hand, rational control. Yet de Piles' theory and literary doctrine differ in one important aspect which makes the parallel between them an imcomplete one: the purpose of painting, for de Piles, is not a didactic one, instruction through painting is possible, no doubt, but it is not essential. And this limits the function of rational control in our observation of a picture. Our awareness of the work of art, which prevents

48 On the collection of the Duc de Richelieu, and de Piles' accounts of it, cf. B. Teyssèdre, 'Une collection française du Rubens au XVIIe siècle: Le Cabinet du Duc de Richelieu décrit par Roger de Piles (1676–1681)'; *Gazette des Beaux-Arts*, 1963, II, pp.241–299.

49 D'Aubignac, II, chap. 2, p.68: 'Supposons qu'un homme de bon sens n'ait jamais vu le Théâtre, & qu'il n'en ait même jamais oui parler, il est certain qu'il ne connaîtra pas si les comédiens sont des Rois & des Princes véritables, ou s'ils n'en sont que des phantômes vivans.'

50 R. de Piles, *Dissertation sur les Ouvrages des plus fameux Peintres* (dedicated to the Duc de Richelieu), Paris 1681, p.89.

51 *Dissertation*, p.89.

us from taking its objects and figures for real objects and persons, does not lead us to reflect upon its subject-matter and the emotional effect it has on us, but to appreciate the overall effect of the painting as a painting, as an artefact.

It now seems possible to take a first step toward reconciling what appeared to be a conflict in the thought of de Piles on illusion and disposition or order: his insistence on illusion is not to be understood in the modern sense of a total mental deception. It does not exclude our awareness of the work of art as such, in particular of its overall composition and disposition. Unless we are completely ignorant and mistake the pictoral representation for reality (and it does need a carefully contrived setting like that of Rembrandt's maid inside the window to reduce us to that state of ignorance), we seem to be aware, at the same time, of two different things, or affected by two different kinds of effects: those of the subject-matter, and those of the painting's disposition.

3. *Attraction and the Musical Effect of Painting*

As if the relationship between illusion and disposition (or order) was not in itself problematic enough, de Piles complicates matters even further by introducing a third term which seems to be related sometimes to illusion, sometimes to disposition. And this compels us to qualify our comparison with dramatic theory; we may already have taken it a little too far.

It is certainly true that de Piles' illusion is as necessary for painting as the *Vraisemblance* of performance, based on the unities of time and place, is for drama. And it is similarly true that in both cases the illusion is contained within our awareness of the object as a work of art. But in dramatic theory this awareness is based on the assumption that theatrical illusion cannot override or exclude our rational controls, which are needed if we are to understand the drama's didactic content. In de Piles' argument, however, it is not the coolness of reflection that limits the illusion, it is another kind of visual, sensuous and irrational effect which limits illusion. It is an effect which the painting can have irrespective of its subject matter which prevents us from being seduced by illusion. This further kind of effect has itself the power to attract and even to 'extacize' us.

It is this effect which in de Piles' theory seems to take on the status of final painterly achievement, which previously had been held by ideal beauty in Bellori's or Félibien's theories and by the didactic end, the purgation of our passions, in drama. What makes it rather difficult to grasp both the real nature and the importance of this effect is, firstly, that de Piles himself became explicit about it only in his last treatise, the *Cours*, and secondly, that it is empirically so closely related to the *vrai simple*, to visual illusion, that de Piles does not draw a clear line between the two. The difference was obviously difficult to establish in the traditional terminology of art theory, and more than once de Piles contradicts himself rather than embark on the tedious task of making his point clear.

In the *Traité du Vrai*, for instance, he mentions Raphael as having been the most successful painter (among his compatriots that is, not in comparison with Rubens) in combining the simple truth and the ideal truth and in taking the art of painting closer to perfection than anyone else. Only a few pages earlier, however, we find that Raphael is criticised for not having:

Been master enough to strike the eye, at first sight, by a faithful imitation, and a truth which ought to deceive, as even excelling nature itself.

(Possedé dans un degré suffisant la partie qui d'abord frappe les yeux par une imitation très-fidele, & par un Vrai dont l'art nous séduise, s'il est possible, en se mettant au dessus même de la nature.)[52]

It is because of this, de Piles claims, 'that men of knowledge have often sought for Raphael's works in the midst of them; that is, in the halls of the Vatican ... and have asked their guides to shew them the works of Raphael, without giving the least indication of being struck with them at the first glance of the eye ... '.

What is missing in Raphael's paintings (Plate 11) is not exact or convincing imitation but a kind of immediate visual attraction. This, as we shall see, is of crucial importance for the whole of de Piles' theory. It is the central *Leitmotif*, as it were, which dominates and directs his discussion of all the other parts of painting.

The criticism of Raphael shows us only one small aspect of de Piles' notions of the immediate visual effect, although it is exactly that aspect which was to remain most popular in eighteenth-century theories of art. They referred to it as the *exordium*, the attractive opening by which the work would catch the spectator's attention.[53] This is certainly implied in de Piles' account, though perhaps only for tactical reasons. After all, painting according to his definition is not a didactic art, and so there is strictly speaking no reason why the public should have an interest in it unless a picture is, by its sheer visual impact, capable of arousing that interest. It is the painting's task to catch the spectator's attention and to persuade him to come closer and have a look at it:

True painting, therefore, is such as not only surprises, but, as it were, calls to us; and has so powerful an effect, that we cannot help coming near it, as if it had something to tell us.

(La veritable Peinture est donc celle qui nous appelle (pour ainsi dire) en nous surprenant: & ce n'est que par la force de l'effet qu'elle produit, que nous ne pouvons nous empêcher d'en approcher, comme si elle avoit quelque chose à nous dire.)[54]

That this cannot simply be achieved by perfect imitation and illusion is obvious; de Piles' example of perfect illusion, Rembrandt's portrait of his maid, did not force its spectators to look at it closely and attentively. Although it is in his terminology *le vrai* which should catch our attention, there can be no doubt that attraction is not to be understood nor to be seen as a quality of the objects depicted.

We have now gone almost full circle: the relationship between attraction and illusion seems as problematic as that between disposition and illusion, and despite de Piles' frequent insistence on the close liaison between visual attraction

[52] *CdP*, p.12; transl. p.7.
[53] See for instance, C.-A. Coypel, 'Parallèle de l'Eloquence & de la Peinture', *Mercure de France*, 1751, p.15; cf. my article in *Art History*, IV, 1981, p.299.
[54] *CdP*, p.4; transl. pp.2/3.

and faithful imitation one cannot help feeling that the former has at least as much to do with disposition, order, or overall pictorial composition.

It is revealing that in this context painting is compared to music. This leads us right back to the beginning of our discussion of de Piles' theory and to the problem of *modes* and subject-matter:

The first care therefore both of the painter and the musician should be to make these entrances (the eyes and the ears) free and agreeable, by the force of their harmony; the one in his *colouring* conducted by the *claro-obscuro*, and the other in his accords.

(Le premier soin du Peintre aussi-bien que du Musicien, doit donc être de rendre l'entrée de ces portes (les oreilles & les yeux) libre & agréable par la force de leur harmonie, l'un dans le Coloris accompagné de son Clair-obscur, & l'autre dans ses accords.)[55]

Although music was considered to be an imitative art,[56] it provided no comparisons for the visual illusions of dramatic performances or painting. Yet references to musical harmonies and accords abound in de Piles, and when we remember that he uses the musical comparison not only in respect of some initial attraction but also for the harmony of the total composition, the *Tout-ensemble*,[57] we realize that the eighteenth-century notion of the first harmonious effect of a painting as *exordium*, as introduction, is, to say the least, inadequate. The overall harmony of a work is, for de Piles, not just an initial eye-catcher, but the very end and the highest aim of painting.

For its relationship with illusion and with the precise nature and the qualities of subject matter, we shall have to continue our search. Literary theory, although elucidating to some extent the meaning of illusion, has offered us little help in describing or defining the effect of the overall visual harmony of a painting; and music or musical theory does not relate the notion of harmony to that of illusionistic representation of nature.

The concept of *exordium* which later writers projected upon de Piles' immediate visual effect is, as I said, inadequate; but it leads us to one set of rules which was available to de Piles and which seems to offer exactly that connection between attraction, the effects of disposition, and imitation which de Piles was looking for. These are the rules of rhetoric. The way in which they can be seen to have served as a model for de Piles will be discussed in the following chapter.

[55] *CdP*, p.9; transl. p.6.
[56] See above chap. I, p.32f.
[57] See above, p.40.

III

RHETORIC AND PAINTING: *L'ORDRE NATUREL* AND *L'ORDRE ARTIFICIEL* IN PICTORIAL IMITATION AND ATTRACTION

1. *Rhetoric and Painting as Arts of Imitation*

THE CLASSICAL system of rhetoric was probably as influential as Aristotle's and Horace's poetics for the formulation of Renaissance and Baroque theories of painting. It provided a major theorist like Alberti with a useful model for a theory of pictorial composition,[1] and it could also offer convenient arguments to a less systematic writer like Ludovico Dolce for his attempt to counter the esoteric implications of Vasari's preoccupation with Michelangelo and *disegno*.[2]

By the end of the seventeenth century, however, rhetoric had lost much of its traditional prestige. Descartes' rigorous definition of truth had exposed it as an art of deception and revived the sense of it as a misleading, dangerous and potentially corrupt method of arguing.[3] Yet for much the same reason which led philosophers to despise rhetoric, *hommes de lettres*, poets and amateurs of the visual arts took a renewed interest in it. When the Jesuit Abbé, Dominic Bouhours, finally drew a definite line between poetical fiction and *fausseté* he simply reformulated the traditional distinction between *vraisemblance* and *vérité*; the reality of poetry and painting is different from the reality philosophy is trying to establish. And the difference is one of kind, not of degree.[4] It was exactly these discussions about 'truthfulness' on the one hand and its traditional means of persuasion on the other which made rhetoric particularly interesting for de Piles. By the end of the seventeenth century, discussions about rhetoric were less about levels of style and subject-matter and more about the basic linguistic question of how language could adequately represent or imitate reality, while still, and at the same time, pursuing its end and aim of persuasion.

* * * * *

[1] See M. Baxandall, *Giotto and the Orators*, Oxford 1971, chap. III, Alberti and the Humanists; on composition and its roots in rhetoric pp.121–139.

[2] For Dolce, see M.W. Roskill, *Dolce's 'Aretino' and Venetian Art Theory in the Cinquecento*, New York 1968, pp.101–103. Dolce invokes the authority of Cicero, *De Oratore*, book III, L,195 and LI,197, to defend the right and the ability of the general public to judge in matters of art. For a wider discussion of art and rhetoric, cf. J.R. Spencer, 'Ut Rhetorica Pictura', *Journal of the Warburg and Courtauld Institutes*, 20, 1957, pp.26–44; G.G. Le Coat, *The Rhetoric of the Arts (1550–1650)*, Seattle, Washington, 1973; A. Becq, 'Rhétoriques et Littérature d'Art en France à la Fin du XVIIe Siècle, Le Concept de Couleur', *Cahiers de l'Association Internationale des Etudes Françaises*, 24, 1972, pp.215–232.

[3] Cf. P. France, *Rhetoric and Truth in France. Descartes to Diderot*, Oxford 1972, on Descartes in particular, p.42:

[4] D. Bouhours, *La manière de bien penser dans les ouvrages d'esprit*, second edition, Amsterdam 1692 (1st ed. 1687), p.10.

Comparisons between painting and oratory are about as frequent in de Piles' writings as those between painting and music. In his early remarks on Dufresnoy, this comparison serves to underline the argument for the immediate recognizability of the main subject, from which we started our exploration of de Piles:

A Painter is like an Orator in this. He must dispose his matter in such sort, that all things may give place to his principal subject.

(Un Peintre est comme un Orateur, il faut qu'il dispose les choses en sorte que tout cede à son principal sujet.)[5]

In his later writings this comparison becomes increasingly sophisticated. We can see it take on central importance for his understanding of painting in the *Conversations sur la Connoissance de la Peinture* of 1677. It is here that he discusses the relative merits of painting and sculpture:

The painter is like an orator, and the sculptor like a grammarian. The grammarian is correct and adequate in his words, he explains himself clearly and without ambiguity in his discourse, just as the sculptor does in his works. We should understand easily what each of them presents to us. The orator needs to be instructed in those things which the grammarian knows, and the painter in those which the sculptor knows. They are necessary for each of them in order to communicate their ideas and to make themselves understood. But the orator and the painter have to go further. The painter has to persuade our eyes as much as an eloquent speaker has to move our heart.

(Le Peintre est comme l'Orateur, & le Sculpteur comme le Grammerien. Le Grammerien est correct & juste dans ses mots, il s'explique nettement, & sans ambiguité dans ses discours, comme le Sculpteur fait dans ses Figures, & l'on doit comprendre facilement ce que l'un & l'autre nous representent. L'Orateur doit estre instruit des choses que scait le Grammerien, & le Peintre de celles que scait le Sculpteur. Elles leurs sont à chacun necessaires pour communiquer leurs pensées, & pour se faire entendre: mais & l'Orateur, & le Peintre, sont obligez de passer outre. Le Peintre doit persuader les yeux comme un homme Eloquent doit toucher le coeur.)[6]

The sculptor's art, based only on *dessin*, can be pleasing insofar as it is a rationally controlled imitation of nature.[7] But the sculptor and the grammarian have to be content with a lower kind of imitation; their aim is correctness, *netteté*, and easy understanding. The orator and the painter may depend on *dessein* and grammar respectively, but their aim is not just correctness but persuasion.

So far, the analogies between, on the one hand, rhetoric and painting and on the other grammar and sculpture, are rather unspecific. The link seems to be

[5] *Remarques*, p.154; transl. p.129; see p.40 above.
[6] *Conversations*, pp.101ff.
[7] This is not an altogether new idea, see for instance, G.P. Lomazzo, *Trattato dell'Arte della Pittura, Scultura, ed Architettura* (edition Rome 1844), p.30, where painting is considered to be superior to sculpture since it is more *artificiosa*.

one of loose association which is used to reinforce a basic prejudice against sculpture. We have to widen our enquiry somewhat to see why this particular comparison had such a forceful hold on de Piles' mind. The main objection to it – within the terms de Piles was using – would be that neither rhetoric nor grammar were traditionally considered to be imitative arts, and so it is difficult to see how the distinction between them could usefully be employed to elucidate the problem posed by our two antagonistic terms, pictorial imitation on the one hand and pictorial effectiveness on the other.

To understand the full meaning of de Piles' analogies we have to go back to classical rhetoric for a somewhat different though related distinction. And this other distinction can be shown to have been redefined by seventeenth-century rhetoricians in France in terms of imitation. It thus became, as I hope to show later in this chapter, an intellectual model not just for de Piles' comparison of sculpture and painting but for his whole discussion of both the imitative and the affective aspects of all parts of painting.

* * * * *

In ancient rhetoric the correctness or *puritas* of grammar did not depend on some immutable standard of exact imitation of external nature, but on *consuetudo*, on custom or habit, on what was currently accepted as the correct use of language.[8]

The orator could use language in the *dispositio*, the arrangement of his speech, in two different ways or according to two different orders, the *ordo naturalis* and the *ordo artificialis*. The natural order would be that of grammatically correct or normal language. 'Natural', here, does not refer to external or objective nature, but to *natura hominis*, the orator's natural or normal state of mind and speech. This is the state which is untutored or unaffected by the *ars* or *doctrina* of rhetoric.

The natural order has one strong advantage: its normality would give credibility to anything the orator said. But this could easily be outweighed by its major disadvantage, its tendency to be dull, uninspiring and unable to retain the interest and the attention of the audience.

Here the artificial order, the true domain of rhetoric, finds its justification.[9] The normal, correct use of language may be sufficient for philosophical disputes where the attention of the participants can be taken for granted. The orator's audience may easily be as uncommitted as the painter's public is likely to be according to de Piles, and then grammatical correctness will not do to arouse its attention and interest. French rhetoricians distinguished very clearly between *convaincre*, which presupposes attention on the part of the listener, and *persuader*, for which the orator has to attract and keep the attention of his

[8] For the following discussion of rhetoric, its natural and artificial orders, I have relied on H. Lausberg's *Handbuch der literarischen Rhetorik*, Munich 1960, as well as his *Elemente der literarischen Rhetorik*, 2nd edition Munich 1963. For the notion of nature in classical rhetoric, cf. Freyr R. Varwig, *Der Rhetorische Naturbegriff bei Quintilian*, Heidelberg 1976.

[9] See below, p.62 and note 20.

audience.[10] This he would do by using artificial means of speech, unexpected turns of phrase, surprising expressions, figures, contrasts, amplifications etc., in short, the *ornatus* of classical rhetoric.

De Piles knew his Quintilian well,[11] and he had used the distinction between a natural and an artificial order, although in a different context, even in his early remarks on Dufresnoy's poem.[12] And the rhetorical distinction between nature and art seems to have been very much in his mind when he wrote first his *Conversations* of 1677 and then, in 1708, the *Cours de Peinture*. Not only do both texts refer repeatedly to the rhetorical model, they also share the design of their frontispieces: an engraving after Rubens representing the bondage of art and nature – *Artis et Naturae fœdus* (Plate 12).[13]

Mercury, representing Art, and a female figure of Nature are being brought together by a winged genius. In one important respect this engraving does not fit in very well with the classical rhetorical distinction between art and nature. *Natura* with her four breasts and a wreath in her hair represents a wider and more general notion of nature than that of the *natura hominis* of Quintilian's rhetorical education.

That nature here, in de Piles, is not meant to be the artist's natural talent as opposed to his artistic knowledge and discipline (*doctrina*) is clear and firmly indicated by the winged genius. Both nature and art are the objects of artistic talent or genius.

To explain the relationship between art and nature, *ordo artificialis* and *ordo naturalis*, as de Piles saw it, I have to expand upon the discussion of causality in the chapter on Félibien.[14] When de Piles wrote his *Conversations* this relationship had already acquired a meaning which was somewhat different from the one it had in classical theories of rhetoric. French linguists in the second half of the seventeenth century, and rhetoricians in particular, were no longer content with the ancient assumption that the standard of normal and grammatically correct language should be *consuetudo*, the currently accepted use of language. French language, in their view, was not only correct and natural according to changing conventions but according to the immutable laws of nature herself. As we said earlier, the logicality of French language was thought to represent

[10] See, e.g. B. Lamy, *La Rhétorique, ou l'Art de Parler*, fourth edition Amsterdam 1694 (1st edition 1675), pp.326f: to convince is the task of the philosopher, to persuade that of the orator.

 It is interesting to note that Reynolds, in an attempt to refute a theoretical position which clearly had its origin in de Piles, also had to refute this rhetorical distinction: 'The powers exerted in the mechanical part of the art have been called the language of painters; but we may say, that it is but poor eloquence which only shews that the orator can talk. Words should be employed as the means, not as the end: language is the instrument, conviction is the work.' (Fourth Discourse, ed. S.O. Mitchell, The Library of Liberal Arts, Indianapolis, New York, Kansas City, 1965, pp.46f.)

[11] See, e.g. *CdP*, pp.445; transl. p.268, where de Piles compares poetry and painting in a way which marginally touches upon the problems discussed here. Cf. also *Remarques*, p.115.

[12] *Remarques*, p.195.

[13] The design, as David Freedberg kindly pointed out to me, is inspired by Rubens' frontispiece for Silvester a Petrasanta, *De Symbolis Heroicis Libri IX*; cf. H.G. Evers, *Rubens und sein Werk. Neue Forschungen*, Brussels 1943, fig. 109.

[14] See above p.12ff.

the logicality of nature, and this also applies to the other qualities of the language.

In 1671, Dominic Bouhours wrote:

It is only the French language which follows nature step by step, as it were; and it only has to follow (nature) faithfully to find that order and that harmony which other languages do not encounter without reversing the natural order.

(It n'y a que la langue Francoise qui suive la nature pas à pas, pour parler ainsi, & elle n'a qu'à la suivre fidelement, pour trouver le nombre & l'harmonie que les autres langues ne rencontrent que dans le renversement de l'ordre naturel.)[15]

The same point is made, in a more systematic fashion, by Bernard Lamy, whose treatise on rhetoric was published in 1675. He claimed that the correctness and the natural beauty of a discourse (in French) consisted in nothing else but its conformity with nature:

One will find that the pleasure one takes in a well-arranged discourse is caused only by that similarity which is found between the image formed by the sentences in our mind, and the things of which they paint that image . . . the truth of a discourse is nothing else but the conformity of sentences with things.

(On trouvera que le plaisir que l'on prend dans un discourse bien fait n'est causé que par cette ressemblance, qui se trouve entre l'image que les paroles forment dans l'esprit, & les choses dont elles font la peinture . . . la vérite d'un discours n'est autre chose que la conformité des paroles qui le composent avec les choses.)[16]

For Lamy as a rhetorician, albeit a French one, this is much more problematic than for Bouhours: 'It is not so much a virtue but a necessity for our language to follow the natural order.' (Ce n'est pas tant une vertu qu'une necessité à nôtre langue de suivre l'ordre naturel.)[17]

The natural order is defined by Lamy as truthful imitation; and it is because of its imitative nature that French language is somewhat hostile to most of the traditional rhetorical devices, like the transposition of words[18] and the use of figures.[19] If they are still necessary it cannot possibly be because of any dullness or deficiency of normal French, but because of the reluctance of man to accept truth:

15 D. Bouhours, *Les Entretiens d'Ariste et d'Eugène*, Paris 1962 (following 1st edition, Paris 1671), p.38. The *Entretiens* went through no fewer than eleven editions in twenty years. A few years later, in his *Manière de bien penser* of 1687, Bouhours underlined the imitative nature of both thinking and speaking by comparing them to painting: 'Les pensées . . . sont les images des choses, comme les paroles sont les images des pensées, & penser, à parler en général, c'est former en soy la peinture d'un objet . . . ainsi une pensée est vraye, lors qu'elle représente les choses fidelement'.

16 Lamy, *La Rhétorique*, p.289.

17 Lamy, *La Rhétorique*, p.49.

18 Lamy, *La Rhétorique*, p.53; 'Lorsqu'on s'attache à l'ordre naturel on est clair, ainsi le renversement de cet ordre ou la transposition des mots, *trajectio verborum*, est une vice opposé à la netteté. Nôtre langue ne souffre point de transpositions que rarement'.

19 Lamy, *La Rhétorique*, p.151: 'Les François sont particulierement ennemis de ces Figures . . .'

If people loved the truth it would be sufficient to present it to them in a lively and sensible manner in order to persuade them; but they hate it, for it does not agree with their interests except in rare instances... Eloquence, therefore, would not be the mistress of our hearts if it did not attack those hearts with weapons other than those of truth.

(Si les hommes aimoient la vérité, il suffiroit de la leur proposer d'une manière vive & sensible pour les persuader; mais ils la haîssent, parce qu'elle ne s'accorde que rarement à leurs interest... L'éloquence ne seroit donc pas la maîtresse des coeurs... si elle ne les attaquoit par l'autres arms que celles de la vérité.)[20]

These other weapons of the orator are the means of the *ordre artificiel*, figures, synonyms, contrasts, etc. He has to use the full range of the rhetorical *ornatus*, but he has to do so discretely and reasonably if he is to achieve his final end of persuasion.

The artificial order, the use of an ornate style of rhetorical figures, is not just ornamentation and beautification for its own sake. We can distinguish three different though related functions: on a basic level its task is to catch the public's attention by surprise and to arouse its interest.[21] But sheer *éclat* and surprise will not achieve persuasion: the orator still needs credibility, and since he can no longer rely on that of normal language, i.e. of correct imitation, he has to use his art, his *doctrina*, in order to hide his abnormal, unnatural rhetoric behind the appearance of naturalness and normality. The notion of *art artem celare* in this context refers to a mimetic relationship, of a rather paradoxical kind, between *ars* and *natura*: the artificial order marks the departure from normal speech, but it has to keep up, at the same time, the appearance of naturalness

[20] Lamy, *La Rhétorique*, pp.144f. This argument belongs to a tradition which shows us a somewhat cruder side of the coin of 'irrationalism'. We normally define the 'irrational undercurrent' of French classicism by reference to Pascal's distinction between *l'esprit de géometrie* and *l'esprit de finesse* (*Œuvres*, ed. Brunschvicg, Paris 1921, XII, pp.11–12), and to the notion of *le je ne sçais quoi*; in this context refinement and sophistication supersede reason (see below pp.109ff). Yet there is another irrational element in French classicism which stems from our inability or unwillingness to use reason. This is invoked by d'Aubignac to justify the status of the theatre as *l'école du peuple*: for the lower classes of the populace, 'toutes ces veritez de la sagesse sont des lumières trop vives pour la faiblesse de leurs yeux... La raison ne les peut vaincre, que par des moiens qui tombent sous les sens' (*La pratique du théatre*, Amsterdam 1715, p.5). With a slightly different twist d'Aubignac himself transferred this irrational principle to rhetoric: the successful orator 'remplit si adroitement l'imagination de ses auditeurs de tout ce qui peut charmer, que le jugement ne se peut appliquer sur les autres objets extérieurs' (*Discours académique sur l'éloquence*, Paris 1668, p.15).

[21] See, for instance, Lamy, *La Rhétorique*, p.141, on the use of figures: 'Pour triompher de l'opiniâtré ou de l'ignorance de ceux qui resistent à la vérité, il suffit d'exposer à leurs yeux sa lumière, & de l'approcher de si près que sa forte impression les réveille, & les oblige d'être attentifs. Les Figures contribuent merveilleusement à lever ces deux premiers obstacles qui empêchent qu'une vérité soit connuë, l'obscurité & le défaut d'attention. Elles servent à mettre une proposition dans son jour; à la développer, & à l'entendre. Elles forcent un Auditeur d'être attentif, elles le réveillent, & le frappent si vivement, qu'elles ne lui permettent pas de dormir, & de tenir les yeux de son esprit fermes aux véritéz qu'on lui propose'. I am quoting this passage in full since it is not only the argument here that is similar to de Piles, but also the whole terminology, words, expressions and phrases.

and normality. Having lost the conviction which natural speech and correct imitation would carry, it has to imitate them artificially in order to regain credibility.

* * * * *

One might think that these first two tasks of the artificial order, to arouse our interest and to hide the means of this arousal behind an appearance of naturally correct imitation, were sufficiently difficult to overwhelm any but the most talented orator. Yet according to French seventeenth-century rhetoricians the artificial order and in particular the use of figures could achieve even more: it could produce emotional effects in the listener rather similar in kind to the effects of the modes of ancient theories of music. Bernard Lamy describes rhetorical figures as:

Certain turns (of speech)... which are able to produce in the minds of our listeners any effects we wish, whether we want to carry them to fury or sweetness, to hatred or love.

(Certain tours... capables de produire dans l'esprit de ceux à qui nous parlons les effets que nous souhaitons, soit que nous voulions les porter ou à la colère, ou à la douceur, à la haine ou à l'amour.)[22]

and:

It would be wrong to think that the figures of rhetoric were only certain turns invented by orators to embellish their discourse... the figures of discourse are able to conquer and bend the minds (of the listeners).

(Il ne faut pas s'imaginer que les figures de Rhetorique soient seulement de certains tours que les Rheteurs aient inventez pour orner le discours... les figures du discours peuvent vaincre ou fléchir les esprits.)[23]

It is worth mentioning that the natural order is not entirely deprived of beautiful or agreeable effects; yet they are of a modest kind. *Netteté* (*un arrangement net*) is considered to be *une beauté naturelle*.[24] The corresponding, though much more effective quality of the artificial order would be, not surprisingly, harmony (*un arrangement harmonieux des paroles*), which is listed by Lamy as an *ornement artificiel*.[25]

What is of interest for our discussion of de Piles is that it was thought to be possible for an orator to reconcile exactly those two principles which de Piles considered to be essential for painting: attraction and imitation or illusion (and we shall find also in de Piles' theory a clear equivalent to the third function of the *ordre artificiel*, that of producing profound emotional effects similar to music).

[22] Lamy, *La Rhétorique*, p.8.
[23] Lamy, *La Rhétorique*, p.113.
[24] Lamy, *La Rhétorique*, p.53: 'Je ne parle encore ici de cet arrangement qui rend le discours harmonieux, mais de celui qui le rend net'.
[25] Lamy, *La Rhétorique*, p.291.

It is now important to see how this reconciliation of apparently contradictory principles is meant to work in painting. Although our brief excursion into rhetoric has not yet solved that problem, it has provided us with a set of terms and distinctions which we shall find useful for our exploration of the structure and coherence of de Piles' thought. Since he himself invoked the analogy between rhetoric and painting it does not seem inappropriate to transfer the rhetorical distinction between the natural and the artificial order to his discussion of the basic parts of painting.

2. Dessin: *Imitation and Elegance*

The comparison between the sculptor on the one hand, whose art relies on *dessin* only, and the grammarian on the other, suggests that de Piles thinks of *dessin* mainly as a means of truthful and exact imitation of natural (and that includes corrected, or idealized[26]) objects, – though it is, as we know, not a sufficient means to achieve complete imitation and illusion. The imitative qualities of sculpture and drawing are described by de Piles in exactly the same terms as those used by rhetoricians for the qualities of correct grammar: *netteté, justesse*, correction.[27]

But even sculpture and drawing, in de Piles' view, are capable of certain effects which are not imitative and do not depend on close observation of nature. Again his vocabulary is the same as that of rhetoric: even sheer grammatical correctness, without having recourse to any artificial means of persuasion, could acquire an attractive quality which would elevate the orator's style to a level of ornateness not normally found in everyday speech. In addition to purity or perspicuity, correct grammar could display *élégance* or *politesse*.[28] And this is exactly the quality which *dessin* in its subtlest form can achieve:

Elegance of design may be . . . defined to be a manner of embellishing objects . . . without destroying the truth.

(On peut . . . définir l'élégance du Dessein de cette sorte. C'est une maniere d'être qui embelit les objets . . . sans en détruire le Vrai.)[29]

3. Couleur *and* Coloris

On its own, drawing is as insufficient for the final end of painting – for illusion or *tromperie* – as grammar is for the purposes of rhetoric. Both are necessary

[26] Cf. *CdP*, pp.446f.

[27] For *netteté* see Lamy, p.53 and passim; for *justesse* p.10. In de Piles, see *CdP*, pp.126ff., chapter on *Dessein* with subsection on classical sculpture.

[28] On *elégance* see Lamy, p.83, where he illustrates his point with references to the *elegantia* of classical sculpture; on *politesse*, which abhors the extravagant use of figures, cf. Lamy, p.151. In de Piles, cf. *CdP*, pp.159ff for both *élégance* and *politesse* (*De l'Elégance* being a subsection of the chapter on *Dessein*).

[29] *CdP*, p.160; transl. p.100. While Lamy referred to sculpture to make his point about the elegance of speech, de Piles invokes rhetoric: 'L'Elégance en general est une manière de dire ou de faire les choses avec choix, avec politesse, & avec agrément' (p.159).

and fundamental parts of their respective arts: 'Design must be learned before everything, as it is the key of the fine arts, as it gives admittance to the other parts of painting'. (Le dessein ... est la clef des beaux Arts; c'est lui qui donne entrée aux autres parties de la Peinture.)[30]

Yet perfect imitation, as we have been told by de Piles, requires more: nature is only imitable as far as she is visible, and 'she is only visible, as she is coloured'.[31]

De Piles is of course by no means the first to compare painting and rhetoric, or to adapt certain parts of the system of rhetoric to painting. Traditionally, colour could be compared either with elocution, as in Tasso, who talks of the colours and lights of elocution[32], or with the *ornatus*, the ornamental style or artificial order.[33] Lamy, for instance, in order to underline the importance of grammatically correct language, i.e. of the natural order of French, refers to colour as an analogy for rhetorical ornament in a wholeheartedly academic manner:

Many people wrongly imagine that rhetoric consists only in the ornament of the discourse, and that reflections of the kind we are about to make were only suitable for the grammarian. They judge about eloquence in the same way in which those, who do not know what painting is, believe that colour was its principal part.

(Bien des gens se trompent qui s'imaginent que la Rhétorique ne consiste que dans les ornemens du discours; & que des reflections semblables à celles que nous allons faire ne conviennent qu'aux Grammairiens. Ils jugent de l'éloquence, comme ceux qui ne scavent ce que c'est que la peinture, pensent que le coloris en est la principale chose.)[34]

Since de Piles regards colour no longer as an accidental ornament of objects but as the main condition of their visibility (and hence of our ability to imitate them), his comparison has to be much more sophisticated. The simple equation of colour with ornamental embellishment is surely no longer acceptable.

To say, on the other hand, that objects in nature are only imitable as far as they have colour does not mean that colour, for the painter, has to be considered only as a simple means of imitation, as a part of the natural order of painting. De Piles, in fact, considers colour in two distinct ways which correspond

[30] *CdP*, p.127; transl. p.79.

[31] Cf above p.43; see also *CdP*, pp.17f: 'Il faut beaucoup plus de Genie pour faire un bon usage des lumieres & des ombres, de l'harmonie des couleurs & de leur justesse pour chaque objet particulier, que pour dessiner correctement une figure'.

[32] Cf. G.G. Le Coat, *The Rhetoric of the Arts (1550–1650)*, Seattle, Wash., 1973, p.36.

[33] Cf. A. Becq in *Cahiers de l'Association Internationale des Etudes Françaises*, 24, 1972, pp.215–232.

[34] Lamy, *La Rhétorique*, p.17. When he later tries to establish the importance of the *ordre artificiel*, we find, not surprisingly, that colour provides a rather more useful comparison: 'Lorsque nous parlons, nous devons avoir un soin particulier des principales choses ... Les Peintres grossissent les traits principaux de leurs Tableaux, ils en augmentent les couleurs, & affaiblissent celles des autres traits, afin que l'obscurité de ces derniers releve l'éclat de ceux qui doivent paroître' (p.45).

very closely to the two orders of rhetoric. Like *dessin*, colour is necessary for truthful and natural imitation; but its main domain is that of artificial, non-imitative (or not directly imitative) effects.

Colour as part of the natural order of painting follows logically from de Piles' initial definition. His argument that objects are visible only insofar as they have colour, and that consequently the painter, as a perfect imitator of nature, ought to consider colour as his principal object, leaves us in no doubt that without colour truthful imitation would not be possible.

In a way the argument seems almost too logical. One does not have to take sides with de Piles' academic opponents to ask: how can colour be truthfully imitative? The old notion of colour as purely accidental was based, quite correctly, on the changing, unstable character of colours, their dependence on the changes of light. Despite his confident insistence on colour as the most important part of pictorial imitation de Piles is aware that he is tackling a very delicate and complex problem.

As he himself is quick to point out there is no such thing as a straightforward point by point imitation of colour, in the sense that the painter could simply transfer the colour of his object in nature to the spot on his canvas where he wants to depict that object. Colour itself turns out to be an extremely complex phenomenon of which we have to distinguish its applications, effects, and meanings.

* * * * *

De Piles makes three major distinctions between different aspects of colour: between (in this sequence) *couleur* and *coloris*; simple and local colours; and natural and artificial colours. In order to see the point of these distinctions more clearly, it may be wise to discuss them in reverse order; de Piles' sequence seems to be less a result of his desire to set up a coherent system of colour, and more a result of the fact that his first distinction, between *couleur* and *coloris*, had been a central issue in the dispute between *Rubénistes* and *Poussinistes*.

The most basic distinction, and the one which provides the framework for the rest of the discussion of colour, is that between natural and artificial colours. Despite the similarity in terms this is not to be understood in analogy to the natural and artificial orders of rhetoric: natural colours are those we see in nature. It is to them that de Piles refers when he says that objects are only visible and imitable insofar as they have colour. Artificial colours, on the other hand, are the painter's means of imitating natural colours:

The natural colour is that which makes all objects in nature visible to us; and the artificial is, a judicious mixture of the simple colours on the pallet, in order to imitate those of natural objects.

(La couleur naturelle est celle qui nous rend actuellement visibles tout les objets qui sont dans la Nature; & l'artificielle est un mélange judicieux que les Peintres composent des couleurs simples qui sont sur leur palette, pour imiter la couleur des objets naturels.)[35]

[35] *CdP*, p.305; transl. p.186.

The reference to simple colours leads on to de Piles' second distinction, between simple colours and local colours. Both are, although in a different sense, sub-divisions of artificial colour to which I have referred as the painter's *means* of imitation. Simple colours are in fact his *materials*, i.e. pure colours 'first put on the pallet',[36] like pure white, pure black, pure yellow, etc. Artificial colour, then, consists of simple colours applied to the purpose of imitation. Whereas simple colours provide, so to speak, the material ingredients for artificial colour, local colours are a particular form of artificial colour; local colour is the *mélange*, the mixture required to imitate a single object, such 'as a carnation, linen, stuff, or any object distinct from others'.[37]

One could argue that a comparison between simple colours as materials and artificial colour in general as the means of imitation would make more sense than de Piles' distinction between simple colours and local colours, i.e. between material in general and means only in a specific and particular form. But then one would miss exactly the point de Piles is trying to make. By comparing simple colour, 'which does not by itself represent objects' (qui toute seule ne représente aucun objet),[38] with local colour which 'represents a single object' (qui . . . représente un objet singulier),[39] he is emphasizing the fact that even the imitation of the apparently simple colour of one natural object cannot be achieved by mechanically applying one's materials. No single simple colour can imitate the effect of one colour in nature. Local colour, in painting: 'By its agreement with the place it possesses, and by the assistance of some other colour, represents a single object'. (Est celle qui par rapport au lieu qu'elle occupe, & par le secours de quelque autre couleur represente un objet singulier.)[40]

And according to de Piles it is called local colour not, as one might think, because it is applied to an isolated part of the canvas meant to represent one object, but: 'Because the place it fills requires that particular colour, in order to give the greater character of truth to the several colours about it'. (Parce que le lieu qu'elle occupe l'exige telle, pour donner un plus grand caractère de vérité aux autres couleurs qui leur sont voisines.)[41]

* * * * *

That the imitation of colour was not a simple mechanical process had been an important argument in de Piles' dispute with the academy; whereas Félibien and Lebrun held the view that the liberal art of painting had its foundations in the painter's intellectual mastery of his subject-matter, de Piles claimed that it was colour, *le coloris*, which not only distinguished the painter from the mere

36 *CdP*, p.304; transl. p.185.
37 *CdP*, p.304; transl. p.185.
38 *CdP*, p.304; transl. p.185.
39 *CdP*, p.304; transl. p.185.
40 *CdP*, p.304; transl. p.185.
41 *CdP*, pp.304ff; transl. p.185. This is a slight change from de Piles' own earlier definition of the *Abrégé* (p.6): 'La Couleur locale n'est autre chose que celle qui est naturelle à chaque objet en quelque lieu qu'il se trouve, laquelle le distingue des autres objets, & qui en marque parfaitement le caractère'.

craftsman, but which also put him on an equal footing with other 'liberal artists' like poets, mathematicians, and geometricians.[42]

One of the reasons (a second one will be discussed soon) why the imitation of colours is such a difficult and demanding exercise is that neither natural nor artificial colours are simple. Both are the result of a number of components affecting and modifying each other. Natural colour is composed of: '1. The true colour of the object. 2. The reflected colour. 3. The colour of the light'. (1° la couleur vraie de l'objet; 2° la couleur réflechie; 3° la couleur de la lumiere.)[43]

Artificial colours, on the other hand, although resulting from the application (in a material sense) of simple colours, cease to be simple as soon as they are applied to their imitative purpose. For this requires, even if the object of imitation is only one, more than one simple colour to do justice to the different components of the object's natural colour. As soon as two or more simple colours are brought together they mutually influence and modify each other by their sympathy or antipathy, their *valeur*, strength, etc.

The painter's materials, the simple colours, have their own qualities and properties which vary according to their mixture or combination as artificial colours. It is the 'scientific' understanding of these qualities as well as of the components of natural colours that is required if the painter wants to master the most important and comprehensive part of painting so far, colouring, *le coloris*, which de Piles contrasts with a similarly wide notion of colour, *couleur*:

Colour is what makes objects perceptible to sight: And, *Colouring* is one of the essential parts of painting, by which the artist imitates the appearance of colours in all natural objects, and gives to artificial objects the colour that is most proper to deceive the sight.

This part includes the knowledge of particular colours, their sympathies and antipathies, their manner of working, and the knowledge of the *claro-obscuro*.

(La Couleur est ce qui rend les objets sensibles à la vûe. Et le Coloris est une des parties essentielles de la Peinture, par laquelle le Peintre sait imiter les apparences des couleurs de tous les objets naturels, & distribuer aux objets artificiels la couleur qui leur est la plus avantageuse pour tromper la vûe.

Cette partie comprend la connoissance des couleurs particulieres, la simpathie & l'antipathie qui se trouvent entr'elles, la maniere de les employer, & l'intelligence du Clair-obscur.)[44]

* * * * *

Given the complexity of natural and artificial, simple and local colours, even the full mastery of the principles of *coloris* will not enable the artist to achieve a simple, straightforward imitation; on the contrary: the *intelligence du coloris*, the knowledge of colouring, would require him to deviate from such a simple imitation (were such simple imitation possible). De Piles considers a natural

[42] *CdP*, pp.312f; transl. p.190.
[43] *CdP*, p.306; transl. p.186.
[44] *CdP*, p.303; transl. pp.184f.

order of imitating colours insufficient, for two reasons. Firstly, the conditions under which artificial colours are applied, and under which they will be seen by the spectator, are not the same as those under which natural colours are seen; and secondly, the natural colours, which the painter will find in nature, are themselves 'deficient'.

De Piles introduces both points, which are in fact quite distinct, as one rather oblique argument: the conditions under which we see artificial colours are less advantageous than those of nature:

It must be considered, that a picture is a flat superficies; that, some time after the colours are laid, they lose their freshness; and that the distance of the picture takes from it much of its brightness and vigour; and therefore, that 'tis impossible to make up these three deficiencies without the artifice which colouring teaches, and which is its chief object.

(Il faut faire réflexion qu'un Tableau est une superficie plate, que les couleurs n'ont plus leur premiere fraîcheur quelque tems après qu'elles sont employées; qu'enfin la distance du Tableau lui fait perdre de son éclat & de sa vigueur; qu'ainsi il est impossible de suppléer à ces trois choses sans l'artifice que la science du coloris enseigne; & qui est son principal objet.)[45]

In order to compensate for these deficiencies of pictorial imitation the artist has to deviate from the way in which his objects are presented to him by nature; he has to exaggerate some colours and to reduce the effect of others. He must pay more attention to the rules of his art than to his model in nature.

What is, in fact, a comment on the fundamental conditions and limitations of pictorial representation and imitation, is then very quickly turned into a rather different kind of argument. De Piles tries to make a virtue of necessity. In the very next paragraph he no longer argues that the painter *cannot* fully and simply imitate nature because of the limiting conditions of his means of imitation, but that he *should not* imitate a nature which, as a rule, is incomplete and deficient.

The tactical reasons for this abrupt switch from one argument to the other are obvious: by putting the blame on the deficiencies of nature which need to be corrected, de Piles can now claim that *coloris*, the mastery of colouring, is as demanding of thought as was *dessin* according to academic idealism:

There is . . . no part of painting where nature is always proper to be imitated, that is, such nature as offers itself by chance. Though she is mistress of arts, yet she seldom shews us the best road; she only hinders us from going astray. The painter must chuse her according to the rules of art, and if he does not find her to be such as he looks for, he must correct what she offers to him. As he who designs, does not imitate all he sees in a defective copy, but changes the faults

[45] *CdP*, p.306: transl. p.186; cf. also *CdP*, pp.354f. A similar argument can be found in the earlier *Conversations*, p.290: 'Dans l'imitation des objets particuliers, le grand secret n'est point de faire en sorte qu'ils ayent leur véritable couleur, mais qu'ils paroissent l'avoir . . . les couleurs artificielles ne pouvant atteindre à l'éclat de celles qui sont en la Nature, le Peintre ne peut les faire valoir que par comparison'.

into the just proportions: So the artist must not imitate all the colours which indifferently present themselves to the eye; but chuse the most proper for his purpose; adding others, if he think fit, in order to fetch out the effect and beauty of his work.

(Il n'y a point dans la Peinture de partie où la Nature soit toujours bonne à imiter telle que le hazard la presente. Cette maîtresse des Arts nous conduit rarement par le plus beau chemin; elle nous empêche seulement de nous égarer. Il faut que le Peintre la choisisse selon les règles de son Art; & s'il ne la trouve pas telle qu'il la cherche, il doit corriger celle qui lui est presentée. Et de même que celui qui dessine n'imite pas tout ce qu'il voit dans un modèle défectueux, & qu'au contraire il change en des proportions convenables les défauts qu'il y trouve; de la même maniere, le Peintre ne doit pas imiter toutes les couleurs qui s'offrent indifferement à ses yeux, il ne doit choisir que celles qui lui conviennent: & s'il le juge à propos, il y en ajoûte d'autres qui puissent produire un effet tel qu'il imagine pour la beauté de son ouvrage.)[46]

De Piles' reference to the *correction* and idealization of *dessin* would suggest a reading of this passage in terms of the *vrai ideal* of his introductory *Traité du Vrai*. Yet the connection between *coloris* and ideal truth is only an apparent one. There is a fundamental difference between de Piles' perfection of colours and the correction of *dessin* according to academic idealism, which reveals the purely tactical nature of de Piles' implicit suggestion: he is trying to make his theory of *coloris* more readily acceptable to his opponents (who, by now, are his fellow-academicians). *Correction*, for them, referred to an intellectual process of improving a naturally deficient object to its own idea of perfection; this is also what de Piles meant when he distinguished between simple truth and ideal truth. But we remember that for him idealization was less important than truthful imitation; the ideal truth was not superior in kind to simple truth in the sense in which academic theory considered ideal beauty to be superior to natural beauty, – or, in fact, in the sense in which now de Piles' artificial perfection of colours is supposed to be superior to the deficient colours of nature.

The standard of perfection de Piles invokes now is radically different from that of academic idealism. It is not that of the object according to any perfect idea we have of it, but that of the picture as a whole, of its overall composition and effect. The deficiencies of nature he is talking about are not deficiencies in relation to an ideal state or prototype of nature, but in relation to an ideal picture and its prototypical overall effect:

A knowing painter ought not to be a slave to nature, but a judge, and judicious imitator of her. Let a picture but have its effect, and agreeably deceive the eye, and 'tis all that can be expected in this point; but this can never be attained, if the painter neglects colouring.

(Un habile Peintre ne doit point être escalve de la Nature; il en doit être arbitre & judicieux imitateur: & pourvû qu'un Tableau fasse son effet, & qu'il impose

[46] *CdP*, pp.307f; transl. p.187.

agréablement aux yeux; c'est tout ce qu'on en peut attendre à cet égard, & c'est ce que le Peintre ne sauroit faire, s'il néglige le coloris.)[47]

* * * * *

Colour, introduced originally as the painter's crucially important means of imitation, has by now acquired two additional functions, that of compensating for the insufficient powers of painting to imitate its objects truthfully, and that of establishing the beauty of painting, its agreeable effect. Whereas the function of compensation could still be thought of as an imitative aspect of colour, although of an artificial kind, the last function, creating a certain kind of overall pictorial effect, seems to be of a different order altogether.

It does not seem to be imitative; *coloris*, understood in terms of the relation which the colours should have with each other, is set apart, by de Piles, from colour considered 'in relation to the object it represents' (par rapport à l'objet qu'elle represente).[48]

The effects colours can have, irrespective of their *rapports à l'objet qu'elles representent*, are primarily those of the *clair-obscur* (which will be discussed in the next section) and of the sympathy and antipathy of colours. When talking about them de Piles invokes, yet again, the analogy with music: 'The agreement and opposition of colours are as necessary as union and the cromatick in musick'. (L'accord des couleurs & leur opposition ne sont pas moins nécessaires dans le coloris, que l'union & la cromatique dans la Musique.)[49]

The problem posed by the apparently contradictory demands of disposition and imitation (or illusion) is a problem implicit in the notion of *coloris* itself. The painter must not only imitate; he must also create a whole with its own harmonious effect.

This distinction between an imitative and an autonomous use of colour is not seen as problematic by de Piles. It is of importance only within an analysis of the principles of painting. It is not a distinction we experience as part of the visual character of pictures. As far as our visual experience of the effects of pictures is concerned, *coloris* is meant to include both the imitative and the compensatory use of colours and to exclude, by its force and harmony, any possible comparison with natural colours. If colour in its imitative function is only acceptable as long as it contributes to the final aim, the picture's overall effect, then this overall effect, in its turn, is supposed to improve and enhance our awareness of the objects as depicted in the work.

For de Piles then, these two aspects of colour are not mutually exclusive or limiting, but mutually reinforcing in the same sense in which the artificial order in rhetoric is supposed to enhance, by its very artificial ornateness, our awareness of and our attention to the truth the orator wants to communicate. In the same sense in which the *ordre artificiel* has to retain an appearance of truthfulness or normality, the *coloris* in painting, despite its mainly artificial nature, has to retain a convincing *vrai semblance*:

[47] *CdP*, p.307; transl. p.186f.
[48] *Conversations*, p.290.
[49] *CdP*, pp.334f; transl. p.203.

And of what import is it, after all, if things, on examination, be not perfectly just? If they appear so, they answer the end of painting, which is not so much to convince the understanding, as to deceive the eye . . . It is this artifice (the *coloris*) which supports the character, both of the particular objects, and of the whole together

(Quand les choses, après avoir été bien examinées, ne se trouveroient pas justes, comme on les suppose, qu'importe après tout, pourvû qu'elles le paroissent; puisque la fin de la Peinture n'est pas tant de convaincre l'esprit que de tromper les yeux . . . c'est lui (le *coloris*) qui soûtient le caractere des objets particuliers & du Tout-ensemble.)[50]

4. Le Clair-Obscur

The distinction between an imitative use of colour and an artificial autonomous effect is even more sharply formulated in de Piles' chapter on *Clair-obscur*. This he considers to be the foundation and the most important part of *coloris*, which because of its importance and complexity deserved to be treated in a separate chapter.

Clair-obscur consists of two things:

The incidence of particular lights and shades, and the knowledge of general lights and shades, which we usually call the *claro-obscuro*. And tho', according to the force of the words, these two things seem to be the same, yet they are very different. . . .

(Cette partie de la Peinture contient deux choses, l'incidence des lumieres & des ombres particulieres, & l'intelligence des lumieres & des ombres generales, que l'on appelle ordinairement le Clair-obscur: & quoique selon la force des mots, ces deux choses n'en paroissent qu'une seule, elles sont neanmoins fort differentes. . . .)[51]

The incidence of lights and shades is strictly imitative; it refers to the illumination of particular objects according to the laws of nature. It can be achieved almost mechanically:

[It is] a knowledge easily attained from the books of perspective. By the incidence of lights we therefore understand the lights and shades proper to particular objects . . . The incidence of light is demonstrated by the lines which are supposed to be drawn from the source of that light to the body enlightened.

(C'est une connoissance que l'on acquiert facilement dans tous les livres de perspective ausquels on peut avoir recours. Ainsi par l'incidence les lumieres l'on entend les lumieres & les ombres particuliers . . . L'incidence de la lumiere se démontre par des lignes que l'on suppose tirées de la source de la même lumiere sur un corps qu'elle éclaire.)[52]

[50] *CdP*, p.348; transl. p.211. The last point refers in particular to Rubens' large works seen at a distance.
[51] *CdP*, pp.361f; transl. p.219.
[52] *CdP*, p, pp.362f; transl. p.220.

This imitative part of the *clair-obscur* is imposed upon the artist by his objects and by the laws of their illumination in nature; it is not open to artificial modification: 'this the painter must strictly observe' (elle force & nécessite le Peintre à lui obéir).[53]

The knowledge of general lights and shades, the real and essential *clair-obscur*, is by comparison an area of relative artistic freedom – like most of the *coloris*. The painter can establish his own order and achieve effects according to his own imagination:

The *claro-obscuro* depends absolutely on the painter's imagination, who, as he invents the objects, may dispose them to receive such lights and shades as he proposes in his picture, and introduce such accidents and colours as are most to his advantage.

(Le clair-obscur dépend absolument de l'imagination du Peintre. Car celui qui invente les objets est maître de les disposer d'une maniere à recevoir les lumieres & les ombres telles qu'il les desire dans son Tableau, & d'y introduire les accidens & les couleurs dont il pourra tirer de l'avantage.)[54]

Since the painter chooses his own objects he can and should arrange them in such a way that their literal lights and shades which he imitates integrate with the 'devised' general *clair-obscur*, and so become part of it.[55]

To say that the *clair-obscur* in general depends on the artist's imagination or *intelligence*, that it is an area of artistic freedom unconstrained by the requirements of truthful imitation, does not mean to imply, however, that there are no rules, objectives or purposes determining the arrangement and order of *clair-obscur*. What de Piles refers to as the advantage of the *clair-obscur* is, in fact, a strict prescription: it defines a requirement which must be met by any picture that is to be successful and effective. The end of the *clair-obscur* is to provide: 'For the repose and satisfaction of the eye, as for the effect of the whole together. (Tant pour le repos & pour la satisfaction des yeux, que pour l'effet du tout-ensemble.)[56]

The *clair-obscur*, then, is not something which the artist is free to disregard; and de Piles is not content with discussing different means of achieving a successful distribution of lights and shades in general. He also presents his reader with some theoretical and practical 'proofs' of the necessity of *clair-obscur*.

The first proof, 'taken from the necessity of making a choice in painting',[57]

53 *CdP*, p.363; transl. p.220.
54 *CdP*, p.363; transl. p.220. In his early *Remarques* the distinction between *incidence* and *intelligence* is not yet fully worked out; de Piles' recourse to the rhetorical model of different orders, however, is already clearly formulated: there are 'deux manières, dont l'une est Naturelle, & l'autre Artificielle: La Naturelle se fait par une étenduë de Clairs ou d'Ombres, qui suivent naturellement . . . les Corps solides . . . Et l'Artificielle consiste dans les Corps des Couleurs que le Peintre donne à de certaines choses telles qu'il luy plaist' (p.195).
55 *CdP*, p.363; transl. p.220: 'Comme les lumieres & les ombres particulieres sont comprises dans les lumieres & dans les ombres generales, il faut regarder le clair-obscur comme un tout, & l'incidence de la lumiere particuliere comme une partie que le clair-obscur suppose'.
56 *CdP*, p.362; transl. p.220.
57 *CdP*, p.370; transl. p.224.

is based on an argument we have already encountered in his discussion of *coloris*: since nature is normally defective and in need of perfection, the painter cannot simply rely on his imitative skills: 'He must, by the help of art, make as good a choice of her as possible, in all her visible effects in order to bring her to some perfection.' (Pour la reduire dans un état parfait, il doit recourir à son Art qui lui enseigne les moyens de la bien chosir dans tous ses effets visibles.)[58]

The standard of perfection here, as in the discussion of *coloris*, is not that of nature (despite de Piles' reference to *'un état parfait* of nature'); it is, again, that of a perfect picture and its successful effect. In this respect, one of the other 'proofs' is a logical extension of the first one. It is based on the advantage which the other parts of painting gain from *clair-obscur*. Here the distinction between imitation and attraction, between an *ordre naturel* an an *ordre artificiel* of painting is made quite explicit. De Piles first lists what we may call imitative elements:

Figures ought to be well set and distanced, their draperies well cast, and the passions of the soul finely expressed: In a word, each object should be characterized by a just and elegant design, and by a true and natural local colour.

(Il est nécessaire de bien poser les figures, de les dégrader, de bien jetter une draperie, d'exprimer les passions de la'me, en un mot de donner le caractere à chaque objet par un Dessein juste & élegant, & par une couleur locale vraie & naturelle.)[59]

In terms of de Piles' comparison between painter and orator, sculptor and grammarian, all these elements would only be 'grammatically' correct and truthful. And so they need to be supported and put into their proper and effective place by the painter's 'rhetorical' means:

But it is as necessary to support all these parts, and give them a good light, in order to make them the more capable of attracting the eye, and of agreeably deceiving it, by means of the force and repose which the knowledge of general lights gives to a picture.

(Mais il n'est pas moins nécessaire de soûtenir toutes ces parties, & de les mettre dans un beau jour, en les rendant plus capables d'attirer les yeux, & de les tromper agréablement par la force & par le repos que l'intelligence des lumieres generales introduit dans un Tableau.)[60]

Neither of these two 'proofs' does anything more than simply affirm the necessity of *clair-obscur*. What exactly its advantages are, and what kind of effects it could and should achieve is discussed in two other 'proofs'.

The points de Piles is making in order to support these further 'proofs' are precisely the same as those he is discussing in his chapter on disposition, on the *Œconomie du Tout-ensemble*. *Coloris* and *clair-obscur* are among the most important contributors of disposition; and so it seems to be in order here to

[58] *CdP*, p.370f; transl. p.224.
[59] *CdP*, p.373; transl. pp.225f.
[60] *CdP*, p.373; transl. p.226.

discuss them in the wider context of de Piles' theory of pictorial composition, where the full range of their implications and their crucial importance for the whole of de Piles' argument are brought out more forcefully and comprehensively than in the chapter on *clair-obscur*.

5. *Pictorial Composition:* Le Tout-Ensemble *and Its Harmonies*

The difference between Félibien's and de Piles' theories of painting is brought out most distinctly in their respective definitions of *disposition*. For Félibien, this was the mental or intellectual ordering of the painter's subject-matter according to the rules of *convenance* and the *unité de sujet*. It was part of the 'theory' of painting, its intellectual mastery. The actual arrangement and formal ordering of figures, forms and colours, the picture's '*ordonnance*', was part of the painter's 'practice', for which he had to draw on his natural talent and his working experience.

What Félibien called disposition is in de Piles' system part of invention, where the painter displays his abilities not as a painter but as a poet or historian.[61] De Piles' disposition is, in fact, almost identical with Félibien's rather lowly placed '*ordonnance*'.

De Piles' different approach is clear from the outset: no matter how good and ingenious the invention of the subject-matter and how truthful the imitation of the painter's objects might be, if they are not well distributed, if their arrangement does not completely satisfy the disinterested spectator, the picture will never receive general approval:

Œconomy and good order is what gives a value to every thing; and in the fine arts, draws attention, and fixes it . . . And this œconomy I properly call disposition.

(L'œconomie & le bon ordre est ce qui fait tout valoir, ce qui dans les beaux Arts attire notre attention, & ce qui tient notre esprit attaché . . . Et c'est cette Œconomie que j'appelle proprement Disposition.)[62]

Disposition, according to de Piles, contains six parts of which, however, only two are of real importance for our purpose: the distribution of objects in general and the effect of the whole together ('*l'effet du Tout-ensemble*').

The first part, the distribution of objects in general, is the closest de Piles gets to Poussin's and Félibien's theories of pictorial modes:

In *composition*, the painter ought to contrive, as much as he possibly can, that the spectator may, at the first sight, be struck with the character of the subject, or at least may, after some moments of reflection, take the principal scope of it.

(Dans la composition d'un Tableau, le Peintre doit faire en sorte, autant qu'il lui sera possible, que le Spectateur soit frappé d'abord du caractere du sujet, & que du moins après quelques momens de reflexion, il en ait la principale intelligence.)[63]

[61] Cf. chap. II, Note 14. See also *Conversations*, pp.106f: 'Si un Peintre en representant vous instruit, il ne le fait pas comme Peintre, mais comme Historien'.

[62] *CdP*, pp.94f; transl. p.58.

[63] *CdP*, p.96; transl. p.59.

De Piles' suggestions how to facilitate this quick response to the picture's subject-matter appear, at the beginning of the eighteenth century, rather moderate and traditional:

It will greatly contribute to this end, that he (the painter) place the hero and the principal figures, in the most conspicuous places; yet this must be done without affectation, and in such a manner as the subject and probability require.

(Le Peintre peut faciliter cette intelligence en placant le Heros du Tableau & les principales figures dans les endroits les plus apparens, sans affectation neanmoins; mais selon que le sujet, & la vraisemblance le requereront.)[64]

The nature or quality of the subject is again described in terms very similar to those in the theories of modes; it may be:

Either pathetick or gay, heroick or popular, tender or terrible; in short the picture must have more or less motion, as its subject is more or less stirring or still.

(Tantôt patetique & tantôt enjoué, tantôt heroïque & tantôt populaire, tantôt tendre & tantôt terrible, & enfin qui demande plus ou moins de mouvement, selon qu'il est plus ou moins vif ou tranquille.)[65]

Yet despite all the similarities this is not another attempt to establish effects of pictorial modes. De Piles is talking about the nature of different subjects and the way they may inspire a painter's arrangement of his figures and objects. This is only of interest because it determines the composition and facilitates our understanding (and even that may require a few moments of reflection). De Piles, in fact, does not claim any analogy between the nature of subject-matter and musical modes, nor does he attribute to it any emotional – let alone miraculous or profound – effects.

Here again, it becomes clear that de Piles is reluctant to give too much credit to what he would consider the painter's literary, historical, or philosophical activities. They must not be neglected; one has to admit that the distribution of objects is the most imitative aspect of disposition; that the imitation is often one of actions from literature or history; and that, in this respect, some part of the composition appears, as a result or a function of the subject and its qualities, as being determined by something which de Piles does not admit as essential to painting.

One could say that as far as the qualities of subject-matter are concerned, the distribution of objects is merely descriptive; it is not yet visually effective. What makes it visually effective is an emotional or expressive force which is not derived from the subject but added to it by the way the picture is composed:

As the subject points out to the artist the proper œconomy in the disposition of objects, so distribution, in its turn, wonderfully contributes to the expression of the subject, gives both force and grace to what is invented, prevents confusion in the figures, and makes every thing in the picture more clear, more apparent,

[64] *CdP*, pp96f; transl. p.59.
[65] *CdP*, p.97; transl. pp.59f.

and more capable to produce the effect above-mentioned, of calling to and detaining the spectator.

(Mais si le sujet inspire au Peintre une bonne œconomie dans la distribution des objets, la bonne distribution de son côté sert merveilleusement à exprimer le sujet. Elle donne de la force & de la grace aux choses qui sont inventées; elle tire les figures de la confusion, & fait que ce que l'on represente est plus net, plus sensible & plus capable d'appeller, & d'arrêter son Spectateur.)[66]

What is implied in this statement is not only that the representation of a given subject will gain in effect and truthfulness if it is ordered in a way appropriate to its character, but moreover, that the disposition of the picture in general can achieve certain effects, like *force* and *grace*, which are not functions of the subject but autonomous effects of the disposition irrespective of the action depicted.

These autonomous effects of the overall disposition are closely related to those of *coloris* and *clair-obscur*; or, to be more precise, those of *coloris* and *clair-obscur* are contained within the effects of disposition. As far as colour is concerned, these were the effects of harmony achieved by establishing an *accord* among the colours of a composition irrespective of their imitative function. This could be done in basically two ways, either according to the sympathy among colours, or according to their antipathy or opposition.

That a composition of *couleurs sympathiques* will result in some kind of harmony seems evident, even if de Piles faces considerable difficulties in trying to explain the causes of sympathy among some colours and its absence among others.

Mere absence of sympathy is not the same as opposition. The contrast of colours, too, is a positive means of achieving harmony; though this is a harmony of a different kind. It is similar to (and perhaps even identical with) that of *clair-obscur*, the subordination of all particular lights and shades under one main contrast of light and darkness dominating the whole picture.[67]

It is from this same notion of subordination that de Piles derives his concept of harmony of disposition. Here again, de Piles makes his by now rather familiar distinction between properties of particular objects and properties of the whole painting, implying that the former have to be imitated as truthfully as possible within the limits set by the latter.

Harmony in general is the result of arrangement and good order:

There is harmony in moral as well as in natural philosophy; in the conduct of human life, as well as in the proportions of the human body; and, in short, in every thing that consists of parts, which, however different from one another, yet agree to make but one whole, more or less general.

(Il y a de l'harmonie dans la Morale comme dans la Physique; dans la conduite

[66] *CdP*, p.97; transl. p.60.
[67] De Piles' discussions of the antipathy and opposition of colours again follows closely the example of rhetoric; part of its *ordre artificiel* are antitheses and oppositions, see Lamy, *La Rhétorique*, pp.124f: 'On sçait que les choses opposées se font appercevoir les unes les autres: la blancheur éclate aupres de la noirceur'.

de la vie des hommes, comme dans le corps des hommes mêmes. Il y en a enfin dans tout ce que est composé de parties, qui bien que differentes entr'elles s'accordent néanmoins à faire un seul Tout, ou particulier, ou général.)

It follows that harmony can be achieved in each part of a painting separately; this de Piles calls *harmonie particulière*. Yet much more important is that in a picture all parts should harmonize with each other:

They must all agree together in the picture, and make but one harmonious whole; in the same manner as it is not enough, in a concert of musick, that each part be heard distinctly, and follow the particular arrangement of its notes; they must all agree together in a harmony which unites them, and which, out of several particular wholes, makes but one whole that is general.

(Il faut encore que dans un Tableau elles s'accordent toutes ensemble, & qu'elles ne fassent qu'un Tout harmonieux; de même qu'il ne suffit pas pour un concert de Musique que chaque partie se fasse entendre avec justesse, & demeure dans l'arrangement particulier de ses notes, il faut encore qu'elles conviennent d'une harmonie qui les rassemble, & qui de plusieurs Tous particuliers n'en fasse qu'un général.)[68]

This notion of the harmony of the whole has to be set apart quite clearly from the character or quality of the subject. Subject-matter, as we have seen, has comparatively distinct qualities – *patetique ou enjoué, heroïque ou populaire, tendre ou terrible*. This list of possible qualities could be continued almost indefinitely (and it was continued throughout the eighteenth century in the discussion about pictorial modes).[69]

Pictorial harmony, as a visual effect, also has its own kind of mode; but these modes are of a more general kind. *Grace* and *force* seem to mark the two opposite ends of only one possible range of effects or expressions, though these are, by their very nature, fairly wide and comprehensive. Félibien had confused the discussion about the modes to some extent by not distinguishing clearly enough between the modes of subject-matter on the one hand and the expressive qualities of a painter's personal style, or the style of a school of painting, on the other. Having separated pictorial harmony from the nature of subject-matter, de Piles is on much safer ground when he uses artists' personal styles (described in very general terms) to illustrate the different possible effects of harmony in painting:

There are in painting several sorts of harmony; the sweet and the temperate, as usually practised by Correggio, and Guido Reni; and the strong and great, as that of Giorgione, Titian, and Caravaggio.

(Il y a dans la Peinture differns genres d'harmonie. Il y en a de douce & de moderée, comme l'ont ordinairement pratiqué le Correge & le Guide. Il y en a de forte & d'élevée, comme celle du Giorgion, du Titien & du Caravage.)[70]

[68] *CdP*, pp.111f; transl. pp.68f.
[69] Cf. Bialostocki, in *Zeitschrift für Kunstgeschichte*, 24, 1961, pp.136f.
[70] *CdP*, p, p.112; transl. p.69.

But to call these *genres d'harmonie* general kinds of personal style would show us only one side of the coin. De Piles' remark that disposition could add *force* or *grace* to the representation of any subject-matter also refers to them as general qualities or effects of subject-matter. To put it somewhat more pointedly: these effects *will* be used by the artist because they agree with the requirements of his own artistic personality or temperament, while on the other side, they *can* and *should* be used to support and bring out to the best advantage the specific quality of the subject-matter. They are bound to come out most clearly in a painting where the (general) emotional and expressive quality of the artist's *persona* is similar to the (specific) emotional and expressive quality of his subject-matter.

The best way of referring to de Piles' *genres d'harmonie* would be to call them 'modes of the medium' – and the medium, as we shall see in the following chapter, which links not only the artist and his subject-matter, but also a third party, not yet properly introduced, the spectator. Eighteenth-century critics would have been familiar with my term 'modes of the medium', yet they understood it, as we shall see later on, in a much narrower sense than that implied here: reluctant to come to terms with de Piles' autonomous effects of pictorial composition, they reduced them to what they called technical effects, *la magie de faire* or *la magie de la technique*.[71]

It is de Piles' much wider concern with painting as the medium of a triangular relationship of artist, composition, and spectator (which does not mean that all three points of the triangle are always equally important), that makes his theory both immensely complex and surprisingly modern.

[71] See below pp.129.

IV

THE UNITY OF OBJECT: VISION, HARMONY, AND *L'EFFET AU PREMIER COUP D'OEIL*

THROUGHOUT his discussion of the separate parts of painting, *dessin*, *coloris*, *clair-obscur*, and *disposition*, de Piles insists on their dual character: they are both means of imitation and means of attraction and visual effectiveness. But the last of these, *disposition*, is more than a separate part; as the *Oeconomie du Tout-ensemble* it includes the others, and it finally determines to what extent all the other parts will succeed both in creating an illusion and in attracting the spectator's attention.[1]

The judge in this matter is the spectator perceiving the whole picture. In this third chapter on de Piles I shall discuss the way in which he considers disposition and vision as interrelated, as reciprocally determining. His ideas about our visual perception can be seen as guiding his notions of pictorial order and composition; and this will explain how illusion and attraction can be thought of as mutually reinforcing. It is not the subject-matter and its qualities which define his sense of pictorial and compositional unity, but the structure of our vision. This sense of order as a correspondance between our vision and its objects enables the painter, according to de Piles, to achieve effects entirely specific to painting. And these effects are illusionistic in both senses of illusion: as actual visual deception, and as an overwhelming and overpowering effect absorbing our interest and attention, and even culminating in a state of *enthousiasme*, affecting our whole being.

[1] When Gombrich linked de Piles and Aristotle (cf. Chap. I, p.1) he failed to see the over-important rôle of disposition in the Frenchman's theory. He quoted from the English translation of the *Cours*: 'It is not enough ... that each part (of a painting) has its particular arrangement and propriety; they must all agree together and make but one harmonious whole'. The dependence of this statement on Aristotle's *Poetics* is obvious (cf. Gombrich, *Norm and Form*, p.71), yet its precise meaning is somewhat different: de Piles, here, does not talk about the constituent parts of the art of painting (which he himself listed in the *Balance* as composition, design, colouring, and expression), but about the visually effective parts of a composition. Gombrich, following Aristotle, sees overall harmony and unity resulting from a process of balancing and reconciling mutually limiting demands made on the artist by the different departments of his art. De Piles, on the other hand, sees harmony and unity as the result of *disposition*, of formal arrangement: it is to be achieved 'by the subordination of objects, groups, colours, and lights, in the general, of a picture' (Transl. p.69). It is important to insist on this distinction, since de Piles is quoted by Gombrich as a key-witness against the modern *monism* of 'formal analysis' (Gombrich, pp.74/75). Although Gombrich is surely right as far as the whole of de Piles' theory is concerned, the particular passage quoted by him has to be seen as, perhaps, the first major step in the direction of a more modern approach to painting, that of assessing the visual effectiveness of forms, colours, and overall composition.

1. L'Unité d'Objet *and the Effect of Vision*

De Piles refers to the harmony of disposition as: 'A wonderful effect, which the whole together produces'. (Un effet merveilleux du Tout ensemble.)[2] How is this effect supposed to work? *Affetti* in traditional theory were expressions of passions and emotions of figures involved in an action; they worked on the spectator by means of empathy or imitation. The effects of harmony and the *Tout-ensemble* are obviously of an altogether different kind. For the modern reader whose ideas about the effectiveness of paintings have been formed by romantic and post-romantic theories and art this question would not seem to pose any problems at all. De Piles, however, is treading new ground: what we, only too easily, may take for granted presents itself to him as an elusive phenomenon, difficult to explain or only to describe within the terminology available. A closer examination of the use of some of the terms which de Piles brings into the discussion may help us not only to understand his answer to the question but also sharpen our awareness of the problems involved.

The *Tout-ensemble* is defined by de Piles as: 'Such a general subordination of objects one to another, as makes them all concur to constitute but one'. (Une subordination générale des objets les uns aux autres, qui les fait concourir tous ensemble à n'en faire qu'un.)[3]

A notion of unity based on the general subordination of objects within a whole, the *Tout-ensemble*, the result of which is harmony, may sound to us very much like formalistic aesthetics, or like *clichés* without much practical significance. Yet in de Piles' theory these terms acquire a rather more precise meaning. The crucial concept which we would expect to elucidate the others, is that of subordination. What does it mean?

Initially it seems to mean little more than the mutual relationship within a hierarchy of all the parts of the whole which de Piles compares to the *Tout politique*:

Where the great have need of the lower people, and these have need of the great. All the objects, lines, colours, lights and shades, of a picture, are great or small, strong or weak, only by comparison.

'Où les grands ont besoin des petits, comme les petits ont besoin des grands. Tous les objets qui entrent dans le Tableau, toutes les lignes & toutes les couleurs, toutes les lumieres & toutes les ombres ne sont grandes ou petites, fortes ou faibles que par comparaison.)[4]

The qualities of each feature or form are defined and limited by the qualities of all the other features or forms. So far, general subordination is similar in kind to the overall accord or harmony of the *coloris*.

But then there is another side of it which corresponds more closely to the overall unified contrast established by *clair-obscur*: 'This subordination, by which several objects concur to make but one, is founded on two principles, viz.

[2] *CdP*, p.110; transl. p.68.
[3] *CdP*, p.105; transl. p.65.
[4] *CdP*, pp.104/105; transl. p.64.

the satisfaction of the eye, and the effect of vision. (Cette subordination qui fait concourir les objets à n'en faire qu'un, est fondée sur deux choses, sur la satisfaction des yeux, & sur l'effet que produit la vision.)[5]

These are exactly the principles invoked in the last 'proofs' of the necessity of *clair-obscur*, which was the reason why I have postponed their discussion until now. De Piles, here, turns to the spectator and his perception of paintings. He sees the spectator not just as passively succumbing to the picture's attraction or illusion, nor as sharing (in a traditional way) the passions and emotions of the subject-matter, but as forcing upon the artist the very rules on which both successful illusion and immediate attraction depend. With painting defined as an art of representing on a flat surface all possible objects, and aiming at attraction and illusion, the spectator and his responses to painting take on a crucial rôle for the formulation of a coherent theory of art.

From a superficial reading, de Piles' treatment of the first point, concerning the satisfaction of the eye, will probably look like a curiously elaborate version of a rather traditional theme in artistic theory. I quote here from the chapter on disposition:

The eye has this in common with the other organs of sense, that it cares not to be obstructed in its office; and it must be agreed, that a great many people, met in one place, and talking together at the same time, and with the same tone of voice, so as that no one in particular could be distinguished, would give pain to those who heard them: it is just so in a picture, where many objects, painted with equal force, and illuminated by the same light, would divide and perplex the sight, which being drawn to several parts at once, would be at a loss where to fix; or else, being desirous to take in the whole at one view, must needs do it imperfectly.

(Les yeux ont cela de commun avec les autres organes des sens, qu'ils ne veulent point être interrompus dans leurs fonctions, & il faut convenir que plusieurs personnes qui parleroient dans un même lieu, en même tems & de même ton, feroient de la peine aux Auditeurs qui ne sauroient auquel entendre. Semblable chose arrive dans un Tableau, où plusieurs objets séparés, peints de même force, & éclairés de pareille lumiere, partageroient & inquieteroient la vûe, laquelle, étant attirée de differens côtés seroit en peine sur lequel se porter, ou qui voulant les embrasser tous d'un même coup d'œil, ne pourroit les voir qu'imparfaitement.)[6]

De Piles, here, is not just making the obvious and traditional point that too many figures, or too much variety, would be detrimental to our understanding of the subject-matter, or that they would distract our attention from the main figure or action. His argument is not about subject-matter or understanding at all, but about vision: if it cannot properly fulfil its function, our visual sense will be disquieted, it will suffer pain.

[5] *CdP*, pp.105/106; transl. p.65.
[6] *CdP*, p.106; transl. pp.65/66. For the more traditional use of this argument, cf. Alberti's little anecdote about Varro's dinner-guests.

The eye is 'desirous to take in the whole at one view'. The means of *coloris* and *clair-obscur*, contributing to the picture's overall unity, are thus essential to guarantee the satisfaction of the eye:

Now, to hinder the eye from being dissipated, we must endeavour to fix it agreeably, by a combination of lights and shades, by an union of colours, and by oppositions wide enough to support the groups, and give them repose.

(Pour éviter donc la dissipation des yeux, il faut les fixer agreablement par des liaisons de lumieres & d'ombre, par des unions de couleurs, & par des oppositions d'une étendue suffisante, pour soutenir les Grouppes, & leur servir de repos.)[7]

* * * * *

Yet the requirements of our vision, according to de Piles, allow for a more precise definition of pictorial unity.[8] It is only in the paragraphs on the effect of vision that de Piles specifies the kind of subordination of parts which will lead to a clearly defined visual unity, for which he introduces the term *l'unité d'objet*, and finally to an overall harmony and the satisfaction of the eyes. He presents us with a theory of vision which at first sight we are almost bound to find objectionable, and to which some of his contemporaries and fellow-academicians did, indeed, object.

De Piles claims that *l'unité d'objet* which previously has been described as synonymous with general subordination, that is with a rather artificial kind of overall disposition, is to be found in nature herself:

The eye is at liberty to see all the objects about it, by fixing successively on each of them; but, when 'tis once fix'd, of all those objects, there is but one which appears in the centre of vision, that can be clearly and distinctly seen; the rest, because seen by oblique rays, become obscure and confused, in proportion as they are out of the direct ray.

(L'œil a la liberté de voir parfaitement tous les objets qui l'environnent, en se fixant successivement sur chacun d'eux; mais quand il est une fois fixé, de tous les objets il n'y a que celui qui se trouve au centre de la vision, lequel soit vû clairement & distinctement: les autres n'étant vûs que par les rayons obliques, s'obscurcissent & se confondent à mesure qu'ils s'éloignent du rayon direct.)[9]

De Piles uses an illustration, a diagram, to make his point as clear as possible (Plate 13); on which he comments:

I suppose my eye, for instance, at A, directed to the object B, by the straight line A B. 'Tis certain, that if I do not move my eye, and yet would observe the other objects, which can only be seen by oblique lines to the right and left of A B, I shall find, that though they are all in the same circular line, and at the same distance from my eye, yet they decrease, both in force and colour, in proportion as they recede from the straight line, which is the centre of vision.'

[7] *CdP*, pp.106/107; transl. p.66.
[8] *CdP*, p.107; transl. p.66.
[9] *CdP*, pp.107/108; transl. p.66.

(Je suppose, par exemple, que mon œil A. se porte sur l'objet B. par la ligne directe A.B. Il est certain que si je ne remue pas mon œil, & qu'en même tems je veuille observer les autres objets qui ne sont vûs que par les lignes obliques à droit & à gauche, je trouverai que bien qu'ils soient tous sur une même ligne circulaire à la même distance de mon œil, ils s'effacent & diminuent de force & de couleur à mesure qu'ils s'écartent de la ligne directe, qui est le centre de la vision.)[10]

I have quoted these passages in full because of their central importance for de Piles' theory of composition. These passages offer an account of vision very close to what modern psychologists of perception call peripheral vision. J.J. Gibson has described this phenomenon at some length as a kind of abnormal, rather artificial visual approach to the world around us:

To do so you must fixate your eyes on some prominent point and then pay attention not to that point, as is natural, but to the whole range of what you can see, keeping your eyes still fixed... If you persist, the scene comes to approximate the appearance of a picture... This is what will here be called the visual field (as different from the visual world of our normal visual perception).[11]

According to Gibson, the visual field has two distinct characteristics: it has a centre and boundaries, which the visual world around us has not, and it has a central-to-peripheral gradient of clarity, again something we do not perceive in the normal world around us. Of these two de Piles mentions explicitly the last one, that the clarity and definition of objects decrease according to their distance from the centre of our vision. The first characteristic of the visual field is implied in his statement 'that vision proves the unity of an object in nature'. (Que la vision est une preuve de l'unité d'objet dans la Nature).[12] Nature brings: 'Several objects into one glance of the eye, so as to make them but one'. (Sous un même coup d'œil plusieurs objets pour n'en faire qu'un.)[13]

There are no other illustrations in the whole *Cours de Peinture* except for those which demonstrate the unity of object. We may take this as indicating the importance de Piles attaches to this notion of unity; but perhaps we should also see it as a sign of the difficulties he faces in describing and explaining his notion.

Félibien's coherent and systematic theory of *unité de sujet* provides the obvious standard of comparison. It is this that de Piles is trying to emulate or even to replace with his notion of a purely visual unity of painting:

The faculties of the soul are, at one time, taken up with one thing only, in order to act well; and the organs of the body cannot satisfactorily enjoy more than one object at a time... Thus, as in a picture there ought to be an unity of subject for the eyes of the understanding, so there ought to be an unity of object for those of the body.

[10] *CdP*, p.108; transl. pp.66/67.
[11] J.J. Gibson, *The Perception of the Visual World*, Cambridge, Mass., 1950, pp.26f.
[12] *CdP*, p.108; transl. p.67.
[13] *CdP*, p.109; transl. p.67.

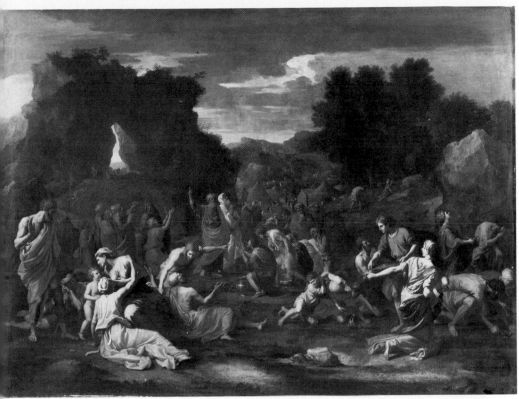

1. Poussin, *The Israelites Gathering the Manna*. 149 × 200 cm.; 1639. Musée du Louvre, Paris.

2. Poussin, *Landscape with a Man Killed by a Snake*. 119.5 × 198.5 cm.; probably 1648. Reproduced by Courtesy of the Trustees, National Gallery, London.

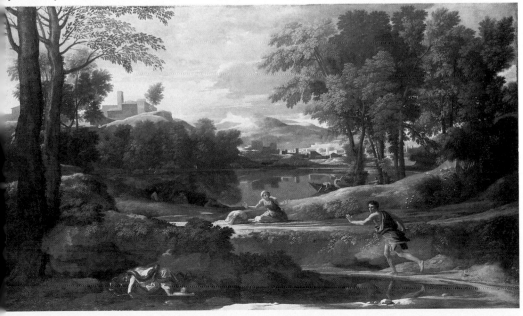

3. Poussin, *The Massacre of the Innocents*. 147 × 171 cm.; *circa* 1628–29. Musée Condé, Chantilly. (Photo Girandon).

4. Rubens, *The Massacre of the Innocents*. 199 × 302 cm.; *circa* 1635. Alte Pinakothek, Munich.

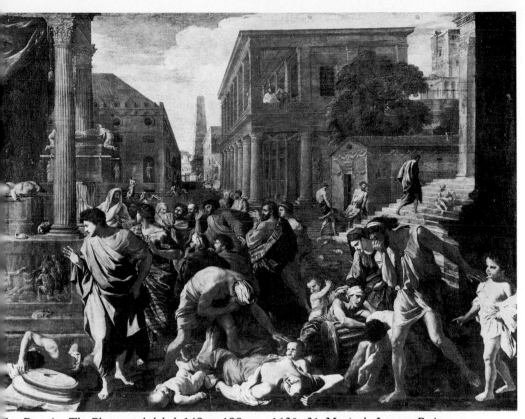

5. Poussin, *The Plague at Ashdod*. 148 × 198 cm.; 1630–31. Musée du Louvre, Paris.

6. Poussin, *The Massacre of the Innocents*. 98 × 133 cm.; *circa* 1625–26. Ville de Paris, Musée du Petit Palais, Paris. (Photo Bulloz).

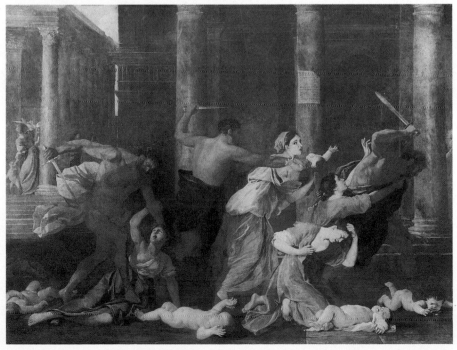

7. Poussin, *Eliezer and Rebecca*. 118 × 197 cm.; 1648. Musée du Louvre, Paris.

8. Poussin, *Landscape with Hercules and Cacus*. 156.5 × 202 cm.; *circa* 1655. Pushkin Museum, Moscow.

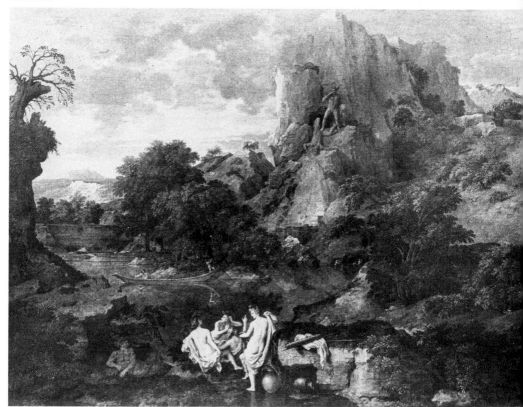

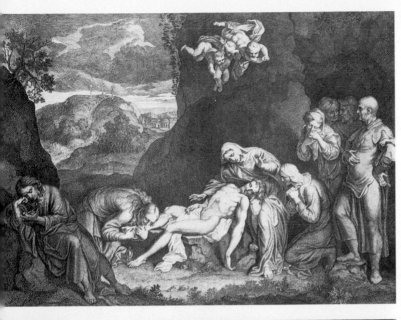

9. Elisabeth Sophie Chéron, Engraving after the wax-figure group of the *Deposition* by Don Gaetano Giulio Zumbo (1710).

10. Rubens, *The Fall of the Damned*. 288 × 225 cm.; *circa* 1615–20. Alte Pinakothek, Munich.

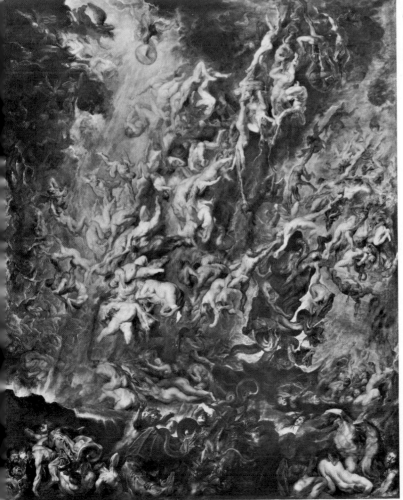

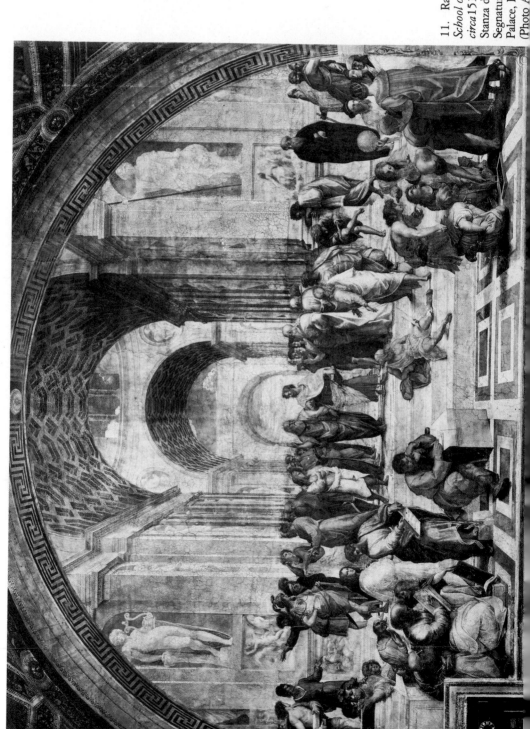

11. Raphael, *The School of Athens*. *circa* 1510–12. Stanza della Segnatura, Vatican Palace, Rome. (Photo Anderson).

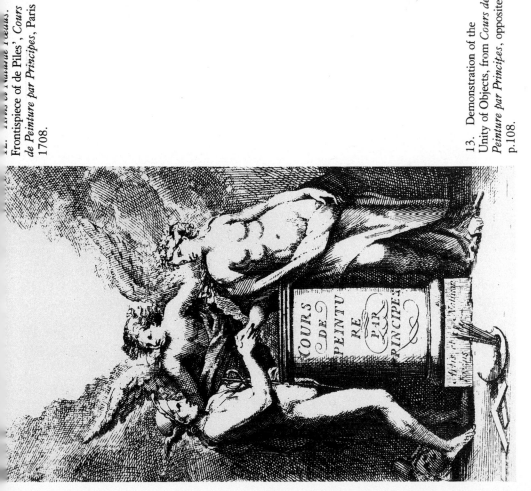

*Demonstration
d'vnite' d'objet*

B

A

Frontispiece of de Piles', *Cours
de Peinture par Principes*, Paris
1708.

13. Demonstration of the
Unity of Objects, from *Cours de
Peinture par Principes*, opposite
p.108.

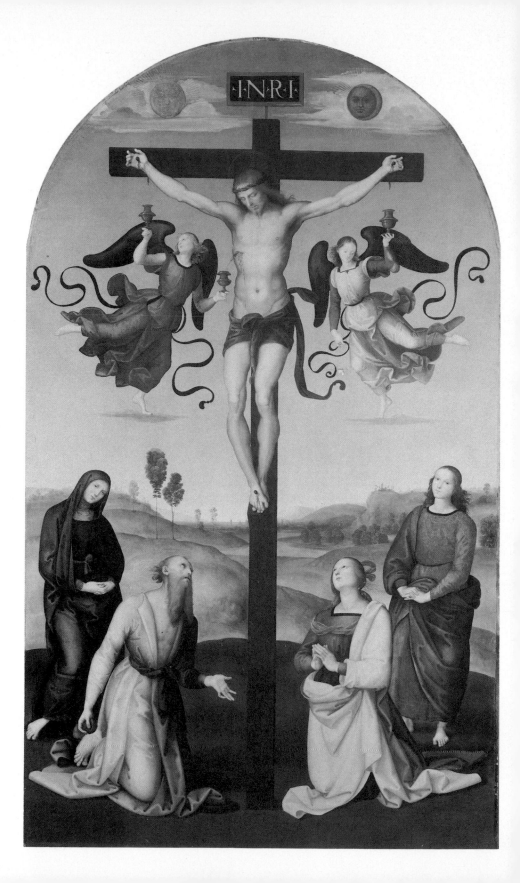

5. Rembrandt, *Portrait of Jan Six*. 112 × 102 cm.; 1654. The Six Foundation, Amsterdam. (Photo nderson).

4. Raphael, *Crucifixion with the Virgin, Mary Magdalene, John and Jerome*. 280 × 165 cm.; *circa* 503. Reproduced by Courtesy of the Trustees, The National Gallery, London.

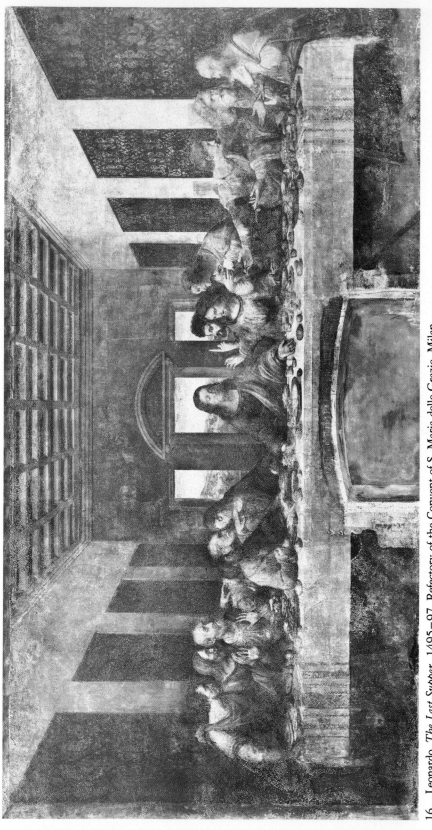

16. Leonardo, *The Last Supper*. 1495–97. Refectory of the Convent of S. Maria delle Grazie, Milan.

17. Rubens, *The Rape of the Sabine Women*. 170 × 236 cm.; *circa* 1635. Reproduced by Courtesy of the Trustees, The National Gallery, London.

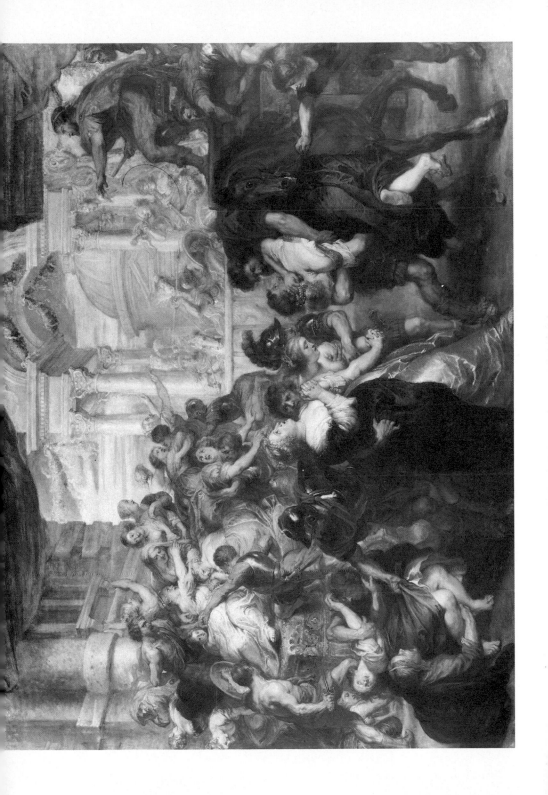

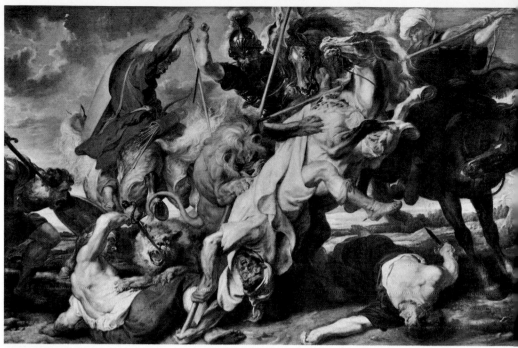

18. Rubens, *The Lionhunt*. 249 × 275.5 cm.; *circa* 1615–20. Alte Pinakothek, Munich.

19. Rubens, *The Battle of the Amazons*. 121 × 165.5 cm.; *circa* 1618. Alte Pinakothek, Munich.

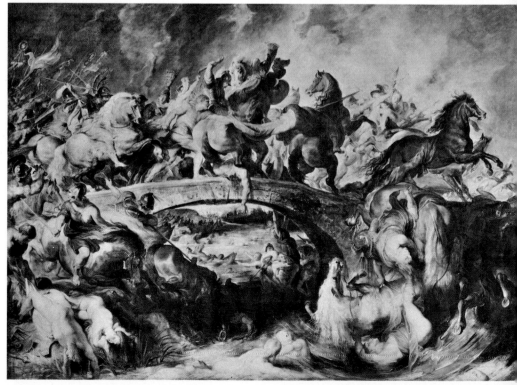

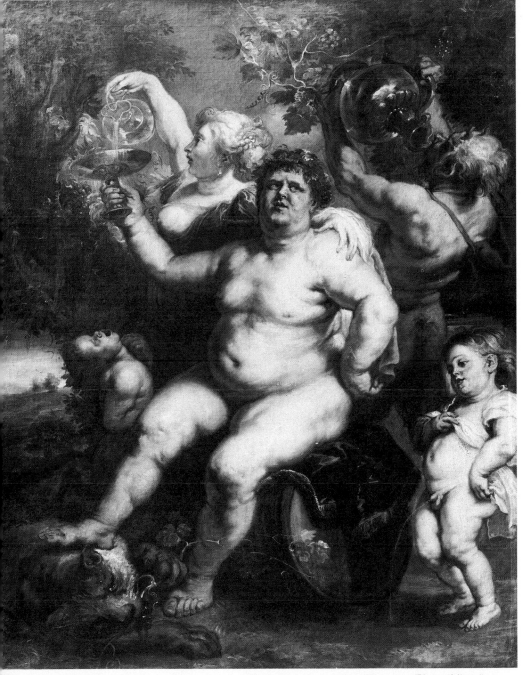

20. Rubens, *Bacchus*. 152 × 118 cm.; *circa* 1640. Galleria degli Uffizi, Florence. (Photo Alinari).

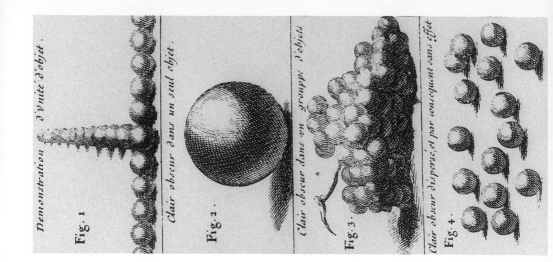

Demonstration d'unité d'objet.

Fig. 1

Clair obscur dans un seul objet.

Fig. 2.

Clair obscur dans un groupe d'objets

Fig. 3.

Clair obscur dispersé, et par conséquent sans effet

Fig. 4.

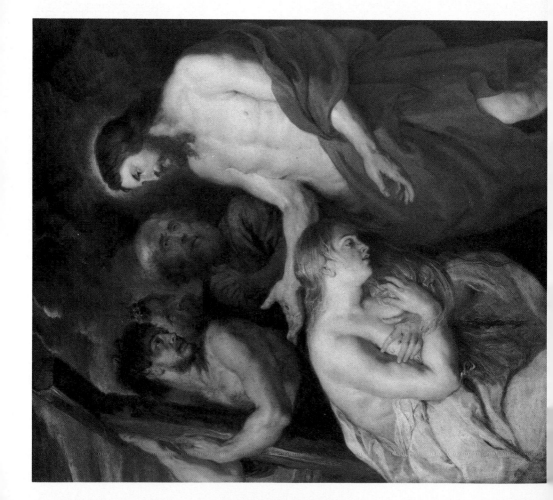

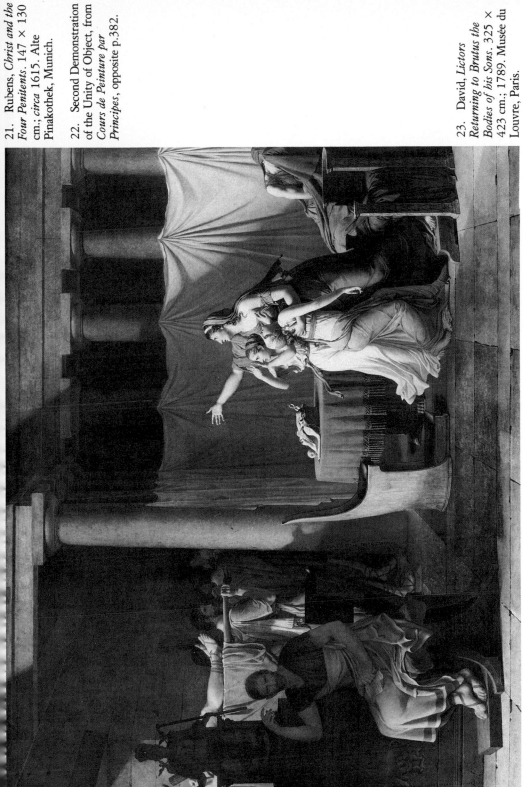

21. Rubens, *Christ and the Four Penitents*. 147 × 130 cm; *circa* 1615. Alte Pinakothek, Munich.

22. Second Demonstration of the Unity of Object, from *Cours de Peinture par Principes*, opposite p.382.

23. David, *Lictors Returning to Brutus the Bodies of his Sons*. 325 × 423 cm.; 1789. Musée du Louvre, Paris.

24. Boucher, *The Rising of the Sun*. 324 × 264 cm.; 1753. Reproduced by permission of the Trustees, The Wallace Collection, London.

(Les facultés de l'ame ne sont occupées dans un même moment que d'une seule chose pour la bien faire, & les organes du corps ne peuvent bien jouir dans un même tems que d'un seul objet . . . Ainsi, comme dans un Tableau il doit y avoir unité de sujet pour les yeux de l'esprit, il doit pareillement y avoir unité d'objet pour les yeux du corps.)[14]

* * * * *

De Piles is looking for an order or structure in the functioning of our natural vision to which the arrangement of figures and forms in a composition could be made to correspond. On the basis of this we could establish rules or *principes* for the art of pictorial composition; and these would be as firm and solid as those of the ordering of subject-matter which Félibien had based on the logical structure of our reason and understanding. And it would, furthermore, invalidate Poussin's distinction between a natural way of seeing and attentive observation: if our natural vision was susceptible of an order of its own which could be used to attract and guide our attention, there would no longer be any justification for the artist to stay aloof from his picture's sensuous effects and to rely solely on our intellectual curiosity. To put it more pointedly in rhetorical terms: if painting can *persuade* by its own controlled and 'principled' means there is no need for it to try and *convince* by relying on activities or faculties of the spectator which may be appropriate for other arts, but which are extrinsic or marginal to the art of painting.

De Piles' proof of the unity of object in nature, however, is not without its problems. Modern writers would argue that the 'visual field' is not the result of our natural and normal vision, that to see it requires specific efforts and mental attitudes by the spectator.[15] This, of course, would defeat de Piles' requirement that a painting has to attract and detain a disinterested spectator. Although Gibson claims that the visual field is rather similar to the effect of a painting, even de Piles' fellow-academicians, who as painters may have been used to the kind of vision he is suggesting as a model for pictorial unity, were apparently not entirely happy with it. De Piles first proposed his theory of composition in an academic lecture delivered in 1704; in the final version of the *Cours de Peinture* he includes a section called *Reponses à quelques objections*.[16]

The main objection seems to have been based upon de Piles' assumption that the unity of object was the result of our natural vision, that our eye, in the course of its normal operation, would establish unity among its objects. If that was true, one might argue, then there was no need to 'artificially' establish unity in the composition:

[14] *CdP*, pp.375/376; transl. p.227; from the fourth proof of the necessity of *clair-obscur*. Teyssèdre has pointed out that the notion of the satisfaction of our senses and faculties is derived from Aristotle, *Nicom. Ethics*, 1153 b 16.
[15] Cf. Gibson himself: 'The visual field, I think, is simply the pictorial mode of visual perception, and it depends in the last analysis not on conditions of stimulation but on conditions of attitude. The visual field is the product of the chronic habit of civilized men of seeing the world as a picture . . . So far from being the basis, it is a kind of alternative to ordinary perception'. (J.J. Gibson, 'The Visual Field and the Visual World', *Psychological Review*, LIX, 1952, pp.148–151; quoted by Gombrich, *Art and Illusion*, p.277).
[16] Cf. Teyssèdre, *Roger de Piles*, p.650.

Because 'tis not necessary to confine the eye; since in any part of the picture, to which it is carried, it will naturally fix itself, and thereby make an unity of object, without the aid of the principles of art.

(Par la raison qu'il n'est pas necessaire de déterminer l'œil, puisqu'en quelque endroit du Tableau qu'il se porte, il se déterminera naturellement lui-même, & fera l'unité d'objet, sans qu'il soit autrement besoin d'avoir recours aux principes de l'Art.)[17]

De Piles' reply to this objection is somewhat disappointing. He produces two arguments unrelated to each other, both of which seem to discard his initial assumption that the unity of object was a result of our natural vision. The first argument comes rather as a surprise; having tried throughout the whole treatise to establish the principles of the art of painting on the basis of its definition as a visual art, de Piles now resorts to the *convenance*, the appropriateness of subject-matter (though he calls it, somewhat misleadingly, *vraisemblance*) to justify his rules for compositional unity:

'Tis not proper to leave the eye at liberty to gaze at random; because if it should happen to be detained on any side of the picture, this will frustrate the painter's intention, who, according to the best approved probability, must needs have placed his chief objects in the middle, and the by-objects towards the sides of the picture; since upon such disposition often depends the knowledge of the whole thought of the picture.

(Il n'est pas à propos de laisser à l'œil la liberté de vacquer avec incertitude, parce que s'arrêtant au hazard sur l'un des côtés du Tableau, il agiroit contre l'intention du Peintre, qui aroit placé, selon la vraisemblance la plus approuvée, ses objets les plus essentiels dans le milieu, & ceux qui ne seroient qu'accessoires dans les côtés: car il arrive souvent que de cet ordre dépend toute l'intelligence de sa pensée.)[18]

Félibien and most of the traditional academicians would have been delighted with this kind of argument; it would re-establish the supremacy of subject-matter over visual order. Yet de Piles' second argument is so much more in line with the rest of his theory that I suggest we consider the first one mainly as a tactical move, as a gesture of reconciliation toward his traditional opponents: although they would not accept de Piles' main line of argument, they might be prepared to accept the final result if it could be shown to be in agreement with their own ideas.

De Piles' second argument is concerned solely with the pleasure and satisfaction of the visual sense. The unity of object is now no longer discussed as a natural phenomenon only; de Piles, yet again, distinguishes between Nature and Art, and although the unity of an object can be found or established in natural things, this will not be sufficient for the pleasure and satisfaction of our eyes unless it is complemented or supported by an artificial unity:

[17] *CdP*, p.122; transl. p.75.
[18] *CdP*, pp.122/123; transl. p.76.

The second answer is, that, with respect to the senses, all objects of pleasure require not only the agreeableness they have received from nature, but also the help of art, to make their effects more lively.

(La seconde chose que l'on répond, c'est que dans les sens tous les objets qui regardent les plaisirs, ne demandent pas seulement les agrémens qu'ils ont reçûs de la Nature; ils exigent encore les secours que l'Art est capable de leur donner pour rendre leurs effets plus sensibles.)[19]

The kind of unity de Piles is looking for in a painting does not have to be completely identical with the 'visual-field'-effect of what he described as natural *unité d'objet*. This is more a general model than an object of exact imitation. The actual advice de Piles gives on compositional unity is rather more practical than theoretical. He draws the painter's attention to the convex mirror: 'Which improves upon nature as to the unity of the object in vision'. (Lequel encherit sur la Nature pour l'unité d'objet dans la vision.)[20] It brings out more clearly the objects in its centre while, at the same time, it reduces the visual impact and importance of peripheral objects. A second possible model for pictorial unity is provided by the *grappe de raisin*, the grouping together of objects in a way similar to a bunch of grapes:

This was Titian's great rule, and ought still to be the rule of those who would observe in their paintings that unity of object, which with skilful colouring constitutes all the harmony of the art.

(Qui étoit la grande regle du Titien, & qui doit l'être encore aujourd'hui pour ceux qui voudront observer dans leur Tableau, cette unité d'objet qui avec les couleurs bien entendue, en fait toute l'harmonie.)[21]

De Piles does not want to give any more specific rules; the final result must not appear to be arranged; and bearing in mind the overall need for unity, the painter must use his imagination in composing his works.

There are, however, two essential requirements which a composition has to fulfil in order to achieve unity. First of all, there has to be one clearly defined and immediately recognizable centre of vision, and secondly, the remaining objects have to be arranged in such a way that they will be seen as peripheral to the centre, that is, as belonging to the same whole of which it is the centre, while at the same time being visually subordinate to it.

The best way of achieving this effect, which the *grappe de raisin* shares with the convex mirror, is a generally circular overall composition. This would provide not only an immediate sense of centre and periphery, but it would also, by

[19] *CdP*, p.123: transl. p.76.
[20] *CdP*, p.109; transl. p.67.
[21] *CdP*, p.382: transl. p.231. It seems that Dufresnoy was the first to project this device upon Titian:

Unde nec immeritâ fertur Titianus ubique
Lucis & Umbrarum Normam appellasse Racemum.

(*De Arte Graphica*, verses 328–9)

avoiding uncomfortable angles, correspond as closely as possible to the structure of vision, that is of the eye.[22]

By corresponding to the structure of our eye a circular composition with a strongly emphasized centre would produce exactly that effect which is the cause of the satisfaction and pleasure of our sense: our eyes could fulfil their function with a degree of both ease and perfection which they would not normally experience in their perception of the real world around us. Art, once again, would surpass Nature.

2. *Focal Illusion and Peripheral Harmony*

Behind the notion of a centralized circular composition is, of course, still the paradigm case of visual unity, the unity of object in nature, or, as modern scientists would call it, the phenomenon of the visual field. To attend to a circular pictorial composition means to attend to forms and their relationships on a two-dimensional plane.

We come back, here, to the point previously made about the apparent dichotomy between visual order and visual illusion. The visual field may be a useful instrument for achieving an overall and comprehensive order and unity of vision, but the visual attitude required to produce this experience would seem to destroy any chances of achieving pictorial illusion. The mental and visual procedure of establishing a visual field is directly opposed to the mental and visual procedure required to see a picture as a representation of a three-dimensional world. In the first case we reduce our normal three-dimensional world to the appearance of a flat two-dimensional plane, in the second case we project figures and objects, which are really only patches of colour on a two-dimensional plane, into space so as to make them appear to be part of a three-dimensional pictorial world.

We have seen that the dichotomy between illusion and attraction determined de Piles' distinction between natural and artificial parts of painting, between an *ordre naturel* and an *ordre artificiel* of representation. The artificial elements were unfailingly those which belong to the picture as a whole, like the sympathy of colours, the harmony of *clair-obscur* and *coloris*, general subordination, etc. It would seem that all these notions apply to the visual field, while de Piles' constant insistence on illusion would relate to the opposite visual attitude, the projection of all elements into a spatially coherent pictorial world.

The initial dichotomy of illusion and attraction can thus be reformulated in terms of visual perception. By insisting on both, de Piles seems to ask us to perform two directly opposed visual activities at the same time: in order to achieve

[22] See already *Conversations*, pp.233/234: 'Or de tous les objets qui peuvent tomber sous le sens de la veuë, il n'y en a point qui luy soit plus agreable que celuy qui est circulaire... Et pourquoy de toutes les figures... la circulaire est-elle plus amie des yeux? C'est qu'elle leur fait moins de peine à regarder... les autres figures ont des angles, & les angles attirent la veuë & la separent en autant de rayons visuëls: Les yeux ne souffrent donc aucune division, & sont tous entiers à un simple & seul objet quand leur objet est en rond. Ainsi puisque de toutes les figures la plus parfaite & la plus agreable est la circulaire; la disposition de quantité d'objets la plus parfaite & la plus agreable sera celle qui approchera davantage de cette figure...'

illusion we have to project painted objects into a three-dimensional pictorial world, in order to see the visual harmony and unity of the *Tout-ensemble* we have to keep the objects in a two-dimensional, planimetric relationship to each other.

Modern psychologists of vision tell us that it is impossible to see a picture simultaneously as a surface pattern and as a world of space and objects. We either see a meaningless patchwork of colours or we perceive objects in space. We cannot have it both ways.[23]

In what is perhaps the most extreme case of visual illusion, our own image in a mirror, we find it surprisingly hard if not impossible to see any surface pattern. But is the illusion of the mirror-image really comparable to the illusion created by paintings? Does the alternative between our seeing flat arrangements of patches or dots, on the one hand, and our perceiving objects in space, on the other, really provide an adequate description of what happens in our visual appreciation of pictures?

The traditional distinction between sensation (the reception of light and colours by our eye) and perception (the recognition of objects), which was so dear to scientists and artists in the eighteenth and nineteenth centuries, may have forced upon us a theoretical alternative too radical to be of much use in explaining our visual experience of paintings. We have come to accept that we cannot see sensations, but only objects in a visual world; that it is, as E.H. Gombrich puts it, even harder to see the visible world as a two-dimensional field than it is to see one's own image on the surface of the mirror.[24] This does not mean, of course, that there was never a problem for the painter to divert the spectator's attention away from the picture-plane and toward a three-dimensional world of illusion behind it. It simply means that if the painter succeeded, the spectator switched from the perception of one three-dimensional world, ie. the real one in which he saw the picture as a flat object covered with paint and hanging on a wall, to the perception of another three-dimensional world, created by visual illusion and projection 'inside' the picture.

* * * * *

To look at the history of European painting from the fourteenth to the nineteenth century as a period of continuous improvement of the means of visual illusion seems to be a very attractive idea. The artists' attempts to find and develop more and more sophisticated devices to make us forget the presence of a rectangular piece of canvas or wood in front of us, and to lead us into an imaginary world behind the picture-plane could then be considered as one of the driving-forces behind many of the stylistic changes painting has undergone over the last five-hundred years.

I suggest that there is at least one break in this development (and there might easily have been more); and this break I see reflected in de Piles' theory of vision

[23] See Gombrich, *Art and Illusion*, in particular pp.5 and 198.
[24] Gombrich, *Art and Illusion*, p.278. For a new theory of the relation between sensations and perceptions cf. J.J. Gibson, *The Senses Considered as Perceptual Systems*, London 1968, in particular pp.237ff.

and composition. It may even indicate that we have to revise the old assumption that we have only one alternative: to see either an illusionistic three-dimensional world behind the picture-plane, or a patchwork arrangement of lines and colours on its surface.

We may justifiably assume that for early Renaissance artists the picture-plane appeared as an obstacle: its obvious existence had to be overcome by a multitude of well organized and related cues which would lead us to an illusion of a coherent three-dimensional world behind it (or, perhaps we should say, through it). The very obviousness of the picture-plane, however, required some sort of two-dimensional ordering and arrangement as well, which could be detrimental to the illusionistic effect of the pictorial world. As a rule, with these kinds of painting, the spectator has to make a complete switch from observing the picture's surface pattern (for example, the triangular forms of Raphael's *Madonnas*) to perceiving a coherent world of objects, figures, and landscapes. We seem to have become accustomed to the switching of our attention as being part of the general convention of looking at pictures; and we are not normally aware of doing it except in those cases where for some reason this switch is difficult to make. Raphael's *Crucifixion* (Plate 14) in the National Gallery in London has always struck me as one of these difficult cases;[25] the swirling drapery of the angels' garments is hard to read as anything else but a beautifully designed surface pattern which enforces the two-dimensional symmetry of the composition and prevents us from projecting the angels into an appropriate distance where they are supposed to accompany the crucified (and easily projectable) Christ. As a result we not only experience a strong feeling of unease, we actually remain consciously caught in the ambiguity of our perception of the picture.

The switch from one visual approach to another is often facilitated by the central perspective construction, which can provide in one point a centre for any surface pattern and a focus for spatial projection. Leonardo's *Last Supper* (Plate 16) is almost too famous an example to be quoted in this context. This dual function of perspective was still important for de Piles' theory, although in a rather modified way, to which we shall return shortly.[26]

We assume on the whole that seventeenth-century painters like Rubens and Rembrandt could rely far more than earlier artists on the spectator's readiness to project painted objects into an imaginary three-dimensional world. It is difficult to say whether this was the result of a convention of the medium having become a mental habit of the spectator; or whether it was simply that the artists had learned the lesson that we project almost automatically provided there is no contradictory evidence (as there is in Raphael's *Crucifixion*).

Where Renaissance artists had to give (or felt they had to give) an accurate description of every small detail in order to provide a consistent three-dimensional world, Baroque painters could rely on suggestion and the spectator's imagination which would, as de Piles knew, complete what the painter had left unfinished and undefined.

To rely on the spectator's imagination and to leave certain parts or areas of

[25] National Gallery, London, No. 3943.
[26] See below p.96ff.

one's pictures 'unfinished' must have been a very appealing thought for paint-ers; theorists from de Piles to Reynolds refer to it not just as a measure of proce-dural economy, but as a forceful means of involving the spectator in the process of creating an illusion.[27]

Our imagination, however, does not necessarily work in the same way or toward the same end as our visual perception. One suspects that many suggested or 'unfinished' parts or areas in Baroque painting do not simply wait to be com-pleted by our imagination; by appealing to our imagination for support they could be trying to escape from the rigid alternative of our visual perception. This needs some explanation.

The obvious example one would refer to in this context would be a picture like Rembrandt's portrait of Jan Six (Plate 15), where the face of the sitter is shown in every detail and painted according to high standards of finish, while everything else is left in a relatively sketchy state.[28] We would take the sketchy state of those parts as an indication that our imagination is supposed to make up for it, to complete what the painter thought of as being only of secondary impor-tance. Yet portraits are a special and rather limited case; there is another aspect to the Baroque preference for 'unfinished' parts of a painting. The spectator's readiness to transform everything he sees into a spatial, three-dimensional form was not only an advantage for painters, enabling them to make economies of procedure in their representation of the world. It had, at the same time, some dangerous implications when compared with the stricter standards of Renais-sance art: it could be seen as threatening the sense of order and coherence of pic-torial representation. The actual picture-plane, as the place where symmetry, balance, and harmony could be established (and had been established in the Renaissance) had become more and more obsolete. What was required, in the face of the spectator's almost unlimited and by now somewhat facile power of

[27] Cf. Reynolds, *Eighth Discourse*: 'It is true sketches, or such drawings as painters usually make for their works, give this pleasure of the imagination to a high degree. From a slight undeter-mined drawing, where the ideas of the composition and character are, as I may say, only just touched upon, the imagination supplies more than the painter himself, probably, could pro-duce'. Yet in finished paintings Reynolds finds this unacceptable: the argument is not one about the degree to which the spectator's power of visual projection would allow the artist to economize: 'We cannot recommend an undetermined manner, or vague ideas of any kind, in a complete and finished picture. This notion therefore, of leaving anything to the imagination, opposes a very fixed and indispensable rule in our art, – that everything shall be carefully and distinctly expressed ... This is what with us is called Science and Learning; which must not be sacrificed and given up for uncertain and doubtful beauty ... '.

Reynolds' argument is in the end a moral one: the task of the artist is not simply to gratify our imagination, to provide for the pleasure we derive from its free play; but to control and direct our imagination toward a vision of ideal beauty. De Piles would certainly agree that the painting has to keep its hold over our imagination: the different degrees of finish between a powerfully illusionistic centre and increasingly vague peripheral areas are meant to ensure the artist's control over our imagination rather than to allow it to follow its own whims. It seems almost pedantic to remind the reader once again of the difference between Reynolds' theories and his own practical work as a painter – the point has been made so many times that its only interest in this context derives from the fact that Reynolds' practice is much more in line with de Piles', than with his own, advice.

[28] Rembrandt, *Portrait of Jan Six*, 1654, Amsterdam, Six Collection. I take this example from Gombrich, *Art and Illusion*, pp.280/281 where it is used to illustrate artistic economy.

projection, was something by which it could be checked, limited and directed. This applied, in particular, to larger and more complex compositions.

* * * * *

De Piles' *Tout-ensemble* and its overall effect has (and is clearly intended to have) a limiting and directing influence on our projective vision; it comprises both objects depicted with a high degree of definition and clarity, and areas with a relatively low degree of finish. Objects of the first kind would immediately be projected into a three-dimensional context; yet undefined areas can be interpreted in two ways: they may either require a stronger involvement of the spectator, a more imaginative effort to set up a complete world of illusion, or they may indicate that further detailed investigation and projection is not required or even not profitable.

We know that de Piles' theories were inspired largely by the paintings of Rubens (and, to a lesser extent, Titian and Rembrandt). He described and analyzed in great detail a whole collection of Rubens' work, then in the possession of the Duc de Richelieu,[29] and here we find the perfect visual models of his theories. The *Rape of the Sabine Women* (Plate 17), for example, now in the National Gallery, London, can be used to exemplify the unity of object and the overall harmony brought about by the artificial use of colour and light.

The *centre de la vision* is clearly indicated by the brightest light in the whole picture, the bare white bosom of the Sabine lady in the very centre of the foreground. It is set beside the darkest part of the composition, her deep blue coat. The very first impression of the foreground figures is one of volume and plasticity, of clearly defined and strongly emphasized local colours and of forceful contrasts of light and shade.

The figures in the middle-ground, of which the group of Sabine girls on the left forms a perfect *grappe de raisin*, are treated in a rather different way. Their colours and shades are subdued, they seem to be absorbed by a rather subtle opposition of light and shade which dominates the whole group and endows it with an almost atmospheric quality; this is clearly different in effect from the forceful sense of physical presence which prevails in the foreground.

The background is even less clearly defined; colours are even more absorbed by light. The level of differentiation between individual colours is so low that we could almost speak of a *grisaille*.

To reduce the intensity of colours would normally be taken as a means of aerial perspective, indicating a considerable distance between the spectator and his objects; and it may look as if that is what Rubens was trying to do. Yet the effect in his picture is quite different: the distance between the foreground figures, those of the middle-ground and those of the background – indicated by their respective sizes – in no way justifies such a striking decrease in clarity, colour, and shade. The size-distance relationship provides a stronger clue for

[29] Cf. *Dissertation*, pp.77–134; see B. Teyssèdre, 'Une collection française du Rubens au XVIIe siècle: Le Cabinet du Duc de Richelieu décrit par Roger de Piles (1676–1681)', *Gazette des Beaux-Arts*, 1963, II, pp.241–299.

the projection of depth than the loss of clarity and finish.[30] By exaggerating 'artificially' the effects of aerial perspective, Rubens achieves almost exactly the opposite effect: being too large for the exaggerated loss of colour, the figures do not disappear into the distance but remain very close (although somewhat unreal) to the main scene in the foreground. What looks very much like a traditional cue to depth in painting is here, in fact, used as a means of reducing it, of keeping the background in close contact with the foreground.

We see the figures in Rubens' picture in a spatial context even if this context cannot be very clearly defined in terms of our normal vision. While we are focusing attention on the *centre de la vision*, the voluminous Sabine lady and her group in the foreground, both middle and background play their part within our overall field of vision; they serve, as de Piles puts it, *de fond à les trois groupes principaux*.[31] The relatively large area of the background, in its overall brightness without any strong contrasts of light and shade, serves as a visual contrast to the similarly large area of shadow and deep colours in the foreground. Yet even this visual comparison of large areas of the picture never challenges the pride of place of the *centre de la vision* : the large area of the background, dominated by the white marble of its architecture, only helps to emphasize visually the even whiter flesh of the Sabine woman.

* * * * *

To make visual comparisons like this does not mean that we have to switch from perceiving a three-dimensional world to looking at flat surface patterns. I share Gombrich's doubts about our ability visually to reduce the real three-dimensional world to a two-dimensional patchwork of colours and lines, and I suppose that Rubens' voluminous lady would withstand any such attempts without great difficulties. If the centre of vision presents us with such a strikingly successful illusion of three-dimensionality we may, for the moment, take the rest of the picture for granted. That does not mean that we see the rest of the picture as a flat surface; while we fix our gaze on the powerfully illusionistic centre of the composition we are perfectly aware of other objects, figures, etc. within our field of vision, but we leave them, for the moment, in what we may call a state of suspended projection where we do not yet care about their actual location within the pictorial world. Rather than activating our imagination, or, indeed, our projective mechanism those peripheral objects and areas should, in de Piles' terms, provide 'repose' for the eye while it is concentrating on the centre.[32] Being neither flat nor yet integrated into a coherently projected world

[30] On size-distance relationship, see Gombrich, *Art and Illusion*, pp.204ff.

[31] *Conversations*, p.122.

[32] De Piles repeatedly uses the terms *repos* or *fond* for areas peripheral to the centre; e.g. *Conversations*, p.230: 'Dans le Ravissement des Sabines [by Rubens], le ciel, l'architecture & les soldats que l'on voit sur le derrière, font un fond clair pour l'amphiteatre qui en fait un autre, avec toutes les figures dont il est rempli pour d'autres objets plus avancez: Dans le Jugement de Paris les satyres, la discorde qui est dans les nuées & le Païsage, ne composent ensemble qu'un fond d'un brun doux, pour soustenir & pour faire paroistre l'esclat du tein des trois Déesses'. This would seem to suggest that the relationship between central figures and peripheral areas was to be seen as one of figure and ground; and to some extent this is certainly

these peripheral objects of our vision are nevertheless part of the composition and its overall effect: if the painter has followed de Piles' advice about composition and unity, we should find that our peripheral field of vision is ordered, balanced and harmonized in terms of colour relationships, *clair-obscur*, and overall effect.

Alois Riegl, the Austrian art-historian, once described as a specific characteristic of Baroque paintings that they displayed what he called *optische Ebene*.[33] This is not to be confused with the picture-plane or surface; it is more like Gibsons' visual field – an arrangement not of meaningless patches of colour on a surface, but of objects deprived of the third dimension. Like Gibsons' visual field, Riegl's *optische Ebene* cannot be firmly located at any specific distance, since the whole process of seeing it depends on the spectator suspending the visual mechanism of projection, of size-distance constancies, which in normal vision would guarantee the stability and continuity of our visual world.

The precise meaning of Riegl's *optische Ebene* has been obscured in German art-historical writing by its indiscriminate application to paintings of almost any other period; to produce a visual-field effect of an illusionistic painting requires much less of an effort and can be done much more successfully than to deprive our real world around us of its three-dimensionality. Yet what Riegl meant when he described the *optische Ebene* as a typical feature of Baroque painting was not that we *could* see it if we wanted to, but that it presented itself to us without any effort on our side; the spectator, while looking at a convincing image of a three-dimensional world, is made aware, by the very arrangement of the pictorial objects themselves within his overall field of vision, of relationships between the different parts, areas, or objects (Riegl called these relationships *optical* as opposed to the *haptical* qualities indicating volume and depth).

De Piles' unity of object is similar to Riegls' *optische Ebene* to the extent that they both agree that our awareness of a picture's overall harmony and balance of parts must not be the result of a deliberate effort on our side, but of the pictorial objects simply falling into their place within our field of vision. Yet they differ insofar as de Piles insists on just those 'haptic' elements which Riegl seems to dismiss, in the *centre de la vision*. De Piles is not just asking for an attractive overall balance and harmony of colours and lights, but also for a striking and forceful illusion of life as the focal point for our attention.

In this respect he is much closer to Jakob Burckhardt's assessment of Rubens' art. Burckhardt was struck by the painter's 'combination of dramatic movement with a mysterious visual restfulness':

Only in Rubens do we find the richest symmetrical manipulation of a variety of elements of equal values, of equivalents, in the picture, combined with a most

true. Yet the central figures are not to be seen as separated or detached from their ground: if there is unity of object in the picture, figures and ground would be part of the same continuous spatial composition. The spatial continuity, though, would not be that of our visual world, of our normal spatial projection; it would be an 'artificial' continuity created by the artist in his concave or convex circular composition (see below n.37).

33 On Riegl's concept of *optische Ebene*, cf. W. Schöne, *Über das Licht in der Malerei*, Berlin 1954, pp.247 and 432.

animated, or even agitated incident to produce an effect which triumphantly captivates both eye and mind.[34]

Such a combination of order and life, of unity and movement in a painting could result, according to Burckhardt, neither from a 'vast imagination, even in full inspiration, (which) would in itself have produced nothing more than a worthless profusion of detail', nor from a 'patient, conscious building up of the picture by equivalents'.[35]

The origin of this combination is to be found, and here again Burckhardt agrees with de Piles, in some sort of initial vision:

We like to think that great masters had their moments of vision when future works appeared before them complete. This vision would appear to have been of a peculiar kind in Rubens. He saw at one and the same time a restful symmetrical arrangement of the masses in space and vehement spiritual and physical motion; he saw light and life radiating mainly from the centre, and his triumphant colour harmonies, his near and far distances and scheme of light and shade rose before him, as they could not but rise, till all was matured to the harmony and power we have spoken of.[36]

For Burckhardt as for de Piles the unity of Rubens' compositions constituted itself not in a flat visual field or *optische Ebene*, but in an overall form or figure. Burckhardt detects 'mathematical figures' like hexagons or pyramids in the vehement motion of his pictures (Plate 18), while de Piles suggests the circle as the ideal overall form of pictorial arrangement. As his reference to both the convex mirror and the *grappe de raisin* make sufficiently clear, this circle, which in its entirety would be the unified object of our vision, was not to be flat but in itself suggestive of depth and volume, it was to be either convex or concave (Plates 19 and 20).[37]

In one important point, however, de Piles and Burckhardt differ. Burckhardt extends his notion of equivalents from purely visual values to 'ideal' ones, in the sense that one particularly important figure, like Christ in the Munich

[34] J. Burckhardt, *Recollections of Rubens*, London 1950, p.65. The similarities between Burckhardt's and de Piles' approach to Rubens may not be entirely coincidental. One of Burckhardt's main sources was E. Fromentin, *Les Maîtres d'Autrefois*, Paris 1876. Fromentin's descriptions of Rubens' works are, if not directly influenced by de Piles, certainly affected by a critical tradition which has its roots in de Piles. It is worth noting that Fromentin was trained as a painter in those years of the nineteenth century which saw, according to W. Drost, a renewed interest in Baroque art and in the writings of de Piles (W.W.-R. Drost, 'Baudelaire et le Néo-Baroque', *Gazette des Beaux-Arts*, 1950, 37, II, pp.115–136).

[35] *Recollections*, p.63.

[36] *Recollections*, pp.63/64.

[37] It seems to be the spatial coherence and continuity of such a concave or convex circular composition which would bind background and centre (ground and figures) together and in doing so would replace the coherence of our normal visual projection by an artificial one of general 'roundness'. Even compositions which are not strictly circular can achieve this kind of continuity; Rubens, in the *Massacre of the Innocents* (which is not circular), 'donne la rondeur à son tout-ensemble par le noir qu'il a mis au groupe du milieu, qui par la force & la vivacité de ses couleurs sort de la toile & maîtrise les groupes de côtez, les constraint, pour ainsi dire, de se retirer, & de former avec luy la rondeur dont je vous parle' (*Conversations*, p.236).

picture of the *Four Great Penitents* (Plate 21) can balance a whole group of less significant figures; 'Moral and spiritual importance can balance moral and spiritual subordination'.[38] Here Burckhardt goes far beyond de Piles' purely visual theory of composition; the appreciation of paintings for him is a long process of becoming aware of the mutual interaction of subject-matter and visual order, of understanding and effect.

For de Piles, however, the definite success or failure of a picture is decided in one single moment – the moment when it either fails or succeeds to attract its spectator. And although this may reduce somewhat the conviction his theory might otherwise carry, it gives it its final coherence.

3. L'Effet au Premier Coup d'Œil

The effect of the *Tout-ensemble*, with its overall harmony and contrast, its unity centred around a strongly illusionistic focus, is meant to strike us at the very first moment, *au premier coup d'œil*. Without this immediate first effect there would be neither illusion nor attraction, and without one of these, so de Piles assumes, the spectator would not even care to look at the painting.

Most of us would probably feel disinclined to accept this basic assumption even if we were prepared to respect it as a valuable argument in de Piles' attempt to liberate the art of painting from the discursive treatment it received from the academy. Yet there are also two traditional arguments in favour of the immediacy and spontaneity of vision which we have to take into account: they fit in so neatly with de Piles' two requirements of illusion and attraction that it is rather safe to assume that in some ways they influenced the development of his theory. The first argument de Piles would have found in the traditional theory of perspective, the second one in sixteenth and seventeenth-century *paragone* literature, particularly in discussions about the harmonious effects of poetry, painting, and music respectively.

We shall look at traditional perspective theory first, since its links with de Piles' ideas about pictorial composition are fairly obvious. His claim that disposition should not depend on qualities of subject-matter but on the way the picture is to be taken in by our eyes implies that the same basic laws of optics apply to compositions a to perspective. There are even clues indicating that in the early stages of his critical career de Piles thought of his notion of unity not so much in terms of composition and harmonious order as in terms of an objectively correct perspective construction. This, at least, is how Abraham Bosse, one of the last great defenders of geometrically correct perspective construction, understood de Piles' reference to the convex mirror in his comments on Dufresnoy's *De Arte Graphica*; Bosse condemned as completely false and utterly ridiculous the assumption that by imitating the effect of a spherical mirror in a painting one could represent one's objects in the same manner in which our eye would normally see them:

Car ces Messieurs [de Piles and Dufresnoy] vont comme vous scavez, à faire à

[38] *Recollections*, p.63. The picture is in the Alte Pinakothek, No. 329.

tout un Tableau le mesme effet du miroir (c'est à dire spheriquement) ce qui est representer les objets dont il sera composé comme l'œil les voit, qui est une chose absolument fausse et du dernier ridicule à avancer.[39]

Even in the late *Cours de Peinture* de Piles tries at least once to convince his readers that his notion of the unity of object refers to little more than a particular form of perspective. The second illustration of the unity of object (Plate 22) shows not only objects parallel to the picture-plane decreasing in clarity and definition as their distance from the clearly defined *centre de la vision* increases; it also shows objects extending into depth. The accompanying text stresses the similarity between unity of object and perspective:

Both diminish equally in force as they recede from the centre of vision. Their only difference is, that the latter decreases in magnitude, according to the rules of perspective, as they go off from the said centre; and the former, which only extend to the right and left of that centre, grow fainter by distance, without losing their forms or bigness.

(Les uns & les autres objets diminuent également de force en s'éloignant du centre de la vision. Toute la difference qui est entre eux, c'est que les objets qui rentrent diminuent de grandeur en s'éloignant de centre de la vision, selon des regles de la perspective; & que ceux qui s'étendent seulement à droit & à gauche, s'effacent par l'éloignement, sans diminuer de forme ni de grandeur.)[40]

The comparison is a superficial one; in the first case, the objects are losing in force and clarity according to the principles of aerial perspective, that is according to the objectively increasing volume of air between the objects and the spectator and the decreasing sharpness of our vision. In the second case the degree of clarity and definition depends entirely on the subjective fixation of our eyes.

In one important point, however, Abraham Bosse would have agreed with Roger de Piles; and this point concerns what we may call the spatial limits of de Piles' *premier coup d'œil*. That the spectator should be able to take in the whole picture at once was by no means an original idea of de Piles. It is, in fact, better known as a basic tenet of what we have come to call seventeenth-century classicism, the ideal of de Piles' worst opponents inside the academy. Even Poussin himself would have found no fault with this requirement. Commenting on the envisaged decoration of the *Grande Galerie* of the Louvre, he noted with satisfaction, in a letter addressed to Sublet de Noyers, *Surintendant des Batiments*, that the width of the gallery would allow the spectator to see with one glance the painting on its ceiling: 'La largeur de la Gallerie est d'une distance

[39] Cf. Teyssèdre, *Roger de Piles*, p.131. For an account of Bosse, of his attempt to derive a whole theory of painting from the principles of scientific perspective (as formulated by his friend and teacher Desargues), and of his quarrel with the academy, see A. Fontaine, *Academiciens d'Autrefois*, Paris 1914, pp.67–114 (Le Cas d'Abraham Bosse), and C. Goldstein, *The Art Bulletin*, XLVII, 1965, pp.231–256.

[40] *CdP*, p, pp.381/382; transl. pp.230/231. For a comment on this illustration, cf. E.H. Gombrich, *The Sense of Order. A Study in the Psychology of Decorative Art*, Oxford 1979, p.99 and fig. 114.

proportionnée pour voir d'un coup d'œil le Tableau qui doit estre dans le lambris.'[41]

C. Goldstein has pointed out that many of the ideas expressed in this letter have their origin in Italian perspective theory; and that is certainly true of this passage. The single *coup d'œil* had been a basic part of the theoretical definition of perspective at least since Vignola-Danti's *Le due regole della prospettiva prattica* of 1583, which on its very first page defines perspective as: 'Quel prospetto, che ci rappresenta in un'occhiata qual si voglia cosa'.[42]

Abraham Bosse likewise saw the *coup d'œil* as a condition of successful perspectival illusion:

One should take such a reasonable distance between the eye and the object, or the intersection, which is (as I have said) the location of the drawing or picture, that one can easily and with facility embrace or see both the one and the other with a single glance of the eye, without having to move in any way one's head...

(Que l'on doit prendre une distance si raisonnable de l'œil à l'objet, ou section, qui est comme j'ai dit la place du dessin ou tableau, que l'on puisse aisement et facilement embrasser ou voir l'un et l'autre d'une seule œillade, sans être obligé de varier la tête en aucune facon...)[43]

Henri Testelin, secretary and perhaps the most dogmatic member of Le Brun's academy, was equally convinced that perspective depended on the simple *coup d'œil*: [La Perspective] s'apperçoit par la surface exterieure, & que l'on découvre d'un simple coup d'œil... qu'on voit le sujet par un seul endroit d'un seul vûe...[44]

Goldstein was certainly right in pointing to perspective theory as the origin of much of Poussin's letter to de Noyers. It is hard to accept, however, that that should exhaust the meaning of the passage quoted here, or indeed the meaning of the passages from Bosse and Testelin. The *coup d'œil* seems rather to involve a reference to a neo-Aristotelian notion of wholeness and unity, probably of Roman origin. In the first chapter, I have mentioned the theoretical disputes between the 'Baroque' painters and the 'Classicists' in Rome; we do not know very much about them apart from what surfaced in the academic disputes between Pietro da Cortona and Andrea Sacchi in the 1630s.[45] Yet in practical terms the differences between the two groups are most clearly visible in the size and scale of their works. 'Baroque' artists, like Cortona or Lanfranco, indulged in vast illusionistic *quadratura* paintings, while 'Classicists' like Domenichino and Sacchi, preferred to decorate even large areas, like the ceilings of churches,

[41] *Correspondence de Nicolas Poussin*, pp.139ff. See C. Goldstein, 'The Meaning of Poussin's Letter to de Noyers', *The Burlington Magazine*, CVIII, 1966, pp.233–239.

[42] Vignola-Danti, *Le due regole della prospettiva pratica de M. Jacomo Barozzi da Vignola*, Rome 1583.

[43] A. Bosse, *Le Peintre Converty aux precises et universelles regles de son Art*, Paris 1667, p.48.

[44] H. Testelin, *Sentimens de plus habiles peintres sur la pratique de la peinture et sculpture, mis en table de preceptes*, Paris 1696, p.10.

[45] See above chap. I, p.18.

with *quadri riportati*, i.e. with what looked like removable and transportable easel paintings of a size which could easily be taken in *d'un coup d'œil*.

Given the visual evidence provided by Italian *quadratura* painters, and Andrea Pozzo in particular, it seems difficult to argue that the insistence on the single *coup d'œil* was prompted by a desire for perspectival illusion. I would rather see it as expressing a desire for order, for a unified view of the pictorial world.

<p style="text-align:center">*　*　*　*　*</p>

In more recent times R. Arnheim has argued that the 'invention' of central perspective construction was stimulated not so much by a desire for correct pictorial representation of reality, as by a striving 'toward a unification of space... Central perspective recaptures a unity of space, which was lost at the moment when the orthogonals began to run in more than one direction'.[46]

Whether this is an accurate historical explanation is doubtful; the unification of space is one, but not the only, effect of the rather complex development of central perspective. There is little evidence to suggest that it was the cause of, or the driving force behind, this development. Yet behind Arnheim's argument is a very valuable (though probably not quite new) observation, which leads us back to a point raised in the previous section of this chapter.

Italian *Quattrocento* artists were quick to exploit the visual order and unity provided by perspective construction. I have argued above that central perspective can facilitate the switching of our attention from a centrally ordered surface pattern to a spatially coherent pictorial world. We are told that we cannot see both the surface pattern and the pictorial world at the same time and that by focusing on the one we automatically exclude the other from our awareness.[47] Yet this theory of mutual exclusion is not entirely convincing.

Obviously, in the case of most European painting since the *Quattrocento*, the relation between surface and pictorial world is not a symmetrical one. The switch from seeing the surface to perceiving the pictorial world (and this would normally be the first projective activity required of a spectator approaching a painting) seems to be very easy, almost an automatic one. This is probably due to the fact that the surface, even as an ordered, well-arranged pattern of forms, lines, and colours, or of more or less articulate brushstrokes, does not offer us any identifiable 'objects'. As soon as we perceive these, we have already accomplished the switch to the pictorial world. Unless there is contradictory evidence we go ahead almost immediately with resolving the surface pattern into a pictorial world of illusion.[48] Yet this does not necessarily and entirely exclude the surface pattern from our awareness (or, indeed, our visual perception).

Implicit in the theory and practice of the central perspective construction is the analogy between the picture-plane and an open window. This has its limitations,

[46] R. Arnheim, *Art and Visual Perception*, London 1956, pp.275–278.

[47] Gombrich, *Art and Illusion*, fig. 2 and pp.4/5, uses the now famous duck-rabbit drawing as an analogy for the mutual exclusion of surface and pictorial world.

[48] Switching our attention from the duck to the rabbit (and *vice versa*) can be quite a hard task for our powers of concentration. Switching from our perception of the pictorial world to that of the picture's surface can be equally difficult; but not normally the other way round.

too; but it emphasizes one important difference from the 'mutual-exclusion theory'. We may have to exclude from our mind any awareness of the material surface of the picture in order to perceive the pictorial world 'behind' it; but I believe we are right in saying that we see the pictorial world *through* the picture-plane.

By this I do not simply mean to refer to the ideal of central perspective, that the picture-plane, being transformed into an open window, would simply disappear. I mean that we seem to carry certain features or qualities of the surface into our projection of the pictorial world. This may in part simply be the result of the fact that perspectival illusion is hard, if not impossible, to achieve for bifocal vision. Unless we are dealing with a peep-hole show, the overall size and the format of the plane are determining (and limiting) parts of our visual experience of the pictorial world behind them; and if we are dealing with a typical Renaissance central perspective construction it is difficult not to relate the focal point of the orthogonals, as the pictorial centre, to the overall format of the picture. This seems to me to be the case not despite the fact that the focal point is meant to indicate infinite distance, but exactly because of it: infinite distance is beyond our vision and whatever our powers of projection, we still see lines converging or actually meeting each other which we know are not supposed to meet.

As a result, orthogonals, within the context of spatial projection, seem to retain some of their surface quality as diagonals; the focal point, where they converge and meet, establishes itself as a visual centre. The very means of pictorial illusion make themselves felt as elements of visual order, as compositional devices which hold background and picture-plane together. Whether we look at Masaccio's *Trinity* fresco, or Piero's *Baptism*, or the work I referred to earlier, Leonardo's *Last Supper*, we find artists actively and consciously employing perspectival means for compositional ends.

It seems to me that it was this sense of order and compositional structure which seventeenth-century 'classicists' favoured in their perspective *d'un coup d'œil*. The overall format, the diagonals of the perspective, the central focal point provided means of visual concentration and unification which were clearly absent from extensive *quadrattura* paintings or other vast Baroque compositions.

This continuity between perspective and composition was even used for theoretical definitions of pictorial unity; Henri Testelin, the most loyal supporter of Lebrun and opponent of de Piles, felt obliged, in his *Sentimens*, to record another account of the three unities of painting:

To know what happens at one and the same time; what the eye can discover at one glance; and what can be represented within the space of a picture, where the expression should be concentrated on the place occupied by the hero of the story in the same way in which perspective relates everything to one point.

(À scavoir ce qui arrive en un seul temps; ce que la vûe peut découvrir d'une seule œillade; & ce qui se peut representer dans l'espace d'un Tableau, où l'idée de l'expression se doit rassembler à l'endroit du Heros du sujet, comme la Perspective assujettit tout à un seul point.)[49]

49 Testelin, *Sentimens*, p.19.

The basic concerns of de Piles' theory of the unity of object are obviously closely related to this perspectival tradition: they aim both at illusion while, at the same time, using their means of achieving illusion for the purposes of visual order and unity. We shall see in the final chapter how this close interplay between illusion and composition became disrupted and its two sides separated from each other when, in the eighteenth century, compositional lines, *la ligne pyramidale* or *les formes triangulaires*, were charged with those compositional tasks which had previously been the domain of orthogonals and perspectival arrangements, without at the same time acting as means of illusion and projection.[50]

Of the means of traditional perspective, however, de Piles adopts only one, and that only in a modified form: that of providing a central focus for our attention (that this is also the main element on which Testelin based his comparison between composition and perspective is probably no coincidence). Despite some conventional statements to the contrary he shares what seems to have been a fairly widely held view by the end of the seventeenth century, that geometrically correct perspective was not necessary to achieve pictorial illusion.[51] Moreover, perspective was generally considered to belong to the department of *dessin*. The spatial/compositional effects of the orthogonals in perspective should be achieved according to his theory by different gradients of clarity and definition, by the gradation and juxtaposition of colours, and by the contrasts and oppositions of the *clair-obscur*. What we carry through, from the surface-arrangement, into our projection of the pictorial world, are not the directional forces of orthogonals etc, but the harmonious ordering of our peripheral vision.

* * * * *

This leads me to the second tradition which seems to have affected de Piles' notion of the *coup d'œil*. If traditional perspective theory can be seen as providing a model for the spatial limitations and for the centralization of de Piles' unity of object, it does not really explain his insistence on the immediacy and spontaneity of pictorial effects (although it would be a poor illusion which we have to build up, as it were, step by step). The requirement that the effect of the *Tout-ensemble* should make itself felt *au premier coup d'œil* adds a temporal dimension to the spatial limitations of our visual appreciation of a painting. This has less to do with illusion than with harmony.

That painting presents its objects simultaneously while poetry, or literature in general, rely on a succession of words is of course an old argument of the *paragone* literature. Depending on its specifications and its context, it can be used both ways, either to support the case of literature or that of painting. Lebrun, as we will remember,[52] saw as one of the disadvantages of painting the fact that it could not represent the whole sequence of a complete action in the sense of Aristotle's *Poetics*, so that the painter faced serious difficulties in establishing *l'unité de sujet*.

50 See below, chap. VI, p.131f.
51 Cf. de Piles, *Remarques*, pp.149–152; and Félibien, *Entretiens IV* (vol. II), pp.368–371.
52 See above p.8.

Yet other painters saw the problem in a different light. For Leonardo, for example, the simultaneity of all objects in a picture meant that painting could achieve effects superior to anything poetry could aim at, namely effects of harmony and proportion. Some passages by Leonardo are, in fact, so close to certain arguments in de Piles that they are worth quoting in our context.

The power of painting to establish harmonious relationships among its objects and parts is a power which it shares with music but not with poetry:

There is the same difference between the poet's and the painter's representation of the human figure as there is between dismembered and united bodies. Because the poet in describing the beauty or ugliness of any figure can only show it to you consecutively, bit by bit, while the painter will display it all at once ... [The poet] is unable to give an equivalent of musical harmony, because it is beyond his power to say different things simultaneously as the painter does in his harmonious proportions where the component parts are made to react simultaneously and can be seen at one and the same time both together and separately.[53]

From painting which serves the eye, the noblest sense, arises harmony of proportions; just as many different voices joined together and singing simultaneously produce a harmonious proportion which gives such satisfaction to the sense of hearing that listeners remain spellbound with admiration ... But the effect of the beautiful proportion of an angelic face in painting is much greater, for these proportions produce a harmonious concord which reaches the eye simultaneously, just as a chord in music affects the ear.[54]

In one paragraph Leonardo seems to sum up most of de Piles' major arguments:

La pittura ti rappresenta in un'subito la sua essentia nella virtù visiva e per il proprio mezzo, d'onde la impressiva receve li obietti naturali et anchora nel medesimo tempo, nel quale si compone l'armonica proportionalità delle parti, che compongono il tutto, che contenta il senso.[55]

Leonardo, throughout, seems to talk about the parts and the proportions of human figures and objects; yet the frequent references to il tutto would have made it easy for de Piles to transfer his statements to the overall effect of the picture, the Tout-ensemble, particularly so, since he shares with Leonardo the idea that the pleasure we derive from harmony stems from the satisfaction and contentment of our senses (harmony according to Leonardo, will produce 'a joy without parallel and superior to all other sensations').[56]

Yet in Leonardo, the satisfaction of our senses is not the whole explanation of the profound effects of harmony. The immediacy of its effects (in subito) as, in fact, their profundity stems from the predisposition of our soul: 'Do you not

[53] I.A. Richter (ed.), *The Notebooks of Leonardo da Vinci*, quoted from paperback edition, Oxford 1980, p.198.

[54] Richter, *Notebooks*, p.146.

[55] Quoted from H. Ludwig (ed.), *Lionardo da Vinci, Das Buch von der Malerei*, Vienna 1882, pp.36/37.

[56] Richter, *Notebooks*, p.146.

know that our soul is composed of harmony and that harmony is only produced when proportions of things are seen or heard simultaneously?'[57]

Leonardo here relies on the classical microcosm/macrocosm analogy which we have seen in operation in the context of the musical modes and their profound effects.[58] For de Piles and his contemporaries these metaphysical explanations were no longer acceptable; de Piles' approach is basically a physiological and psychological one, and on those occasions when he embarks upon more cosmic principles we would be wrong in attributing more than metaphorical sense to a clearly rhetorical statement.[59]

Yet this leaves us with an uncomfortable problem as far as the immediacy and spontaneity, the temporal quality, of his overall effect is concerned. As an effect *au premier coup d'œil* it may be harmonious, attractive, satisfying for our senses; yet unless we are given to an extreme form of visual hedonism it is difficult to see how such an immediate effect could be more than a merely initial one, a preliminary attraction arousing our interest and activating our attention. Even de Piles' followers accepted it as such an introductory effect, seeing it in analogy to the *exordium* of rhetoric,[60] rather than as the final fulfilment of all the expectations we bring to the appreciation of pictures.

De Piles is particularly ambivalent on this point. There are some passages in his writings where he insists that the success of a painting depends entirely on its first overall effect, there are others where this first effect is clearly described as an introductory one which will lead on to a further and fuller appreciation of the work. It is no use, on an issue as crucial as this, to assume that de Piles did not mean exactly what he said on both occasions. And if we follow his arguments closely we see him, in an attempt to attack the old problem of the relation between visual effects and rational understanding, responding to current discussions in literary circles; and his response is of a kind which clearly sets him apart from even his most perceptive followers.

In the first instance we have to recall that the spectator de Piles had in mind was not generally interested in paintings, and could not be expected to approach a picture with the same degree of attention which Poussin and Lebrun's academy would require. Sensuous attraction, in this context, is first of all a preliminary requirement, an introduction:

'Tis in vain to adorn a stately palace with the greatest rarities, if we have forgot to make doors to it . . . All visible objects enter the understanding by the faculty of seeing, as musical sounds do by that of hearing. The eyes and ears are the doors, which admit us to judge of painting and musick: The first care therefore both of the painter and the musician should be, to make these entrances free and agreeable, by the force of their harmony . . .

[57] Richter, *Notebooks*, pp.201f.
[58] See above p.32.
[59] As, e.g. in *CdP*, p.374 on the universal principle of unity: 'Tous les Etres du monde tendent à l'unité . . . Dieu est Un par l'excellence de sa Nature; le Monde est Un; la morale rapporte tout à la Religion qui est une', etc. etc., and so we should not be surprised to find that our eyes require unity, too.
[60] See above chap. II, p.55, and note 53.

(C'est inutilement que l'on conserveroit dans un Palais magnifique les choses du monde les plus rares, si l'on avoit obmis d'y faire des portes... Tous les objets visible n'entrent dans l'esprit que par les organes des yeux, comme les sons dans la musique n'entrent dans l'esprit que par les oreilles. Les oreilles & les yeux sont les portes par lesquelles entrent nos jugemens sur les concerts de musique & sur les ouvrages de Peinture. Le premier soin du Peintre aussi-bien que du Musicien, doit donc être de rendre l'entrée de ces portes libre & agréable par la force de leur harmonie...)[61]

The visual effect *au premier coup d'œil*, in this context, is clearly described as an initial, an introductory attraction. The analogy with the palace would entitle us to expect more: if the eyes are the doors to the palace, what are its contents? De Piles' answer seems surprisingly simple; the 'rarities' kept in the palace, the qualities of the painting which will keep our interest and affect us long after the first visual effect has made its impression, are the other, the traditional parts of the art of painting – invention, design, expression, etc.

This de Piles makes clear in his discussion of Raphael whom, as we have seen, he considers to have failed as far as the first effect is concerned. Despite this failure, Raphael has still much to offer; one has to admit that his paintings: 'Become more admirable the longer one looks at them; and one continuously discovers new beauties in them'. (Que plus on les voit, plus on les admire, et que l'on y decouvre tous les jours de nouvelles beautez.)[62] De Piles claims that it is exactly because of Raphael's perfection in all the other parts of painting that he has chosen to illustrate the overriding importance of the first overall effect:

Because he excelled more in all the parts of his art, than any other painter, and because I should reap more advantage, and more certainly establish my senti-ment on the idea of painting, if I set it in opposition to all Raphael's perfections. To chuse Raphael, therefore as an example, because he possessed more excel-lencies than any other painter, and in order to shew, that all excellencies lose much of their lustre, when they are not accompanied with a colouring which calls the curious to admire them, can never be thought to argue a contempt of him.

(Parce qu'il possedoit avec plus d'excellence toutes les parties de son Art qu'aucun autre Peintre; que je tirerois plus d'avantage & que j'établirois plus surement mon sentiment sur l'idée de la Peinture, si je l'opposois à toutes les perfections de Raphael. Ce n'est donc pas mépriser Raphael que de le choisir pour example, parce qu'il a plus de parties qu'un autre Peintre, & que par-là il fait sentir combien toutes ses belles parties perdent de n'être point accompa-gnées d'un Coloris qui appellât le Curieux pour les admirer.)[63]

De Piles admits here that failure to achieve a powerful and convincing first effect (one, we may add, of both overall harmonious unity and forceful illusion) does not prevent pictures from succeeding in other ways. Yet he also belies his

[61] *CdP*, p, pp.8/9; transl. pp.5/6.
[62] *Conversations*, p.78.
[63] *CdP*, pp.25/26; transl. p.15.

own previous metaphor of the palace and its doors: the powerful first effect is more than an opening, a door. Its absence will not completely bar us from the palace of painting, from appreciating its contents, but it will devalue them. Without the first visual effect the other parts of painting can still be examined and judged, but they will make their impact in a weaker, less effective way.

De Piles' insistence on the overriding importance of the first effect, of immediate attraction and illusion, can, at times, make it difficult for modern readers (and, needless to say, for art-historians in particular) to follow his arguments. Yet the way in which he links this first visual impression of a work to our consecutive appreciation of its other achievements is worth a closer study. It will lead to a distinction between two receptive faculties in the spectator, vision and reflection, or understanding, which respond to different aspects of the work of art; and while the interaction between these two faculties can be seen to moderate the rigidity of de Piles' *effet au premier coup d'œil*, it also reiterates his basic belief in painting as an essentially visual art. In order to define his position in relation to vision and understanding we shall have to look briefly at a much wider discussion going on at the time reflecting what has been called the irrationalist undercurrent of French classicism.

This discussion provided much of the intellectual and critical material for eighteenth-century aesthetics. For our purposes it will be sufficient to relate de Piles' arguments to those of two major protagonists of this dispute, Dominic Bouhours and Nicolas Boileau-Despréaux. This I shall attempt in the next, the final chapter on de Piles.

V

EFFECTS OF VISION AND UNDERSTANDING: ENTHUSIASM AND THE SUBLIME

1. *Grace, Beauty and Bouhours' Theory of* Delicatesse

THE PROBLEM of relating the first visual impact of a painting to our subsequent examination of all its other beauties takes us back to the beginning of our discussion of de Piles' theory. In his early comments on Dufresnoy's *De Arte Graphica* de Piles held the view that the first impression of a picture should convey the general quality of its subject-matter and should thus contribute to our understanding of it.[1] Less than ten years later, in his *Conversations sur la Connoissance de la Peinture* of 1677, however, he explicitly rejects this view. As his theory of the harmonious first effect and its unity of object developed toward its final formulation in the *Cours*, the problem of relating the initial encounter and sustained attention grew more acute.

De Piles tried to attack it at different times in different ways. The problem could be defined in traditional terms, as referring to the relationship between invention and disposition; it could be related to contemporary discussions about *délicatesse* and the irrational effects of the helplessly vague *je ne sçais quoi*; in the end de Piles was happy to settle for two terms borrowed from Boileau's translation of Longinus, enthusiasm and the sublime. Yet their definition in the context of the *Cours* is mainly de Piles' own, and so is the highly original way in which their interaction is meant to solve the problem of vision and understanding.

The passage in the early *Conversations* does not really attempt such a solution. The first visual effect of a picture is no longer seen as an expression of its subject-matter, and its importance seems to be based on nothing more than its temporal priority: 'It is the pleasure of the eyes which consists in their being surprised first, while that of the mind only follows with reflexion.' (C'est le plaisir des yeux qui consiste à estre surpris d'abord, aulieu que celuy de l'esprit ne vient que par reflexion.)[2]

The two faculties involved, vision and reflection (or understanding), are seen not only as acting consecutively but, what is more, as independent of each other. Despite de Piles' protests to the contrary, it is hard to see the first effect as more than an introduction, as opening the way for our understanding to examine the rest of the work.[3]

[1] See above chapter, II, p.40.
[2] *Conversations*, p.77.
[3] Cf. *Conversations*, p.80: 'Le premier *coup d'œil* est à un Tableau ce que la beauté est aux femmes; quand cette qualité leur manque, on neglige d'examiner le reste'.

In the late *Cours de Peinture*, the comprehensive and considered statement of his theory, de Piles first defines the problem in entirely traditional terms of art theory, and then offers his own original and distinctive solution: he endows the first overall effect with an irrational quality which we may appropriately link to eighteenth-century literary aesthetics.[4]

Let us look first at de Piles' use of traditional theory. The relevant arguments about enthusiasm and the sublime appear at the very end of the chapter on disposition, immediately after the discussion of the unity of object and harmony. They are clearly the conclusion, and the climax, of that chapter. The chapter on disposition itself follows on from the previous one on invention.[5]

The dominance of disposition over invention is reiterated at the end of de Piles' discussion of unity and harmony, where, after a brief summary of his ideas on disposition in general, he concludes:

We shall find, that this part of painting, as it includes a great many others, is of very great consequence; because it gives a value to every thing that invention has supplied it with, and to every thing that is most proper to make an impression upon the eye and the mind of the spectator.

(On trouvera que cette partie qui en contient beaucoup d'autres, est d'une extrême consequence; puisqu'elle fait valoir tout ce que l'invention lui a fourni, & tout ce qui est de plus propre à faire impression sur les yeux & sur l'esprit du Spectateur.)[6]

Yet statements like this only help to highlight the urgent need for a solution to our problem; they do not provide an answer. In what way does disposition (the overall visual effect) make us value the things provided by invention? How does disposition affect invention and its objects if not just by clarifying them and attracting our attention to them?

If it could not achieve more it would, by de Piles' standards, remain at a level of functional subservience to what he considers a non-essential part of painting. We should recall that the purely visual effect of disposition, as analyzed so far by de Piles, does not really enable him to establish any firm links between vision and understanding. The only clearly defined effect he has described so far is that of the satisfaction and pleasure of the eye (what he elsewhere calls *la sensation parfaite*).[7] And this, to which is added a fairly general sense of harmony, is, strictly speaking, a purely psycho-physiological effect; it results from the subordination of all objects in a picture under one central, focal illusion which corresponds to the structure of our eye. Even de Piles' illustration of the unity of object in the *Cours de Peinture* (Plate 13) suggests that it could be achieved almost mechanically by a centralised, circular arrangement of all objects within our field of vision. And when de Piles talks about satisfaction and pleasure,

[4] For a general account of the irrationalist tendencies, particularly in French eighteenth-century thinking, cf. Baeumler, *Das Irrationalitätsproblem in der Ästhetik und Logik des 18. Jahrhunderts bis zur Kritik der Urteilskraft*, Halle 1923 (second edition Darmstadt 1975).

[5] Both invention and disposition are, for de Piles, subsections of composition; cf. *CdP*, p.51.

[6] *CdP*, pp.113/114; transl. p.70.

[7] *Abrégé*, p.39.

these emotions or experiences seem to be limited to the visual organ itself, as if our eyes had a sense of pleasure and satisfaction of their own.

The need to go beyond the eye and its *sensation parfaite* must have been obvious to de Piles, if not from the experience of the visual effects of pictures, then certainly from systematic considerations. If it was not possible to show that the first effect of a picture's overall order could be at least as deep, intensive and strong as the traditional *affetti* of its subject-matter, then de Piles' arguments for the supremacy of disposition and its effects over invention and subject-matter would seem trivial.

Our difficulty in reading de Piles correctly in this respect derives from the way his thought developed; most of his arguments in the *Cours de Peinture* are extensions, if not literal repetitions, of his earlier writings. His ideas about *coloris*, *clair-obscur*, even the unity of object and of overall effect can be traced back, through certain modifications, mainly in the *Conversations*, to his early comments on Dufresnoy. The paragraphs on enthusiasm and the sublime, however, in which he attempts to link the first impact of a painting to our consecutive understanding of its subject-matter, are almost entirely new; and despite their extreme importance their consequences are not really incorporated into the rest of the *Cours*. While the rest of his theory seems to have grown as a coherent and interrelated body of ideas and notions, the problem of relating visual impact and understanding appears as a somewhat isolated issue. Yet it was a central issue in the critical thought of the time and by no means peculiar to de Piles. It was, after all, a problem which occupied some of the best literary minds in France between 1670 and the end of the century (and beyond), and in this sense de Piles can be seen as developing his thought against the background of constantly shifting assumptions of a wider and more general kind. The academy of painting, and its theories, provided by comparison a relatively static (if not fossilized) frame of reference.

<p style="text-align:center">* * * * *</p>

We get some indication of de Piles' problems (and, at the same time, an introduction to his notions of enthusiasm and the sublime), if we look briefly at the work which preceded the *Cours*, de Piles' *Abrégé de la Vie des Peintres* of 1699 (probably composed while he was imprisoned as a spy in Holland in the mid-nineties).[8] Here we see de Piles struggling with a related problem, a distinction between *grace* and *beauté* as two different effects of painting.[9]

According to the *Abrégé* beauty results from the strict application of rules, while *la grace plait sans les regles*.[10] Grace is not, or not only, to be understood as a quality of objects, as the gracefulness or elegance of figures, but of the way the artist represents them in his picture: 'It consists chiefly in the turn the

[8] On the circumstances under which de Piles wrote the *Abrégé*, cf. Teyssèdre, *Roger de Piles*, pp.398f and 648.

[9] In a less considered way, he had dealt with this problem in his comments on Dufresnoy, see above, p.50.

[10] *Abrégé*, p.11; transl. p.8. (*The Art of Painting with the Lives and Characters... of the Most Eminent Painters*, translated from the French of Monsieur De Piles; I have used the second edition, London 1744.)

Painter gives his objects to render them agreeable, even such as are inanimate.'
(Elle consiste principalement dans le tour que le Peintre sçait donner à ses objets
pour les rendre agreables, mem à ceux qui sont inanimez.)[11]

In this sense even scenes of horror and pain, like battle-pieces, can have
grace, for it is a quality which the painter has to add to all that he represents. In
this he must follow not the nature of the subject but his own, and whether he is
successful or not depends on his *génie*. De Piles here touches upon the
irrational nature of art in a way which would have appeared to the old academy
as undermining the whole concept of rules and authoritative legislation. De
Piles admits – with some equivocation – that the painter who follows all the
rules of his art will infallibly produce beautiful things:

Yet not entirely perfect, if beauty be not accompanied with Grace. Grace must
season the parts we have spoken of and every where follow Genius.

(Mais ses Tableaux ne pourront etre parfaits si la Beauté qui s'y trouve n'est
accompagnée de la Grace. La Grace doit assaisonner toutes les parties dont on
vient de parler, elle doit suivre le Genie.)[12]

Grace, like *génie*, is beyond the control of rules; and even the painter himself
cannot tell whether nature has endowed him with grace:

A painter has it from nature only, and does not know that he has it, nor in what
degree, nor how he communicates it to his works.

(Un Peintre ne la tient que de la Nature, il ne sçait pas meme si elle est en luy, ni
a quel degre il la possede, ni comment il la communique à ses Ouvrages.)[13]

As the cause and nature of *grace* is beyond the control of rules or reason so is
its effect on the spectator. While the painter has to rely on the disposition of his
natural genius, the spectator can respond to the *grace* of a painting only
according to the disposition of his *cœur*, his heart or soul:

It surprises the spectator, who feels the effect without penetrating into the true
cause of it; but this grace does not touch his heart otherwise, than according to
the disposition wherein it finds it. We may define it thus: 'Tis what pleases, and
gains the heart, without concerning itself with the understanding.

(Elle surprend le Spectateur qui en sent l'effet sans en penetrer la veritable
cause: mais cette Grace ne touche son cœur que selon la disposition qu'elle y
rencontre. On peut la definir, Ce qui plait, & ce qui gagne le cœur sans passer
par l'esprit.)[14]

In these paragraphs de Piles takes up arguments which had dominated literary
discussions in France for the previous twenty years. Pascal distinguished between
l'esprit de finesse and *l'esprit de géometrie*, between an immediate intuitive

[11] *Abrégé*, p.64; transl. p.43.
[12] *Abrégé*, p.10; transl. p.7.
[13] *Abrégé*, p.10; transl. p.7.
[14] *Abrégé*, p.10; transl. pp.7/8 (slightly corrected!)

judgement and one based on *raisonnement*, and he extended this distinction to the notions of beauty and *agrément*. The term 'beauty' applies to those cases where a standard of perfection can be rationally defined, as in geometry and medicine. In poetry, where it is used most often, we cannot define it: *agrément* refers to effects of an irrational nature; ('on ne sçait pas en quoi consiste l'agrément qui est l'objet de la poésie').[15]

The search for *l'agrément* or *la grace* of poetry became as much a fashionable exercise of polite conversation as did attempts to define what distinguished a beautiful woman from one who possessed *charme*.

* * * * *

This 'irrational undercurrent' of French seventeenth and eighteenth-century thinking has been studied in considerable detail in literary studies. If I concentrate on only one of the major writers of the period, Dominic Bouhours, it is because he seems to have been, according to all accounts, the most representative and influential figure.[16]

In his *Entretiens d'Ariste et d'Eugène* of 1671, Bouhours extended the discussion to include all kinds of mysterious and irrational effects, from the charm of women to the belief in God. He subsumed them all under the telling label of '*le je ne sais quoi*', indicating that reason, or *l'esprit géometrique*, was unable to explain their causes. Nor was reason the adequate recipient of these effects which were to be felt, not understood. And in its turn feeling, sentiment, heart, soul, or whatever non-rational faculty one might think of, has to possess a *je ne sais quoi* of *délicatesse* or *finesse*, an undefinable quality of refinement.

What made these discussions attractive for de Piles and led him, in his *Abrégé*, to participate in them, was probably not so much the simple distinction between beauty and *grace* (which he had already made in his *Remarques*). More important was the emergence of what we would call the notion of aesthetic or intuitive judgement, which was given increasingly sophisticated definition. The effects of any *je ne sais quoi* seemed to require that they be felt immediately and spontaneously, as *effets au premier coup d'œil*. This was first spelt out by Pascal: 'One has to see the object at once and in one instant, not by the progress of reasoning.' (Il faut tout d'un coup voir la chose d'un seul regard, et non pas par progrès de raisonnement).[17]

Within this tradition, Dominic Bouhours looks like the most likely direct source for de Piles' passages on *beauté* and *grace*. The distinction between

[15] Pascal, *Œuvres*, XII, p.42, no. 33; cf. E.B.O. Borgerhoff, *The Freedom of French Classicism*, Princeton 1950, re-issued New York 1968, pp.112/113..

[16] The literature on the problem of 'irrationalism' is vast; the following is no more than a brief selection of works I have found useful: K.H. von Stein, *Die Entstehung der neueren Ästhetik*, Stuttgart 1886; Baeumler, *Das Irrationalitätsproblem*, Halle 1923; W. Folkierski, *Entre le Classicisme et le Romanticisme*, Cracow, Paris 1925; E. Cassirer, *The Philosophy of the Enlightenment*, Princeton N.J. 1951 (transl. from the German edition, Tübingen 1932); Borgerhoff, *The Freedom of French Classicism*, Princeton N.J. 1950; E. Köhler, '''Je ne sais quoi'' – Zur Begriffsgeschichte des Unbegreiflichen', *Esprit und arkadische Freiheit. Aufsätze aus der Welt der Romania*, Frankfurt, Bonn 1966, pp.230–286 (First in *Romanistisches Jahrbuch*, 6, 1953/54, pp.21–59)

[17] Pascal, *Œuvres*, XII, pp.11/12, no. 1; cf. Borgerhoff, p.126.

beauty and the effects of *le je ne sais quoi* is a recurrent issue throughout the *Entretiens*. In the fifth *Entretien*, devoted to *Le je ne sçay quoy*, he praises the great beauties to be found in the writings of Jean Louis Guez de Balzac; these are regular beauties according to the rules (*des beautez régulieres*). Yet the secret charm, the fine and hidden gracefulness of the works of Voiture please him infinitely more.[18]

The sheer speed of these irrational effects is of great importance for Bouhours. Although *le je ne sais quoi*, strictly speaking, cannot be defined, the elements of immediacy, surprise, effectiveness *à une première vue*, are invoked in all attempts to circumscribe its nature.[19] They are, at least tentatively, held responsible for the act that it by-passes reason and *esprit*:

The fastest effect of all is that which affects the heart; and the shortest of all moments, if I may speak like that, is that in which *le je ne sais quoi* makes its effect.

(De tous les traits celuy qui va le plus viste, c'est le trait qui blesse le cœur; & le plus court de tous les momens, si j'ose parler ainsi, c'est celuy dans lequel le je ne sçais quoy fait son effet.)[20]

If the causes of these effects are secret and hidden, the feelings and sentiments they arouse in us are correspondingly inexplicable:

These *je ne sais quoi* of beauty and ugliness, so to speak, incite in us those *je ne sais quoi* of attraction and aversion, which evade reason and which our will does not control . . . These are the first movements which prevent reflexion . . . These feelings of sympathy and antipathy are born in an instant.

(Ces je ne sçais quoy en beau et en laid, pour parler de la sorte, excite dans nous de je ne sçais quoy d'inclination et adversion où la raison ne voit goutte et dont la volonté n'est pas la maîtresse . . . Ce sont de premiers mouvemens qui préviennent la réflexion . . . Ces sentimens de sympathie & d'antipathie naissent en un instant.)[21]

Considering that Félibien's official edition of the *Conférences de l'Academie* had been published just two years before Bouhours' *Entretiens*, one would expect that Bouhours would hesitate to extend his notion of *le je ne sais quoi* to works of the visual arts; it was the academy's clearly expressed view that the beauties of painting could and should be reduced to absolute rules.[22]

Bouhours is aware of the problem, and he is quite adamant that his theory applies to the visual arts as much as to literature or to nature:

At least, added Eugène [the orthodox speaker in Bouhours' dialogue], the *je ne*

[18] D. Bouhours, *Les Entretiens d'Ariste et d'Eugene* (pres. de F. Brunot), Paris 1962, (following the text of the first edition Paris 1671), p.48.

[19] Bouhours, *Entretiens*, p.145: 'Le je ne scay quoy qui surprend, & qui emporte le cœur à une premiere veue . . . '

[20] Bouhours, *Entretiens*, p.143 (literally: 'the fastest dart is that which wounds the heart . . . ').

[21] Bouhours, *Entretiens*, p.147.

[22] Cf. Félibien, *Preface*, (vol. V), pp.302/303.

sçais quoy is limited to natural things; as far as works of art are concerned their beauties are known, and one knows well why they please. – I do not agree, replied Ariste, the *je ne sçais quoy* appertains to art as well as to nature . . . What delights us, in my view, in these pictures and statues, is an inexplicable *je ne sçais quoy*. The great masters, too, who discovered that nothing pleases more in nature than that which does so without our knowing why, have always sought to make their works pleasing by concealing their art with great care and artifice.

(Au moins, ajouta Eugène, le je ne sçais quoy est renfermé dans les choses naturelles; car pour les ouvrages de l'art toutes les beautez y sont marquées, & l'on sçait bien pourquoy ils plaisent. – Je n'en tombe d'accord, repartit Ariste, le je ne sçais quoy appartient à l'art bien qu'à la nature . . . Ce qui nous charme, dis-je, dans ces peintures & dans ces statues, c'est un je ne sçais quoy inexplicable. Aussi les grands maistres qui ont découvert que rien ne plaist davantage dans la nature, que ce qui plaist sans qu'on sache pourquoy, ont tasché toujours de donner de l'agrément à leurs ouvrages, en cachent leur art avec beaucoup de soin, & d'artifice.)[23]

De Piles must have been attracted by a statement which would seem to support so openly his opposition to academic rules. And the agreement between him and Bouhours appears to be even more extensive; neither wants to separate *agrément* or *grace* entirely from beauty. Although they hold that both these qualities work separately, perfection is only reached when they are joined together:

[*Le je ne sais quoi*] is a pleasing effect which animates the beauty and the other natural perfections . . . it is a charm and an air which blends with all actions and sentences.

(Le je ne sçais quoy . . . c'est un agrément qui anime la beauté et les autres perfections naturelles; . . . c'est un charme et un air qui se mesle à toute les actions et à toutes les paroles.)[24]

This is Bouhours; de Piles, as we remember, claims that *grace* must season all the other parts of painting to bring them to perfection.[25] Even his notion of *génie* as an entirely natural gift has its prototype in Bouhours' *Entretiens*:

Some people have *génie* for painting, others for verse [poetry]: It is not enough to have *esprit* and imagination in order to be excellent in poetry; one has to be born a poet, and one has to have that natural talent which depends neither on art nor on learning, and which has something of inspiration.

(Les uns ont du génie pour la peinture; les autres en ont pour les vers: il ne suffit pas d'avoir de l'esprit & de l'imagination pour exceller dans la poésie; il faut

[23] Bouhours, *Entretiens*, p.148.
[24] Bouhours, *Entretiens*, p.141.
[25] See above p.109 and *Abrégé*, p.10.

estre né poète, & avoir ce naturel qui ne dépend ni de l'art, ni de l'étude, & qui tient quelque chose de l'inspiration.)[26]

* * * * *

In the *Abrégé* de Piles seems firmly committed to an irrationalist theory of art; the three elements which determine the effect and the success of a picture, the artist's genius, the *grace* of the work, and the disposition of the spectator, are all outside the rules of the art, inexplicable, and, in Bouhours terms, *mysterieux*.

We should be wrong, however, to accept this as exactly corresponding to de Piles' position. In the *Cours de Peinture* of 1708 neither the distinction between *grace* and beauty, nor the notion of *génie*, nor the particular disposition of the spectator is given any major prominence. We find that he has changed the terms in which the issue is discussed: *grace* and *beauté* are replaced by *enthousiasme* and the sublime. The aim of this change was, first, to reinforce the superiority of pictorial disposition and its effects over the invention of subject-matter (or, in other words, of vision over understanding and reason); and second, to establish a link between the two sides, between disposition and invention, vision and understanding, which would give coherence to the overall notion of composition – and, one may add, to our overall experience of a painting.

The change from de Piles' position in the *Abrégé* to that in the *Cours* is not just one of terms or words. It is the result of our author clarifying his own theory and redefining its relationship with Bouhours' theory of *délicatesse*. It seems that the change reflects de Piles' increasing awareness of at least three problematic aspects of the position he had adopted in the *Abrégé* : first, an implicit weakness in the distinction between *grace* and *beauté*, and in their applicability to painting; secondly a contradiction between some major elements of Bouhours' theory of *délicatesse* and the precise nature of de Piles' own theories; and thirdly a problem brought about by changes in Bouhours' own thought resulting from the introduction of the notion of the sublime into the whole discussion. I shall discuss these three points briefly, simply because it would be difficult to understand the meaning of the two new concepts, enthusiasm and the sublime, without some account of the problems that led to their formulation.

First of all, neither grace nor beauty were particularly suitable notions for the purpose they were supposed to serve. Beauty, even as *beauté regulière*, was not exactly a concept which one would normally associate with all those aspects of invention (the literary, philosophical, historical or other implications of subject-matter) which de Piles wanted to contrast with the immediate visual effect of the whole picture. Having been deprived of all its immediately pleasing aspects like *grace*, *agrément* and *délicatesse*, beauty had become a rather vague, if not altogether meaningless word in the context of the fine arts. This certainly was the prevailing opinion among *amateurs* and *connaisseurs* by the turn of the century, and de Piles recognized it in the *Cours de Peinture* : 'Beauty, say they, is nothing real; every one judges of it according to his own taste, and 'tis nothing

[26] Bouhours, *Entretiens*, p.130.

but what pleases'. (Le beau, dit-on, n'est rien de réel, chacun en juge selon son goût; en un mot, que le Beau n'est autre chose que ce qui plaît.)[27]

With all the pleasing effects separated from beauty and established in their own right and with their own terms, one would be left with a rather abstract concept of beauty without any meaning attached to it. One could of course complete a full circle and superimpose the otherwise redundant notion of beauty on all those pleasing aspects one had previously separated from it; but one could then no longer make a useful and meaningful distinction between *beauté* and *grace*.

Grace, too, was a problematic term; it was not well suited to cover those effects of visual disposition (resulting from the artificial side of the artist's work) which de Piles considered of extreme importance for a picture's success. There is something implicitly wrong in the choice of the word when de Piles refers to the grace of battle-pieces – illuminating as this reference may otherwise be for the distinction he wants to make between the qualities and expressions of the subject-matter on the one hand, and the 'artificial' or artistic effects of the overall disposition on the other. And if we are right in assuming that the meaning of *grace* in the *Abrégé* can be defined by reference to Bouhours' theory of *le je ne sais quoi* and *délicatesse*, then one has to admit that de Piles entangled himself in some major problems by adopting it in the first place: seen in the context of Bouhours' ideas, the notion of *grace* is hardly reconcilable with the rest of de Piles' theory.

Grace, *charme*, *finesse*, and above all *délicatesse* in Bouhours' writings (as well as in the earlier works of the Chevalier de Méré and Pascal),[28] refer to particularly subtle, refined, and delicate effects which cannot be felt by a spectator who is not suitably and adequately predisposed. The *délicatesse* of a work of art or a natural object has to find a spectator with a similar *délicatesse* of mind, heart, or soul, in order to make its effect. In the *Abrégé* de Piles seems to agree with this; his reference to the disposition of the spectator's *cœur* would otherwise be difficult to understand.

Yet, according to the rest of his theory, a picture has to strike any potential spectator immediately and to catch his attention irrespective of his predisposition. The whole structure of de Piles' theory is based on the notion of an unprepared, passive spectator, on whom the artist has to impose his effects and the interest and order of his work. While the notion of a specific predisposition, or of a refinement of our receptive organs, is a basic element of Bouhours' *esthétique de la délicatesse*, it is certainly alien to de Piles' system. The most likely explanation for its appearance in the *Abrégé* is that de Piles thought of it as adding a resonance to his *premier coup d'œil*. The links between the artist's *génie*, the *grace* of the picture, and the disposition of the spectator's heart would seem to elevate de Piles' *sensation parfaite*, the satisfaction of our eyes, above the level of a purely mechanical achievement or a merely physiological effect.

To relate the combination of *génie*, *grace*, and *cœur* to effects *au premier coup d'œil* was problematic not only for de Piles; what he does not seem to have

[27] *CdP*, p.135; transl. p.84; see above, p.50.
[28] See, above all, Köhler, *Esprit und Arkadische Freiheit*, Frankfurt/Bonn, pp.230–286.

realized when he completed the *Abrégé* was that in this respect the theory of *délicatesse* was not really a completely coherent model. There was a sense of uneasiness even in Pascal's account of *les choses de finesse* and their effects on us. If you looked at the problem as one of defining the role of vision or feeling as opposed to reason and understanding, then it seemed to be almost imperative, as we saw earlier, to insist on the immediacy of *le coup d'œil*:

One has to see the object at once and in one instant, not by the progress of reasoning.[29]

If, on the other hand, you looked at it as a problem of the refinement and delicacy of our organs reacting to infinitely subtle and almost imperceptible effects, then the first instant of vision is hardly relevant, as Pascal equally remarked:

One hardly sees [these *choses de finesse*]; we feel them rather than see them. It is infinitely difficult to make those feel them who do not feel them of their own accord; these things are so delicate and so manifold that one needs a very delicate and very distinct sense to feel them.

(On les voit à peine, on les sent plutôt qu'on les voit; on a des peines infinies à les faire sentir à ceux qui ne les sentent pas d'eux-mêmes; ce sont choses tellement délicates, et si nombreuses, qu'il faut un sens bien délicat et bien net pour les sentir.)[30]

While the immediate effect seems to have appeared as the only conceivable alternative to *raisonnement*, its inherent simplicity and spontaneity were rather difficult to integrate into a theory of *délicatesse* and refinement. Bouhours was forced to acknowledge this problem and to adjust his theories by the publication of a work which also provided a new and more suitable model for de Piles: Boileau's translation, with commentary, of Longinus' treatise on the sublime.

2. *Enthusiasm, the Sublime, and the Influence of Boileau*

Nicolas Boileau-Despréaux, the author of *L'Art poétique*, published his translation of Longinus' treatise in 1674. Its influence, and the controversies that followed, have been studied recently in great detail.[31] I cannot, here, give a full account of Boileau's achievement or of the subsequent disputes he engaged in for more than thirty years. Yet the new concept of the sublime is important for our investigation in two respects: first, because its impact on Bouhours made him change his definition of the effects of *délicatesse* to such an extent that it could no longer serve as a useful model for de Piles; and secondly, because it seems to have directed de Piles, at least in some ways, in his own formulations of the notions of enthusiasm and the sublime.

The problems Bouhours had to face when he tried to reconcile the sublime

[29] See above p.110 and note 17.
[30] Quoted from Borgerhoff, p.126. (*Œuvres XII*, pp.11/12, no. 1).
[31] I have used the Paris 1713 edition, *Œuvres de Nicolas Boileau Despréaux*; for general literature on Boileau, see note 16, and, most recent, T.A. Litman, *Le Sublime en France 1660–1714*, Paris 1971.

with his own theory have been analysed by T.A. Litman.[32] The most important point in our context is that he abandoned the idea of an immediate, spontaneous effect of *délicatesse*. In his *Manière de bien penser dans les ouvrages d'esprit* of 1687, *délicatesse* is no longer an effect *au premier coup d'œil*:

But if you ask me what a delicate thought is, I do not know where to find the words to express myself. These are things which it is difficult to see in one instant, and which, being subtle, escape us when we try to keep hold of them. All one can do is to look at them closely and repeatedly to get to know them step by step.

(Mais quand vous me demandez ce que c'est qu'une pensée delicate, je ne scay où prendre des termes pour m'expliquer. Ce sont de ces choses qu'il est difficile de voir d'un coup d'œil, & qui à force d'estre subtiles nous echapent lors que nous pensons les tenir. Tout ce qu'on peut faire, c'est de les regarder de près & à diverses reprises, pour parvenir peu à peu à les connoistre.)[33]

It is now the sublime which possesses an immediate effect together with *vigeur* and *éclat*: 'La sublimité, la grandeur dans une pensée est justement ce qui emporte, & ce qui ravit . . . '.[34]

The source of this is Boileau; and he makes it clear that the question of the listener's predisposition is irrelevant. We are overwhelmed by the sublime, carried away whether we want to be or not:

We can say about persuasion that it normally has no more power over us than we want. That is not so with the sublime. It endows the discourse with a certain noble vigour, an invincible force which carries away the soul of anyone who listens to us . . . When in its proper place the sublime bursts forth it knocks over everything like a clap of thunder, and presents all the power of the orator gathered together.

(Nous pouvons dire à l'esgard de la persuasion, que pour l'ordinaire elle n'a sur nous qu'autant de puissance que nous voulons. Il n'en est pas ainsi du Sublime. Il donne au Discours une certaine vigueur noble, une force invincible qui enlève l'àme de quiconque nous escoute . . . quand le Sublime vient à esclater où il faut, il renverse tout comme un foudre, & présente d'abord toutes les forces de l'Orateur ramassées ensembles.)[35]

For de Piles, whose whole theory of disposition was aiming at an immediate forceful impact, strong enough to attract even the least interested spectator, this

[32] Op. cit., chapter IV, pp.105–120.

[33] D. Bouhours, *La Manière de bien penser dans les ouvrages d'esprit*, 1687; quoted here from second edition, Amsterdam 1692, p.158; on the following page he talks about those thoughts or ideas 'qui se montrent toutes entières à la première vuë' as being not delicate, however spirited they may otherwise be.

[34] Bouhours, *La Manière*, p.79. Compare with Boileau/Longinus, *Traité du Sublime ou du Merveilleux dans le discours. Traduit du Grec de Longin*, 1674, in: *Œuvres de Nicolas Boileau Despréaux*, pp.605–692; p.607: '[Le Sublime] ne persuade pas proprement, mais ravit, il transporte, & produit en nous une certaine admiration meslée d'estonnement & de surprise'.

[35] Boileau/Longinus, *Traité du Sublime*, p.607.

notion of the sublime's effect must have appeared as the ideal solution to his problems. What he needed was an immediate first effect which went beyond the mere satisfaction of the eye, without being caused by the emotional or other qualities of the subject-matter. As Boileau's translation had been available since 1674, and Bouhours' *Manière* since 1687, it is somewhat surprising to see de Piles still experimenting with *grace* and *beauté* in the nineties. Perhaps it was the predominantly literary character of the discussions about the sublime which made him hesitate to give up these traditionally 'visual' terms. It is perhaps significant, too, that after 1700, when he was composing his *Cours*, he and Boileau seem to have become friends; de Piles painted Boileau's portrait, and Boileau showed interest in theoretical writings about painting.[36]

There were also some serious theoretical reasons which would explain de Piles' slow response to the new notion of the sublime. First of all, neither Longinus nor Boileau offered any precise definition of the sublime. There was a lengthy controversy about its actual nature and significance. Our author must have hesitated to build what was to be an important part of his system on such uncertain and contested ground.

There were further problems: the notion of the sublime, at least at this stage of its theoretical development, did not seem to allow for a clear separation of the effects of disposition on the one hand, and those of subject-matter on the other. And as the discussions went on over the next few decades it became increasingly clear that for most French theorists the highest form of the sublime was not that achieved by rhetorical artifice or the orator's passions, but the sublime of thoughts (*pensées*) or real objects expressed in simple and just language.

Matters were further complicated by Boileau's ruling that, although the sublime should make its impact immediately, it should not lie in the first effect of a poem. Its beginning should be simple and without affectation; otherwise the sublime would be *hors de son lieu* and like a promise which the poet would be unable to keep throughout the rest of his poem. In the second of his *Reflexions Critiques sur quelques passages de Longin* of 1694, he attacks a statement made by Charles Perrault two years before, in his *Parallèle des Anciens et des Modernes*. Perrault had praised Scudéry for the magnificent first line of his poem *Alaric*: 'Je chante le vainqueur des vainqueurs de la Terre'.[37]

Perrault compares the beginning of a poem to the façade of a temple or a palace; if in a façade magnificence is not only acceptable but required, why then should the same not apply to the beginning of a poem?

Boileau quite agrees that Scudéry's first line is sublime; but for exactly that reason it is to be criticised:

I admit that the façade of a palace has to be adorned; but the *exordium* is not the façade of a poem. It is rather an avenue, a fore-court, which leads to it and from

[36] See Teyssèdre, *Roger de Piles*, p.513 on de Piles painting Boileau's portrait and n.3 on de Piles and Boileau having dinner with A. Coypel; p.517, n.2: Inventory after de Piles' death lists 'œuvres de Boileau'. The portrait of Boileau was left to Le Verrier (p.519), an engraving after it is reproduced in L. Mirot, *Roger de Piles*, following p.79.

[37] Ch. Perrault, *Parallèle des Anciens et des Modernes*, vol. III, Paris 1692, pp.267–270.

where one discovers it. The façade is an essential part of the palace . . . But a
poem can exist quite well without an *exordium*.

(Le frontispice d'un Palais doit estre orné, je l'avoue; mais l'exorde n'est point
le frontispice d'un Poeme. C'est plustost une avenue, une avant-cour qui y con-
duit, & d'où on le descouvre. Le frontispice fait une partie essentielle du Palais
. . . mais un Poeme subsistera fort bien sans exorde.)[38]

On the surface, this remark might seem to offer encouragement for de Piles;
if the façace of a palace can be sublime, then the same must surely be true of
paintings. Yet for de Piles, as we know, the problem was more complex; he was
thinking in terms of a sequence of different effects, the first visual effect being
followed by the effects of subject-matter. And according to the more traditional
comparisons between painting and poetry or rhetoric, the first effect of a paint-
ing would normally be considered as the visual equivalent of the *exordium*. We
know that de Piles was trying to show that this analogy was wrong, that the first
effect of a picture was more than a mere opening or introduction; yet to argue
this point by linking it with Boileau's notion of the sublime would have been
dangerous: in the light of Boileau's criticism of Perrault the sublime would
have to be associated with the subsequent effects of subject-matter.

* * * * *

Since we know it was de Piles' aim to establish the superiority of visual effects
over those of subject-matter, it may come as a considerable surprise to find that
he did, indeed, follow Boileau's line of argument. In the *Cours de Peinture* he
related the sublime to the highest and most powerful effects of a picture's
subject-matter. We would be wrong, however, if we assumed that in doing so he
was relegating the first visual effect to the status of Boileau's *exordium*.

What de Piles is, in fact, saying is that while the effects of subject-matter can
be sublime, those of the visual effects of the *Tout-ensemble* can be even more
sublime, although he prefers to use a different term to describe it. He splits, as it
were, the sublime into two, by borrowing yet another term from Boileau's
translation, that of enthusiasm. In Boileau/Longinus the term *enthousiasme*
refers to a particularly passionate state of mind of the orator, and thus to one of
the natural causes of sublime effects: 'By pathos I mean that enthusiasm and
that natural vehemence which touches and moves us.' (J'entends par Pathé-
tique, cet Enthousiasme, & cette véhémence naturelle, qui touche & qui
émeut.)[39]

In de Piles, enthusiasm refers to the overall visual effect of the painting, but it
also refers to the state of mind in which the artist conceives this effect, and to
the state of mind which it produces in the spectator. We cannot properly under-
stand the relationship between enthusiasm and the sublime without keeping in
mind his earlier distinction between *grace* (depending on the artist's *génie*) and
beauté, and his intention to explain the mutual dependence of the effects of
visual disposition and literary invention.

[38] Boileau, *Œuvres*, p.499.
[39] Boileau/Longinus, in Boileau, *Œuvres*, p.618.

While the orator's *enthousiasme* will affect his audience directly, as the result of the personal encounter between speaker and listener, the painter's enthusiastic state of mind depends on the medium of the painting to make its impact on the spectator. As a quality of the painting, de Piles' enthusiasm is much closer in kind to those sources of the sublime which, according to Boileau, depend on the orator's art, like rhetorical figures or the composition and arrangement of sentences and words. It is the result of what I have called the artificial order of painting on which, in his *Conversations* and elsewhere, de Piles based his analogy between rhetoric and painting.

If we leave aside for the moment the problem as to how the painter's enthusiastic state of mind is to manifest itself in those artificial means of ordering and constructing a picture, we shall find that de Piles' definition of enthusiasm is, on the whole, quite familiar to us: 'Enthusiasm is a transport of the mind, which makes us conceive things after a sublime, surprising, and probable manner.' (L'Enthousiasme est un transport de l'esprit qui fait penser les choses d'une maniere sublime, surprenante, & vraisemblable).[40]

And even his argument in support of the necessity of *enthousiasme* does not strike us as particularly new:

Though truth always pleases, because 'tis the basis of all perfection, yet 'tis often insipid when it stands alone; but, joined to enthusiasm, it raises the soul to a kind of admiration, mix'd with astonishment; and ravishes the mind with such violence, as leaves it no time to bethink itself.

(Quoique le Vrai plaise toujours, parce qu'il est la base & le fondement de toutes les perfections, il ne laisse pas d'être souvent insipide quand il est tout seul; mais quand il est joint à l'Enthousiasme, il transport l'esprit dans une admiration mêlée d'étonnement; il le ravit avec violence sans lui donner le tems de retourner sur lui-même.)[41]

It is obvious that de Piles brings into the discussion of enthusiasm all those terms and arguments he had used previously to describe the joint effect of attraction and illusion. This effect is now supposed to go beyond the mere satisfaction of our eyes, the *sensation parfaite*; it is held to affect our general state of mind so that we, as spectators, will share the painter's enthusiasm.

How exactly this is to be achieved de Piles does not say; yet we have to accept as sincere his statement that his advice on the unity of object, on circular disposition, and on the harmonies of the *Tout-ensemble*, was only meant to offer guidelines (although highly important ones), not to establish firm rules. It is through disposition with all its constituent parts that enthusiasm was to be transmitted:

Able painters may know, by their own experience, that in order to succeed in so refined a part (disposition), they must rise higher than the ordinary, and, as it were, be transported out of themselves...

[40] *CdP*, p.114; transl. p.70.
[41] *CdP*, p.115; transl. p.71.

(Les habiles Peintres peuvent connoître par leur propre experience, que pour bien réussir dans cette partie si spirituelle, il faut s'élever au dessus du commun, & se transporter, pour ainsi dire, hors de soi même. . . .)[42]

This is how de Piles, having just discussed harmony as a miraculous effect of the *Tout-ensemble*, sums up his treatment of disposition before concluding it in the paragraphs on enthusiasm. And this progress of his argument is quite informative as far as ways of achieving enthusiasm through a composition are concerned. Although the dichotomy of *grace* and *beauté* on which he relied in the *Abrégé*, has disappeared in the *Cours de Peinture*, the notion of grace has not been dismissed altogether. It has been retained as one of a number of possible *genres* of harmony, and although harmony itself does not figure in the paragraphs on enthusiasm, it is dealt with on the immediately preceding pages which end with the passage quoted above. As *un effet merveilleux du Tout-ensemble* it was compared to a *concert de Musique*.[43] The deep emotional effect traditionally attributed to musical harmony is only implicitly invoked because, if my interpretation is correct, the corresponding effect of painting is dealt with two pages later under the heading of enthusiasm.

In the *Abrégé*, the notion of *grace* had referred to the immediate overall visual effect of a work, expressing the quality of the artist's *génie* and elevating the (suitably predisposed) spectator to a state of mind similar to that of the painter; in the *Cours*, these are the tasks of enthusiasm which, as a much more powerful effect, does no longer depend on the spectator's predisposition. Yet while *grace* seemed to imply a particular kind of expression (which was the reason why it seemed a somewhat dubious term to describe battle-pieces), enthusiasm, as a more general concept, now allows for a wider range of expressions or, in de Piles' terms, specific harmonies: from the *grace*, the *harmonie douce & moderée* of Correggio and Guido to the *harmonie forte & elevée* of Giorgione, Titian, and Caravaggio.

Enthusiasm, *cette fureur Pittoresque*, as de Piles calls it,[44] can thus be defined as an overwhelming general effect, containing within it, and imparting to the spectator, the artist's sense of harmony. De Piles' general theory of disposition is meant to provide the means of organizing the medium of this overall effect, which is the picture itself: the unity of object and *la sensation parfaite* provide the compositional and physiological framework not only for illusion and initial attraction, but also for the overwhelming effect of the *Tout harmonieux* which, according to the artist's character and temperament, will inspire in the spectator that sense of ordered enthusiasm which will elevate his state of mind to a level similar to the *fureur Pittoresque* of the artist.

To attribute to our purely visual experience of a painting such an effect on our state of mind may strike us as a surprisingly modern assumption about the powers of painting. It reminds us of the well-known statement by Delacroix who not only thought of the painting as a bridge between the mind of the artist and that of the spectator[45] but who also proclaimed that:

[42] *CdP*, p.114; transl. p.70.
[43] *CdP*, p.111; transl. p.69.
[44] *CdP*, p.118; transl. p.73 as 'this fury of the painter'.
[45] *Journal de Eugène Delacroix*, III, 1857–1863, ed. by A. Joubin, Paris 1932, p.39.

There is a kind of emotion which is entirely particular to painting; nothing (in a work of literature) gives an idea of it. There is an impression which results from the arrangement of colours, of lights, of shadows etc. This is what one might call the music of the picture . . . you find yourself at too great a distance from the painting to know what it represents; and you are often caught by that magic accord. In this lies the true superiority of painting over the other art (literature), for this emotion addresses itself to the innermost part of the soul . . . [This emotion], like a powerful magician, takes you on its wings and carries you away.

(Il y a un genre d'emotion qui est tout particulier à la peinture; rien dans l'autre (l'ouvrage littéraire) n'en donne une idée. Il y a une impression qui résulte de tel arrangement de couleurs, de lumières, d'ombres, etc. C'est ce qu'on appellerait la musique du tableau . . . vous vous trouvez placé à une distance trop grande du tableau pour savoir ce qu'il représente, et souvent vous êtes pris par cet accord magique. C'est ici qu'est la vraie supériorité de la peinture sur l'autre art (la littérature), car cette émotion s'addresse à la partie la plus intime de l'âme . . . Elle, comme une puissante magicienne, vous prend sur ses ailes et vous emporte devant.)[46]

From statements like this there is, theoretically, only a small step to modern theories of abstract art (and it is probably not entirely coincidental that a German translation of this passage, by Julius Meier-Graefe, was available at least since 1912).[47] Delacroix's emotion of pure vision has its origins quite clearly in de Piles' enthusiasm, but it surpasses the earlier notion in one important way by excluding, if only initially, the recognition of objects and figures in the painting.

What de Piles had in mind was certainly an elevated state of *vision* (both of the artist and the spectator); and this vision, at least as far as the spectator was concerned, was that of a highly organized and controlled arrangement of what we might call the *formal* aspects of painting: the unity of object, the subordination of all parts, the harmony of colours, and the contrasts of *clair-obscur*. Yet it also includes illusion, the immediate recognition of figures and objects, and we would be wrong if we equated de Piles' sense of pure vision with the much more modern notion of abstract formalism. By integrating focal illusion with peripheral harmony and overall unity it provides for a visual experience unique to pictures. As such it is meant to be distinct not from our recognition of objects (because the focal illusion depends on such recognition) but from our normal perception of the world around us as well as from our understanding of the literary content of subject-matter.

* * * * *

Being distinct does not necessarily mean being unrelated or unconnected. Although our visual experience is clearly distinguished, by de Piles, from our understanding of subject-matter, because it affects our whole state of mind it also affects our understanding. And this is how de Piles presents the relationship

[46] E. Delacroix, *Œuvres littéraires*, I, Paris 1923, pp.63f.
[47] E. Delacroix, *Literarische Werke*, Deutsch von Julius Meier-Graefe, Leipzig 1912, pp.327f.

between enthusiasm and the sublime. We have to keep in mind that de Piles is trying to establish the proper relationship between the effects of both disposition and invention, and it is to this end that he introduces the notion of the sublime. As enthusiasm was the highest effect of disposition, we must understand the sublime as related to invention, that is, to subject-matter. De Piles deals with this problem in a passage which well deserves to be quoted in full:

I have comprehended the *sublime* in the definition of *enthusiasm*, because it is the effect and production of it: *Enthusiasm* comprehends the *sublime*, in the same manner as the trunk contains the branches, which it sends forth on all sides: Or rather, *enthusiasm* is, as it were, the sun, which by its heat, and vivifying influence, produces elevated thoughts, and brings them to such a state of maturity, as we call the *sublime*. But as *enthusiasm*, and the *sublime*, both tend to elevate the understanding, we may conclude them to be of the same nature; with this difference, that *enthusiasm* is a rapture that carries the soul above the *sublime*, of which it is the source, and has its chief effect in the thoughts and *the whole together* of a work: Whereas the *sublime* is perceived equally, both in the general, and in the particulars, of all the parts. *Enthusiasm*, besides, has this peculiarity, that its effect is more instantaneous; whereas the *sublime* requires, at least, some moments before it can be seen in all its force.

(J'ai fait entrer le Sublime dans la définition de l'Enthousiasme, parce que le Sublime est un effet & une production de l'Enthousiasme. L'Enthousiasme contient le Sublime comme le tronc d'un arbre contient ses branches qu'il repand de differens côtés; ou plutôt l'Enthousiasme est un soleil dont la chaleur & les influences font naître les hautes pensées, & les conduisent dans un état de maturité que nous appellons Sublime. Mais comme l'Enthousiasme & le Sublime tendent tous deux à élever notre esprit, on peut dire qu'ils sont d'une même nature. La difference neanmoins qui me paroiît entre l'un & l'autre, c'est que l'Enthousiasme est une fureur de veine qui porte notre ame encore plus haut que le Sublime, dont il est la source, & qui a son principal effet dans la pensée & dans le Tout ensemble de l'ouvrage; aulieu que le Sublime se fait sentir également dans le général, & dans le détail de toutes les parties. L'Enthousiasme a encore cela que l'effet en est plus prompt, & que celui du Sublime demande au moins quelques moments de réflexion pour être vû dans toute sa force.)[48]

The metaphorical language may well indicate the difficulties de Piles faced in trying to make his ideas clear. Reading the passage only superficially one might think that its first part was generally in agreement with Boileau's definition of enthusiasm as one of the possible sources of the sublime;[49] whereas the last sentence, stating that reflexion was necessary for the sublime to make its effect, would be hard to reconcile with any established idea of the sublime.

Yet de Piles is not talking about one effect and its cause, but about two effects and their interrelation. The first and more powerful one, enthusiasm, is achieved

[48] *CdP*, pp.115/116; transl. pp.71/72.
[49] See above p.118 and note 39.

by purely visual means, the second one, the sublime, requires at least some effort on the part of our reflexion or understanding before it can make its full impact: we have to identify all figures and objects involved and to grasp the meaning of the action or event depicted.

While Poussin and Félibien had insisted on the attentive reading of a painting for a proper appreciation of its subject-matter, de Piles requires only *quelques momens de réflexion* for our understanding of the sublime. Following on from enthusiasm, the sublime of subject-matter should not require elaborate analysis; we ought to be able to grasp it relatively quickly: 'In short, *enthusiasm*, methinks, seizes us, and we seize the *sublime*'. (Il me paroît, en un mot, que l'Enthousiasme nous saisit, & que nous saisissons le Sublime).[50] This applies both to the artist and the spectator. Enthusiasm, as an elevated state of mind, is a necessary predisposition of mind: on the artist's part for the invention, and on the spectator's part for the appreciation and the understanding of sublime effects of subject-matter. Here, at last, we are offered an explanation of de Piles' earlier statement, that the effect of disposition, the overall effect *au premier coup d'œil*, though not to be understood as depending on the nature and quality of subject-matter, could contribute greatly to our understanding of it.[51]

What exactly the sublime of subject-matter is de Piles does not say – probably because he thought of it as similar to the sublime in poetry or rhetoric, and even in these arts it was still very much the subject of controversy. Yet one quality or condition of it we can specify; the subject-matter has to have unity. In justifying the unity of object, de Piles had claimed that: 'As in a picture there ought to be an unity of subject for the eyes of the understanding, so there ought to be an unity of object for those of the body'. (Comme dans un Tableau il doit y avoir unité de sujet pour les yeux de l'esprit, il doit pareillement y avoir unité d'objet pour les yeux du corps).[52]

As the unity of object conveys to us, as spectators, the artist's harmonious vision and elevates us to a state of enthusiasm, so the unity of subject should convey to us, after only a few moments of reflection, a general sense of the subject matter, its nature or character. Although de Piles never clearly defines the unity of subject, we can be sure that it has a much simpler meaning than in Félibien's theory;[53] it seems to be equivalent to what de Piles repeatedly calls *le caractère du sujet*, its dominant emotional impact or, in eighteenth-century terms, its mode.

In this sense we can understand enthusiasm and the sublime as being of the same nature not only as elevated states of mind, but also as effects of harmony and unity: the more general, but also more powerful, harmony of the unity of object contains within it (like a tree containing a branch) the more specific harmony and unity of subject-matter. We can, again, return to the model of rhetoric: the spectator's mode of understanding the picture's subject-matter is not

[50] *CdP*, p.117; transl. p.72.
[51] See above p.75f.
[52] *CdP*, p.376; transl. p.227.
[53] De Piles, for instance, explicitly rejects the idea that the painter could show us more than one moment of his action, cf. *CdP*, p.65; transl. p.40.

one of elaborate philosophical conviction, it is more like the persuasion of an audience carried away (and thus mentally prepared) by the orator's art.

Yet while the orator's enthusiasm is a means of conveying a message (his subject-matter) to his audience, de Piles' sense of enthusiasm is not a means but the end of painting.[54] A sublime subject-matter may be a valuable addition, but it is not a necessary one. The sense of order and unity, which characterizes both, corresponds, according to de Piles, to a basic requirement of our human nature:

It is certain, that all beings tend to unity, either by relation, or composition, or harmony; and this as well in things human as divine, in religion as politicks, in art as nature, in the faculties of the soul as the organs of the body.

(Il est constant que tous les Etres du monde tendent à l'unité, ou par relation, ou par composition, ou par harmonie, & cela dans les choses humaines comme dans les divines; dans la Religion comme dans la politique; dans l'Art comme dans la Nature; dans les facultés de l'ame comme dans les organes du corps.)[55]

If the visual harmonies of enthusiasm make us see a great subject in a sublime way, so much the better. Yet the fact that it can convey the same erudite or morally improving messages as other arts does not define nor justify the art of painting. Even small subjects, like landscapes or still-lives, can be treated in a way which makes them great masterpieces.[56]

The justification of painting lies in the fact that it has its own way of affecting and involving the spectator, and of elevating his mind. Later aestheticians were to relate these visual effects to the workings of our mind in a different way, by thinking of a balance of faculties, in which our rational activity would reconstruct — according to its own laws — the order and harmony presented to it by passive intuition. This would surpass both the aims of de Piles' theory and the limits of his thinking. Yet by defining the unity of painting in a specifically visual sense, that of its overall harmony and unity of effect, and by relating this unity to a fundamental tendency of human nature, de Piles made an early contribution to discussions about art which are still continuing today.

[54] For de Piles' claim that instruction, as the main aim of an elevated subject-matter, is not an intrinsic aim of painting, cf. *Conversations*, p.106.

[55] *CdP*, p.374; transl. p.226.

[56] Cf. *CdP*, pp.70f: 'Si le Peintre se trouve engagé dans un petit sujet, il faut qu'il tâche de le rendre grand par la maniere extraordinaire dont il le traitera'. Someone well versed in history is not therefore a good painter, while an excellent painter might be deficient in his knowledge of history, cf. *Conversations*, pp.106f.

VI

THE UNITY OF OBJECT AND ITS EFFECTS IN THE EIGHTEENTH CENTURY

THE IMPACT of de Piles' theory on later French critics and writers is hard to assess: I shall here attempt no more than a brief summary.[1] His terms, whether they relate to *coloris*, *clair-obscur*, harmony, the immediate total effect and its unity or, in a wider sense, to comparisons with rhetoric or music, became part of the critical and theoretical language of the eighteenth and, to some extent, the nineteenth century. His writings and his name retained a considerable authority among artists, connoisseurs, and critics in France.

The Abbé Dubos, writing only ten years after de Piles' death referred to him as *'grand amateur de la Peinture...[qui] nous a laissé plusieurs écrits touchant cet Art, qui sont dignes d'être connus de tout le monde'*;[2] Lacombe, in his *Dictionnaire portatif des Beaux Arts* of 1752, explicitly acknowledged his debt to de Piles, as Dezailler d'Argenville had done in his *Abrégé de la Vie de plus fameux Peintres* of 1745.[3] Others, like Pernety,[4] Dandré-Bardon,[5] or Watelet,[6] quoted or paraphrased him extensively (and outside France, so did Richardson[7] and Hagedorn, whose *Betrachtungen*[8] influenced Diderot).

In the dispute over the new literary genre of pamphlets criticising works

[1] To trace de Piles' influence (direct or indirect) on artists like Watteau, Chardin, or Boucher, perhaps even Tiepolo, and on the later disputes in England about the picturesque and the sublime, would require separate studies. Reynolds, Turner, and Constable all owned copies of the *Cours de Peinture* (on Turner, cf. E. Mavromihali, *Pictorial Unity in Turner and Roger de Piles' Theory of Art*, M.A. dissertation, Essex University 1981). As I pointed out in the preface, my own interest in de Piles arose from a study of Delacroix's theory which I hope to complete in the near future.

[2] Abbé J.D. Dubos, *Réflexions Critiques sur la Poësie et sur la Peinture*, seventh edition, Paris 1770 (first edition 1719), vol. I, p.284.

[3] J. Lacombe, *Dictionnaire portatif des Beaux-Arts*, Paris 1752, p.VI: *'Les Ecrits de M. de Piles & L'Abrégé de la Vie des plus fameux Peintres, par M. d'Argenville, m'ont aussi beaucoup aidé pour la Peinture'*. A.J. Dezallier d'Argenville, *Abrégé de la Vie des plus Fameux Peintres*, new ed. Paris 1762 (first edition 1745), p.xxxii, note (a) on de Piles: *'J'ai connu particulièrement cet excellent auteur'*.

[4] A.J. Pernety, *Dictionnaire portatif de Peinture, Sculpture & Gravure*, second edition, Paris 1781, quotes repeatedly, and with full acknowledgements, from de Piles.

[5] M.-F. Dandré-Bardon, *Traité de Peinture, suivi d'un essai sur la sculpture*, Paris 1765.

[6] C.H. Watelet and P.C. Levesque, *Dictionnaire des Arts de Peinture, Sculpture et Gravure*, Paris 1792.

[7] J. Richardson, *The Connoisseur: An Essay on the whole Art of Criticism as it relates to Painting*, London 1719; cf. also note 53 below.

[8] Ch.-L. von Hagedorn, *Betrachtungen über die Malerei*, 1762; French translation, *Réflexions sur la Peinture*, Leipzig 1775.

exhibited at the *Salon*, starting with La Font's *Réflexions* of 1747,[9] both sides tried to justify their position by invoking de Piles. Charles-Antoine Coypel, *Premier Peintre du Roy* and director of the Academy from 1747 to 1752, whose father had been a friend and protégé of de Piles', used him as the paradigm of acceptable criticism – '*sage & moderé … aussi galant-homme que profond connoisseur*'[10] – in his attempt to discredit La Font. It is more than likely that Coypel had recognized in La Font's writings whole passages which echo closely de Piles' view, as when La Font says that *le coloris*:

Has always been regarded as the most enchanting of the three parts of painting, that which attracts the spectator, and which constitutes the name and the character (of painting). A painter who only excells in drawing will never be more than a great draughtsman … One cannot conceive of a true painter without the part of colouring.

(On a toûjours regardé cette partie comme la plus enchanteresse des trois de la Peinture, celle qui appelle le spectateur, & qui constituë son nom & son caractère. Le Peintre qui n'excellera que dans la partie du dessein, ne sera jamais qu'un grand Dessinateur … on ne pourra jamais concevoir un véritable Peintre sans la partie du Coloris.)[11]

1. *The Supremacy of Subject-Matter in the Age of the Enlightenment*

All these references, quotations, and outright compliments, however, cannot disguise the fact that theorists, critics, and even artists (as far as they committed their views to paper) from Dubos and Coypel *père* to La Font, Coypel *fils*, Diderot and Watelet disagreed with de Piles on the central point of his theory. Subject-matter, literary content, dramatic actions and human expressions constituted, throughout the century, the highest objectives within the theory of painting. Félibien's hierarchy of genres, with history-painting as the supreme achievement of the art,[12] survived de Piles' attempts at levelling out the differences between the genres by emphasizing the specifically visual effects of pictorial composition irrespective of the kind of subject-matter.

Quite often, de Piles' own terms could have their meaning changed or even reversed by what would have appeared to be no more than a slight change of emphasis; La Font thus 'borrowed' de Piles' notions of enthusiasm and the

9 La Font de Saint-Yenne, *Réflexions sur quelques causes de l'état présent de la peinture en France. Avec un examen des principaux ouvrages exposés au Louvre le mois d'Août 1746*, The Hague 1747. On the emergence of the new criticism, cf. A. Dresdner, *Die Entstehung der Kunstkritik*, Munich 1968, pp.128ff.

10 Ch.-A. Coypel, 'Dialogue sur l'exposition des Tableaux dans le Sallon du Louvre, en 1747', *Mercure de France*, 1751, p.59; first delivered as a lecture to the academy, 5th August 1848 (cf. Montaiglon, *Procès-Verbaux*, VII, pp.62f).

11 La Font, *Réflexions*, pp.90f, cf. also pp.59f on a painting by Parrocel: 'Enfin une harmonie enchanteresse qui résulte de la variété des tons & de leur accord: harmonie qui lie ce grand tout, ce vaste ensemble, & qui met l'œil dans un plein repos, où il ne desire rien, où il jouit de tout, où il admire tout'.

12 See above chap I, p.29, n.84.

sublime in order to confirm history painting as the highest genre. Enthusiasm, with La Font, remains a heightened state of vision, not of the overall picture – as in de Piles – but of the facts and actors of the *sujet* :

History painting is indubitably the highest genre of painting. Only the history painter is the painter of the soul, the others only paint for the eyes. Only he can set to work that enthusiasm, that divine fire which makes him conceive his subjects in a strong and sublime manner: only he can shape heroes for posterity, by presenting to their eyes the great actions and the virtues of famous men, not by the cold means of reading, but by the very sight of the facts and the actors.

(De tous les genres de la Peinture, le premier sans difficulté est celui de l'Histoire. Le Peintre Historien est seul le Peintre de l'ame, les autres ne peignent que pour les ïeux. Lui seul peut mettre en œuvre cet enthousiasme, ce feu divin qui lui fait concevoir ses Sujets d'une manière forte & sublime: lui seul peut former des Héros à la postérité, par les grandes actions & les vertues des hommes célébres qu'il presente à leurs ïeux, non par une froide lecture, mais par la vuë même des faits & des acteurs.)[13]

The main thrust of arguments about art in the eighteenth century ran directly counter to de Piles' theory; where he had tried to isolate painting from other comparable human activities in order to analyze and define its own means and ends, writers in the age of the Enlightenment were more concerned with its similarities with other arts and with the rôle it could and should play in the general process of educating and enlightening mankind.

The wider issues of eighteenth century thought which are involved cannot be discussed here beyond a brief summary of three or four closely interrelated concerns of the period which affected the transformation of the theory of painting more directly than others

The first of these concerns, and the one most clearly hostile to de Piles' views, was that of reducing all the fine arts to the same basic principle of imitation of nature (or, more precisely, of a refined and beautified nature). The particular means with which each art imitates nature (or, in de Piles' view, transforms it) is of minor importance in an argument which is concerned with the kinds of nature (or subject-matter) which all the arts should imitate.

This view is most clearly expressed in the *Réflexions critiques* of 1719, by the Abbé Dubos, (and it was later to be rigidly systematized by Batteux and others).[14] For Dubos, painting and poetry are strictly and essentially imitative; the impressions they make on us are similar in kind to the impressions which the real objects and figures imitated would make on us; and the passions and feelings aroused by works of art are correspondingly similar in kind to those we

[13] La Font, *Réflexions*, p.8.
[14] Ch. Batteaux, *Les beaux Arts réduit à un même principe*, Paris. On Dubos and his importance for later theories in the eighteenth century, cf. A. Baeumler, *Das Irrationalitätsproblem in der Ästhetik und Logik des achtzehnten Jahrhunderts*, Halle 1923, pp.49–60; also A. Lombard, *L'Abbé Du Bos. Un initiateur de la pensée moderne (1670–1742)*, Paris 1913; and R.G. Saisselin, Some Remarks on French Eighteenth-Century Writings on the Arts, *Journal of Aesthetics and Art Criticism*, 25, 1966–67; pp.187–195.

might experience in the real world: 'The copy of the object should, so to speak, arouse in us a copy of the passion which the object would have aroused in us.' (La copie de l'objet doit, pour ainsi dire, exciter en nous une copie de la passion que l'objet y auroit excitée).[15]

Dubos was aware that by insisting on this sense of continuity between art and nature, and their effects, he was attacking de Piles. He admits that painting has its 'artificial', non-imitative means and effects, but considers these to be of minor importance:

A painting can please simply by the charm of its execution, irrespective of the object it represents: but ... our attention and our esteem are concerned firstly and uniquely with the art of the imitator

(Un tableau peut plaire par les seuls charmes de l'exécution, indépendamment de l'objet qu'il represente: mais ... notre attention & notre estime sont alors uniquement pour l'art de l'imitateur.)[16]

Dubos accuses de Piles of not having distinguished between what he calls *composition pittoresque* (which is concerned with the general arrangement of the picture *'dont le coup d'œil fait un grand effet, suivant l'intention du Peintre'*), and *composition poétique* (of the figures and actions: *'elle demande que tous les personnages soient liés par une action princpiale ... '*).[17]

It is not hard to detect behind this distinction the difference between Félibien's unity of action and de Piles' unity of object.[18] Dubos does not concern himself with the technicalities of painting and, having accused de Piles of neglecting the *composition poétique* as an essential part of the art, he himself proceeds without further regard for the *composition pittoresque*.

<div align="center">* * * * *</div>

Dubos' almost exclusive concern with subject-matter, his unwillingness to involve himself in the 'artificial' effects and the specific visual nature of painting, has to be seen in the context of a wider issue, which he himself takes up in the second part of his *Réflexions* and which was to remain a central issue of artistic theory and criticism throughout the century: this was the question of taste and judgment.

De Piles had freely admitted that in his view a basic knowledge of the principles of the art was necessary for anybody who wanted to pass his judgment on a picture; without this knowledge, one might well be sensitive to the effects of a beautiful painting but one cannot give a reasoned judgment.[19]

[15] Dubos, *Réflexions critiques*, I, pp.27f. (cf. also I., p.25).
[16] Dubos, *Réflexions critiques*, I. p.71; see also below, note 22.
[17] Dubos, *Réflexions critiques*, I, pp.270f.
[18] Dubos, *loc. cit.*; on *composition pittoresque* : 'Il faut ... que les groupes soient bien composés; que la lumière leur soit distribuée judicieusement; & que les couleurs locales, loin de s'entre-tuer, soient disposées de manière qui'il résulte du tout une harmonie agréable à l'œil par elle-même'. On *composition poétique* : it requires 'que l'unité d'action soit conservée dans l'ouv-rage de Peintre comme dans le Poème'.
[19] De Piles, *Abrégé*, pp.93f.: 'Ceux qui n'ont pas cultivé leur Esprit par les connoissances des Principes, du moins speculativement, pourront bien être sensible à l'effet d'un beau Tableau: mais ils ne pourront jamais rendre raison des jugemens qu'ils en auront porte'.

The central argument of Dubos' *Réflexions critiques* aimed at establishing the universal validity of judgments of taste. By claiming for taste or *sentiment* the status of a sixth sense, he could attribute to taste the same reliability which Locke had granted to judgments of our other senses; if, according to Locke, 'sensible knowledge' without rational demonstration can be relied upon for almost any judgment we have to make in our normal world; and if, according to Dubos, our experience of paintings and poems is essentially similar to – only slightly weaker than – our experience of the real world, then it would seem to follow that the sense with which we respond to works of art must be as reliable, and its judgments as valid, as those of the other senses responding to the real world.[20]

It is exactly this argument which, in Dubos' theory, and in the writings of many of his followers, deprives the art of painting of most of those effects which for de Piles were specific and essential to painting. As it was crucial to argue that our experience of works of art was continuous with our experience of the real world, the whole 'artificial order' of painting as analysed by de Piles, became a nuisance.

Dubos, like many later writers, talks of secondary beauties of painting, those of the execution, the *mécanique* of painting; these fall outside the range of our normal experience and, therefore, of general taste. Compared with the *composition poétique* of a painting they are, for Dubos, negligible. Diderot, later in the century, immersed himself more seriously and honestly in the problems of painting; yet he also had difficulty in accommodating what he called '*la magie de faire*' of Chardin in his critical thought.[21]

Effects of *la mécanique*, *la magie de faire*, and, by implication, de Piles' artificial overall harmonies and contrasts of composition, *coloris* and *clair-obscur* were considered, in the eighteenth century, as secrets of the trade, as remnants of pre-enlightenment workshop traditions, open only to *les gens du métier*,[22] or perhaps a few self-indulgent connoisseurs. Set against our ability to judge

[20] Dubos, *Réflexions critiques*, II, p.342: 'Lorsqu'il s'agit de connôitre si l'imitation qu'on nous présente dans un poème ou dans la composition d'un tableau, est capable d'exciter la compassion & d'attendrir, le sens destiné pour en juger, est le sens même qui auroit été attendri, c'est le sens qui auroit jugé de l'objet imité. C'est ce sixième sens qui est en nous, sans que nous voyions ses organes...' On Dubos and Locke, cf. Lombard, *L'Abbé Du Bos*, pp.194ff.

[21] See, e.g., his admission: 'On n'entend rien à cette magie. Ce sont des couches épaisses de couleur appliquées les unes sur les autres...Rubens, Berghem, Greuze, Loutherbourg vous expliqueraient ce faire bien mieux que moie...' (*Salon de 1763*, ed. Seznec and Adhémar, I, Oxford 1959, p.223).

[22] Cf. Dubos, *Réflexions critiques*, II, pp.401f: 'Nous avons...vû que les beautés de l'éxécution pouvoient seules rendre un tableau précieux. Or ces beautés se rendent bien sensibles aux hommes qui n'ont pas l'intelligence de la mécanique de la Peinture, mais ils ne sont point capables pour cela de juger du mérite du Peintre...Voilà ce que les gens du métier sçavent'. Cf. also Diderot, *Salon de 1767*, (ed. Seznec and Adhémar, Vol. III, Oxford 1963, pp.235f.): 'La beauté du faire n'arrête que le connoisseur. Si elle le fait rêver, c'est sur l'art et l'artiste, et non sur la chose'; and, mystified by Chardin's technique: 'On dit de (Chardin) qu'il a une technique qui lui est propre, et qu'il sert autant de son pouce que de son pinceau. Je ne sais ce qui en est; ce qu'il y a de sûr, c'est que je n'ai jamais connu personne qui l'ait vu travailler; quoi qu'il en soit, ses compositions appelent indistinctement l'ignorant et le connoisseur'. (*Salon de 1767*, p.128).

subject-matter by recourse to our own common experience, these studio skills are, as indicated by the word *magie*, slightly suspicious: they are outside not only our experience but also our normal language.

Perhaps the greatest handicap of de Piles' theory in the eyes of later critics was the fact that what for him was the supreme effect of painting, the *enthousiasme* inspired by the visual arrangement of the whole picture, was almost by definition impossible to describe or capture in words. Even his own descriptions of Rubens' paintings in the collection of the Duc de Richelieu (Plates 10, 17, 19 and 20) dwell primarily on their subject-matter or give a factual account of their composition without saying in what way the spectator was affected by that composition.[23]

How much more convenient for the new literary generation of critics after 1750 to be able to support their judgments of a work of art by describing their responses as if they were responses to a real event! Even if their readers could not see the actual painting, such an account should enable them to form an adequate judgment on the correspondance between the event described and the responses reported. It was only Delacroix in the following century who again insisted that the highest effects of painting were those of which language could convey no adequate idea.[24] In the eighteenth century, these painterly effects were seen almost as obstacles to our reading of, and empathizing with the picture's subject-matter.

The preoccupation with subject-matter was enforced by two further factors during the eighteenth century, which I shall do no more than mention here: the first is based on the assumption, derived from Dubos' definition of taste,[25] that the arts in their entirety expressed or reflected the moral, religious and political calibre of society (the *goût de la nation* in La Font).[26] The second is the demand, ancient in origin but particularly urgent in the age of the Enlightenment, that painting, like all the other arts, should not simply aim at pleasure and entertainment, but should take an active part in the education and improvement of mankind.

On both counts, de Piles' *enthousiasme* and his visual effects of painting would have appeared, to French writers of the century, as examples of visual hedonism; a noble and elevated subject-matter, on the other hand, perfectly suited the demands of enlightenment and the improvement of *mores*. One would have to look to German aesthetics, and to Kant and Schiller in particular, to justify de Piles' project in terms of the education of all our faculties. This would take us far beyond anything de Piles himself could have considered.

[23] Cf. de Piles, *Dissertations sur les Ouvrages des plus fameux Peintres*, Paris, 1681; and above chapter II, p.53, where the effect of Rubens' *Fall of the Damned* on the spectator (both the ignorant and the connoisseur), as described by de Piles, is in fact that of the subject-matter.

[24] Cf. chapter V, p.121 above.

[25] See Dubos, *Réflexions critiques*, II, pp134ff, where Dubos investigates the moral, geographic and climatic causes of different levels of artistic achievement and of the development of general taste in different countries and in different times.

[26] La Font, *Réflexions*, p.13.

2. *Unity of Action and Unity of Object Compromised*

Despite the fact that throughout the eighteenth century the supremacy of subject-matter was generally accepted (in theory, though not in practice), some notion of the unity of object or effect remained an important part of the theory and the criticism of the period. One should perhaps add that it remained so despite the definition and the value which de Piles himself had attached to it.

Dubos in 1719 did not comment on the relationship between *composition poétique* and *composition pittoresque*; they appear as two different ways of organizing a picture (corresponding very closely to Reynolds' later distinction between the *grand style* and the *ornamental style*).[27] Antoine Coypel, in 1721, set the tone for later discussions about the relationship between the two unities, when he declared that the first effect of a picture should express its mode, the nature or quality of its subject-matter.[28] I have pointed out earlier that this was not at all what de Piles had had in mind. Coypel's son Charles-Antoine, like his father director of the academy, took this argument to its logical conclusion in an article published in 1751: he described the first overall effect of a painting as its *exordium* its opening or introduction (extending de Piles' favourite comparison with rhetoric across the frontier at which de Piles himself had carefully drawn back).[29]

This was typical of eighteenth-century attitudes to visual order and subject-matter: the visual order of a painting was perceived primarily, if not exclusively, as a way of overcoming an obstacle to our perception of the subject-matter. The overall composition of a picture, rather than making its own effects of contrast and harmony – felt as a visual experience *sui generis* – was charged with the task of helping or even compelling the spectator to address the literary or dramatic content. It was this literary content to which, according to the Abbé Dubos, the public could relate in terms of its own experience and language.

When, by the middle of the century, writers like Algarotti[30] and Dandré-Bardon[31] discussed the formal means of painting they did so entirely in terms of the subservience of light and shade, and colour harmonies to the immediate recognizability of the subject-matter. Formal devices were not acknowledged as having their own interest, they were treated purely as means of directing our eyes to the crux of the action, of concentrating our attention on the subject-matter. Dandré-Bardon recommends that the arrangement of groups in a picture should be such that it forms triangular shapes: its diagonal lines would then lead the eye of the spectator away from the frame and toward the centre of the picture where the 'hero' of the story would be found.[32] Light and colour should

[27] Reynolds, *Fourth Discourse*.

[28] See above chapter I, p.30 and note 87.

[29] Ch.-A. Coypel, 'Parallèle de l'Eloquence et de la Peinture', *Mercure de France*, May 1751; delivered as a lecture to the academy, 1st February 1749 (Montaiglon, *Procès-Verbaux*, VI, p.155).

[30] F. Algarotti, *Essai sur la Peinture et sur l'Académie de France établie à Rome*, Paris 1769.

[31] Dandré-Bardon, *Traité de Peinture*, Paris 1765.

[32] Dandré-Bardon, *Traité*, pp.107f: 'Le concours des Groupes doit tendre à donner à l'ordonnance pittoresque une forme pyramidale...Un des principeaux objets de la liaison des groupes est de conduire l'œil du Spectateur sur le Héros du sujet. Il convient que cette opération se fasse par une marche diagonale'.

be used in a similar way to direct the spectator to the centre of the *sujet*'s interest.[33]

These compositional rules, and many others of a similar kind, were meant to ensure that our visual interest in forms, colour and light was so controlled that we were led as swiftly as possible to the recognition and understanding of the picture's subject-matter. Visual prominence given to any part of the composition should indicate the prominence and importance of that part within the action or event depicted. The visual unity of a work, its *unité d'objet* or *unité d'effet*, was understood as a visual prerequisite for our appreciation of the subject-matter, and as such it was regarded by almost all writers of the period as a fundamental requirement of any picture presented to the public.

* * * * *

Although, in this sense, the importance of the unity of object or effect within eighteenth-century theories of art derives directly from the importance attached to the subject-matter, one also has to note that it redefined and delimited the notion of the unity of action. In the first chapter, I described the sense of sophistication and complexity given to the unity of action by the early academicians, André Félibien in particular. In the eighteenth century this unity became a much simpler notion. Dramatic content and structure, introducing into painting notions of sequentiality and causality, could hardly be expressed by an overall compositional unity of effect. The unity of action became narrowly a matter of giving importance to a single principal figure. Only if this principal figure was bathed in the brightest light, given prominence by the overall arrangement of diagonal lines and triangular shapes, could one expect the general public to relate to it immediately and without hesitation.

This mutual dependence between overall visual effect and unity of action, epitomized in the salience of the principal figure, was spelt out clearly in Watelet's *Dictionary* of 1792: 'Everything must tend toward that figure, everything must relate back to it, the general effect, of which it is both the cause and the object, and finally all the parts of the whole'. (Tout doit tendre vers cette figure, tout doit y rappeller, l'effet général, dont elle est *la cause & l'objet*, toutes les parties enfin de l'ensemble).[34]

According to the dictionary, this was the only strictly binding law of pictorial composition.[35] I have discussed elsewhere[36] how this law restricted not only the artist's ordering of his subject-matter but also what subject-matter he would choose; according to the rules of the unity of object or effect the subject-matter should be reducible to a strictly hierarchical display of figures and objects,

[33] Dandré-Bardon, *Traité*, p.230: 'Il faut introduire dans le Tableau une couleur ainsi qu'une lumière plus brillante que toutes les autres . . . Ces effets ménagés pour faire la plus forte illusion, doivent être réservés pour l'endroit où se passe le plus grand intérêt de la scene'.

[34] Watelet and Levesque, *Dictionnaire*, Paris 1792, I, p.425.

[35] Watelet-Levesque, *loc. cit*. ('la seule loi rigoureusement obligatoire de la composition pittoresque').

[36] T. Puttfarken, 'David's *Brutus* and Theories of Pictorial Unity in France', *Art History*, 4, 1981, pp.291–304, where some of the problems and much of the material referred to here is discussed in more detail.

centred around the principal figure. The possibilities of development, sequence, contrast, which had been implicit in Félibien's unity of action, and which had made us *read* Poussin's pictures, could hardly be admissible within these new theories.

Some critics, like A.J. Pernety,[37] noticed this dilemma; Diderot, after reading Félibien's edition of the conferences of 1667, tentatively suggested that paintings should be composed in such a way that our eye was led, not just to one centre of interest, but along a line of interest, the *ligne de liaison*; in this way, one figure or object would appear as following on from the previous one in an intelligible way.[38]

* * * * *

The main attack on the 'compromised' notions of unity came not from a theorist but from a painter, Jacques-Louis David. His *Brutus* (Plate 23) was criticized in 1789 for its lack of both unities, for its separation of interest between the hero, placed in a dark corner, and the subsidiary group of lamenting women bathed in the brightest light on the other side of the picture.[39]

As the unities were considered to be essential rules of composition because they were thought to be necessary for the general public to grasp the sense and the meaning of the picture's subject-matter, the overwhelming public success of David's *Brutus* now demonstrated that they could be disregarded altogether. Visual prominence, in this work, does not imply moral or dramatic prominence; the darkness surrounding the figure of Brutus does not offer itself as repose for our eyes; the whole notion of the correspondence between visual concentration of forms and colours on the one hand and a centralized hierarchy of subject-matter on the other has been abandoned.

David's *Brutus* is not the ready-made *exemplum virtutis*, strikingly displayed to impress a passive public, which, in academic theory and criticism, had embodied the highest ideas and the didactic end of history-painting. David deliberately divides our interest; he does not present us with a glorified hero but with a moral choice of a terrifying order.

Later critics were as unhappy with the lack of unity in this picture as the *amateurs* of painting had been in 1789.[40] We cannot separate the *Brutus* from the public for which it was painted and which acclaimed it wholeheartedly. Visual pleasure, harmonious effects, formal unification are things which are traditionally expected even in paintings of unpleasant or horrible events; they are part of our aesthetic experience of works of art. But they cannot have been of great concern for the general public in 1789. A few years later, in 1792, those *amateurs* who insisted on the 'trivial rules of composition' were themselves criticized:

They raise their magisterial voices against modern compositions which do not form proper pyramids, which show badly arranged groups, which have holes

[37] Puttfarken, *Brutus*, p.301.
[38] Diderot, *Salon de 1767* (Seznec-Adhémar, III), pp.186ff.
[39] Cf. Puttfarken, *loc. cit*.
[40] Cf. Puttfarken, *loc. cit*.

... It is very true that these rules are just ... but if they are generally good they are not absolutely good and have to give way to superior reasons, to a different kind of *convenance*.

(Ils élèvent leurs voix magistrales contre les compositions modernes qui ne pyramident pas bien, qui groupent mal, qui ont des trous ... Il est très-vrai que ces règles sont justes ... mais si elles sont généralement bonnes, elles ne sont pas d'une bonté absolue, & doivent céder à des raisons supérieurs, à un autre genre de convenance.)[41]

3. *Paintings as Abstract Patterns: Laugier's* Manière de Bien Juger

The normal way of accommodating de Piles' 'artificial' effects of painting, the visual harmony of the *Tout-ensemble* with its colours, its *clair-obscur*, and its centralized arrangement, as we have seen, was as an *exordium*, a visual introduction to, and preparation for, our appreciation of the subject-matter.

Yet from the evidence available it would appear that there was, probably among artists in particular, considerable support for de Piles' ideas. It would be difficult otherwise to understand why later writers, like Diderot,[42] and, even toward the end of the century, Watelet,[43] were still trying to refute his arguments. The *Cours de Peinture*, after all, was republished twice, in 1766 and again in 1791. De Piles' comments on Dufresnoy's *De Art Graphica* were studied by the Academy in 1769.[44]

The theories and ideas presented in the literature of treatises and criticism, written either by enlightened *littérateurs* or by artists with literary ambitions, were not necessarily those of all, or even of a majority, of the practising artists. And even within the new literary genre of criticism after 1750 the public opinion and common judgment which was continually invoked (with each critic claiming to express the general opinion of the public, rather than his own views) was a mere fiction. At the Salon of 1753 Boucher's *Rising of the Sun* (Plate 24),[45] which looks like a determined effort to put into practice de Piles' ideas on central composition, *clair-obscur*, centre-to-periphery gradient etc., was

[41] Watelet-Levesque, *Dictionnaire*, I, pp.433f; (by Levesque, who completed the work after Watelet's death).

[42] Cf., e.g., Diderot, 'Essais sur la Peinture', *Œuvres Esthétiques* (ed. P. Vernière), Paris 1968, pp.719f: 'On distingue la composition en pittoresque et en expressive. Je me soucie bien que l'artiste ait disposé ses figures pour les effets les plus piquants de lumière si l'ensemble ne s'addresse point à mon âme ... Tout composition expressive peut être en même temps pittoresque; et quand elle a toute l'expression dont elle est susceptible, elle est suffisamment pittoresque; et je félicite l'artiste de n'avoir pas immolé le sens commun au plaisir de l'organe'.

[43] Cf., e.g., Watelet, *op. cit.*, I, p.344, on *clair-obscur* and the subservience of the physical sense of the eye to the moral sense of *l'âme* or *l'esprit* : 'Comme dans l'ordre des impressions que fait éprouver la Peinture, l'impression physique est nécessairement la première, cette impression doit donc, en précédant les autres, favoriser celles de l'âme ou leur nuire ... '.

[44] Montaiglon, *Procès-Verbaux*, VIII, pp.18ff.

[45] Now in the Wallace Collection, London, no. P485.

ridiculed by La Font de Saint-Yenne[46] and most highly praised by the Abbé Laugier.[47]

Laugier, later, wrote a treatise on how to judge paintings, the *Manière de bien juger des ouvrages de Peinture*, of 1771, and this provides us with further evidence that the near unanimous rejection of de Piles' autonomous effects in written theories and treatises does not adequately reflect the full range of current ideas and discussions about art.

Laugier's book, as pointed out by Ch.-N. Cochin, the permanent secretary of the Academy, who edited it after the author's death, is full of contradictions.[48] It is curiously eclectic, bringing together as many ideas, viewpoints, and arguments as possible without much concern for their mutual compatibility. Most of what Laugier says would have been perfectly acceptable to his fellow-critics; yet occasionally, and often incongruously, his stated views are directly opposed to the general aims and the overall trend of the new criticism. It is more than likely that on these occasions his views reflect those of his painter-friends. To give just one example: Laugier starts with the common 'literary' assumption that one does not have to be an expert or a practitioner of the art of painting to be able to judge its works fairly and justly.[49] More than two-hundred pages later, however, he adopts a different view – one which undoubtedly would have been far more popular with most academic painters. He now suggests that each picture should be submitted to a critical examination by the academy. Its verdict should then be made public as a final and definite judgment and everyone else should 'reform his opinion according to these respectable decisions'.[50]

Laugier is equally inconsistent in discussing the ways in which we should examine a painting and its effects. He distinguishes between two kinds of examination, the *examen en grand*, and the *examen en détail*. Under the second heading he deals with the analysis of subject-matter and makes the obvious and by now familiar point:

[46] La Font de Saint-Yenne, *Sentiments sur quelques ouvrages de Peinture, Sculpture et Gravure, écrits à un particulier en province*, Paris 1754, pp.34ff., e.g. p.38: '...l'indifférence de tout ce Cortège marin, dont presque toutes les figures tournent le dos au dieu du jour, & semblent n'être dans ce tableau que pour en remplir les vides, sans prendre aucun intérêt à l'action principale qui est le depart du Soleil, est une faute essentielle, & plus difficile à excuser'.

[47] Abbé M.A. Laugier, *Jugement d'un amateur sur l'exposition des tableaux. Lettre à M. le marquis de V...*, Paris 1753, pp. 25–8.

[48] Abbé M.A. Laugier, *Manière de bien juger des ouvrages de Peinture*, Paris 1771; the addition of Cochin's notes is justified on p.iv: 'Comme M. l'abbé Laugier lui-même n'étoit ni ne pouvoit être amateur éclairé au degré qu'il exige, on a cru appercevoir quelques erreurs dans son ouvrage. C'est pourquoi, en respectant son texte, on s'est permis de rectifier par des notes quelques-uns de ses jugemens qui ont paru trop légèrement portés'.

[49] Laugier, *Manière*, pp.5f.: 'Je conclus que les peintres ne sont ni les seuls, ni les meilleurs juges des ouvrages de peinture, & qu'il peut très-bien se faire qu'un homme d'esprit, avec la seule ressource de son goût naturel, en décidera beaucoup mieux, s'il a la sincérité de ne rien dissimuler de ce qu'il sent.' Cochin, note (i), adds: '...on verra dans la suite combien cette assertion est peu réfléchie, & l'on sera effrayé de l'énumération des qualités qu'il exige dans un amateur, avant que de lui accorder le droit de juger'.

[50] Laugier, *Manière*, p.247. In view of these, and other similar contradictions, it would seem precipitous to claim, as Hautecoeur did, that Laugier, following Dubos, believed in the superiority of sentiment over reason (cf. L. Hautecoeur, *Littérature et Peinture en France du 17e au 20e siècle*, Paris, 1963, p.21).

It is the first duty of every man of intelligence, who composes for the public, not to leave any uncertainty about the subject he treats . . . One has to recognize the subject-matter almost as soon as one sees it.

(Le premier devoir de tout homme d'esprit, qui compose pour le public, c'est de ne laisser aucune incertitude sur le sujet qu'il traite . . . Il faut . . . qu'on reconnoisse le sujet presque aussi-tôt qu'on l'apperçoit.)[51]

La Font, Diderot, and other *littérateurs* would have agreed; they would have objected most strongly, however, to Laugier's description of the *examen en grand* on the immediately preceding pages.

The *examen en grand* is concerned with two aspects of the picture, the harmony of its colours, and its overall effect (*'l'accord des couleurs, & l'effet du tout ensemble'*).[52] The influence of de Piles is noticeable in these paragraphs, yet their views are not identical. We can either assume that Laugier took de Piles' theory as a starting point to develop his own highly original ideas (which in view of the generally eclectic nature of his investigation is unlikely)[53] or, that his unusual statements reflect current discussions among artists.

The *examen en grand* of a picture is to be carried out at a considerable distance – from which we could hardly see individual objects and figures:

Abstract from the particular objects, disregard the flesh, the materials, the backgrounds. Examine only whether that arrangement of colours contains nothing to offend your eyes, whether you perceive nothing hard and sharp, nothing conflicting and incompatible.

(Faites abstraction des objets particuliers, ne vous occupez, ni des carnations, ni des étoffes, ni des fonds. Examinez seulement si cet assortiment de couleurs n'a rien qui blesse vos yeux, si vous n'y appercevez rien de dur & de tranchant, rien d'opposé & d'incompatible.)[54]

De Piles would have deplored the exclusion from the first effect of a painting of a strong sense of reality; for him, the central illusion of reality provided the visual focus around which the peripheral harmonies of *coloris* and *clair-obscur* could make themselves felt without becoming the object of our immediate attention.

Yet Laugier's definition of the *examen en grand* takes to its logical and radical conclusion de Piles' distinction between the artificial order and the natural or imitative order of painting: colouring and overall formal arrangement are treated as an abstract composition irrespective of the role they might play, in the subsequent *examen en détail*, in the creation of illusion:

In a word, judge of this picture in the same way as you would judge a beautiful

[51] Laugier, *Manière*, pp.239f.
[52] Laugier, *Manière*, p.237.
[53] Laugier might have been influenced by J. Richardson's *Traité de la Peinture et de la Sculpture*, Amsterdam 1728 (first published in English 1715), p.95: 'Il faut que chaque Peinture soit telle, que, lorsqu'à une certaine distance, on ne peut pas distinguer quelles en sont les Figures, ni ce qu'elles font, elle paroisse faire un composé de Masses de jour & d'ombre'.
[54] Laugier, *Manière*, p.237.

fabric decorated with different colours, where the passage from one to the other would be more or less softened.

(Juges en un mot de ce tableau, comme vous jugeriez d'une belle étoffe brochée de diverses couleurs, où le passage de l'une à l'autre seroit plus ou moins adouci.)[55]

Unlike other critics of the period, Laugier does not describe the immediate overall effect of a picture as a preliminary function of our understanding of the subject-matter. Although his first effect is abstract in the sense of a non-illusionistic, ornamental pattern, he ascribes to it an emotional and expressive force of its own which will deeply affect the spectator before he has even fully recognized the subject-matter:

Then, without further approaching the picture, consider the effect of the whole together [le tout ensemble]... Examine whether the general inspection of this picture awakens in you ideas of grandeur and magnificence, of nobility and pride, of horror and terror, of elegance and attractiveness, of voluptuous pleasure and delights, of tumult and turmoil, of simplicity and negligence, of baseness and contempt... If you feel that you have been struck and seized at once, ready to enter into a kind of transport and enthusiasm, say that the picture has a very grand effect... Having spent some time on this broad inspection of the picture, approach it further to get to know its subject-matter well, and carefully study its composition.

(Ensuire, sans vous rapprocher encore du tableau, considérez l'effet du tout ensemble... Examinez si l'inspection générale de ce tableau réveille dans vous des idées de grandeur & de magnificence, de noblesse & de fierté, d'épouvante & de terreur, d'élégance & d'agrément, de volupté & de délices, de tumulte & de fracas, de simplicité & de negligence, de bassesse & de mépris... Au cas que vous vous sentiez d'abord frappé & saisi, prêt à entrer dans une sorte de transport & d'enthousiasme, dites que le tableau est de très-grand effet... Après avoir donné quelque temps à cette inspection vague du tableau, approchez-vous davantage, pour bien connoitre le sujet, & en étudier soigneusement la composition.)[56]

This attribution of expressive force and emotional power to 'abstract' patterns may seem highly interesting and attractive to a modern reader; it may appear as an historical and intellectual precedent of the abstract movements in twentieth-century art. But given the overall lack of coherence of Laugier's treatise these passages do not carry much conviction as part of a systematic theory; their interest rests primarily in the fact that they indicate de Piles' continuing influence. While literary treatises on painting became increasingly hostile to the uniquely visual nature of the art, many artists would have found in de Piles' writings more sympathetic advice — ideas and observations which were more closely concerned with the art of painting than the 'poetical' prescriptions of La

[55] Laugier, Manière, p.237.
[56] Laugier, Manière, pp.238f.

Font and his followers. De Piles' reputation was not only that of a *profond con-naisseur* and *galant-homme* (as Coypel described him in 1751) but that of a painter's theorist. After all, as even Dubos knew,[57] de Piles had himself handled the painter's brush and had experienced both the practical problems and the pure, visual excitement of the art of painting.

[57] Dubos, *Réflexions critiques*, I, p.284.

SELECT BIBLIOGRAPHY

(listing only publications quoted or mentioned in the text)

Alfassa, P., 'L'origine de la lettre de Poussin sur les modes d'après un travail récent', *Bulletin de la Société de l'Histoire de l'Art Français*, 1933, pp.125–143.

Algarotti, F., *Essai sur la Peinture et sur l'Académie de France établie à Rome*, Paris 1769.

Allard, J.C., *Studies in Theories of Painting and Music in Sixteenth and Seventeenth Century France*, M.Phil. dissertation, University of Essex 1977.

Allard, J.C., Mechanism, Music and Painting in Seventeenth Century France, *Journal of Aesthetics and Art Criticism*, 1982.

d'Argenville, A.J. Dézallier, *Abrégé de la Vie des plus fameux Peintres*, new edition Paris 1762 (first edition 1745).

Arnheim, R., *Art and Visual Perception*, London 1956.

d'Aubignac, F.H., *La Pratique du Théatre*, Amsterdam 1715 (first edition 1657).

d'Aubignac, F.H., *Discours académique sur l'Eloquence*, Paris 1668.

Auerbach, E., *Das Französische Publikum des siebzehnten Jahrhunderts*, Munich 1933.

Baeumler, A., *Das Irrationalitätsproblem in der Ästhetik und Logik des achtzehnten Jahrhunderts bis zur Kritik der Urteilskraft*, Halle 1923 (second edition Darmstadt 1975).

Batteux, Ch., *Les Beaux Arts réduits à un même Principe*, Paris 1747.

Baxandall, M., *Giotto and the Orators*, Oxford 1971.

Becq, A., 'Rhétoriques et Littérature d'Art en France à la Fin du XVIIe Siècle. Le Concept de Couleur', *Cahiers de l'Association Internationale des Etudes Francaises*, 24, 1972, pp.215–232.

Bellori, G.B., *Le Vite de'Pittori, Scultori ed Architetti moderni*, Rome 1672 (introduction: *L'Idea della Pittura, Scultura ed Architettura*, first given as a lecture at the *Academia di San Luca*).

Bialostocki, J., 'Das Modusproblem in den bildenden Künsten', *Zeitschrift für Kunstgeschichte*, 24, 1961, pp.128–141; also in Bialostocki, *Stil und Ikonographie*, Dresden 1966, pp.9–35.

Blunt, A., Poussin's Notes on Painting, *Journal of the Warburg Institute*, I, pp.344–351.

Blunt, A., *The Paintings of Nicolas Poussin*. A critical catalogue, London 1966.

Blunt, A., *Nicolas Poussin*, London, New York 1967.

Boileau-Despréaux, N., *Œuvres de Nicolas Boileau-Despréaux*, new and augmented edition, Paris 1713.

Borgerhoff, E.B.O., *The Freedom of French Classicism*, Princeton University Press 1950 (reissued New York 1968).

Bosse, A., *Le Peintre Converty aux precises et universelles règles de son Art*, Paris 1667.

Bouhours, D., *Les Entretiens d'Ariste et d'Eugène*, Paris 1962 (following the text of first edition 1671).

Bouhours, D., *La Manière de bien penser dans les ouvrages d'esprit*, second edition Amsterdam 1692 (first edition 1687).

Bramich, R., *Roger de Piles, the Abbé Dubos and the Comte de Caylus: Theories of composition and the Judgement of Paintings*, M.A. dissertation, University of Essex 1974.

Bray, R., *La Formation de la Doctrine Classique en France*, Paris 1927.

Bryson, N., *Word and Image: French Painting of the Ancien Régime*, Cambridge 1981.

Burckhardt, J., *Recollections of Rubens*, London 1950.

Cassirer, E., *The Philosophy of the Enlightenment*, Princeton 1951 (first published in German, Tübingen 1932).

Chambray, R.F. de, *Idée de la Perfection de la Peinture*, Paris 1662.

Conisbee, P., *Painting in Eighteenth-Century France*, Oxford 1981.

Coypel, Ch.-A., 'Parallèle de l'Eloquence & de la Peinture', *Mercure de France*, May 1751, p.15.

Coypel, Ch.-A., 'Dialogue sur l'Exposition des Tableaux dans le Salon du Louvre en 1747', *Mercure de France*, 1751, p.59.

Dandré-Bardon, M.-F., *Traité de Peinture suivi d'un essai sur la sculpture*, Paris 1765.

Delacroix, E., *Journal de Eugène Delacroix* (ed. A. Joubin), Paris 1932.

Delacroix, E., *Œuvres littéraires*, Paris 1923.

Delaporte, Y., 'André Félibien en Italie (1647–1649). Ses visites à Poussin et Claude Lorrain', *Gazette des Beaux-Arts*, 1958, I, pp.193–214.

Diderot, D., *Salons*, ed. J. Seznec and J. Adhé-
mar, Oxford 1957 ff.

Diderot, D., *Œuvres Esthétiques*, ed. P. Ver-
niere, Paris 1968.

Dolce, L., see: Roskill, M.

Dresdner, A., *Die Entstehung der Kunstkritik*,
Munich 1968.

Drost, W.W., 'Baudelaire et le Néo-Baroque',
Gazette des Beaux-Arts, 1950, II, pp.115–
136.

Dubos, Abbé J.B., *Réflexions critiques sur la
Poèsie et sur la Peinture*, seventh edition,
Paris 1770 (first edition 1719).

Dufresnoy, Ch.-A., *De Arte Graphica – l'Art
de la Peinture, traduit en François*, avec des
remarques (by Roger de Piles), Paris 1668:
transl. by Dryden, *The Art of Painting*, Lon-
don, 1694; by W. Mason, York 1783, with
annotations, replacing those of de Piles, by
Sir Joshua Reynolds).

Evers, H.G., *Rubens und sein Werk. Neue For-
schungen*. Brussels 1943.

Félibien, A., *Conférences de l'Académie Royale
de Peinture et de Sculpture*, Paris 1669.

Félibien, A., *Entretiens sur les Vies et sur les
Ouvrages des plus excellens Peintres anciens
et modernes*, Trevoux 1725 (first published
between 1666 and 1685).

Fénelon, F. de Salignac de la Motte, *Dialogues
des Morts* (first published 1712), in *Œuvres
choisis. Dialogues sur l'Eloquence*, Paris
s.d., pp.352–452.

Folkierski, W., *Entre le Classicisme et le
Romanticisme. Etude sur l'esthétique et les
esthéticiens du XVIIIe siècle*, Cracow, Paris
1925.

Fontaine, A., *Les Doctrines d'Art en France.
Peintres, Amateurs, Critiques, de Poussin à
Diderot*, Paris 1909.

Fontaine, A., *Académiciens d'Autrefois*, Paris
1914.

France, P., *Rhetoric and Truth in France, Des-
cartes to Diderot*, Oxford 1972.

Fréart de Chambray, R., see Chambray, R.F. de.

Fried, M., *Absorption and Theatricality: Paint-
ing and Beholder in the Age of Diderot*, Ber-
keley 1980.

Fromentin, E., *Les Maîtres d'Autrefois*, Paris
1876.

Gerson, H., *Rembrandt Paintings*, London
1968.

Gibson, J.J., *The Perception of the Visual
World*, Cambridge, Mass. 1950.

Gibson, J.J., 'The Visual Field and the Visual
World', *Psychological Review* LIX, 1952,
pp.148–151.

Gibson, J.J., *The Senses Considered as Percep-
tual Systems*, London 1968.

Goldstein, C., 'Studies in Seventeenth Century
French Art Theory and Ceiling Painting',
The Art Bulletin, XLVII, 1965, pp.231–
256.

Goldstein, C., 'The Meaning of Poussin's Let-
ter to de Noyers', *The Burlington Maga-
zine*, CVIII, 1966, pp.233–239.

Goldstein, C., Review of Teyssèdre, Roger de
Piles, *The Art Bulletin*, XLIX, 1967,
pp.264–268.

Gombrich, E.H., *Art and Illusion. A Study in
the Psychology of Pictorial Representation*,
London 1962 (first edition 1960).

Gombrich, E.H., 'Raphael's *Madonna della
Sedia*', *Norm and Form. Studies in the Art of
the Renaissance*, London 1966, pp.64–80.

Gombrich, E.H., *The Sense of Order. A study
in the Psychology of Decorative Art*, Oxford
1979.

Goncourt, E. and J., *L'Art du XVIIIeme Siècle*,
Paris 1927–28.

Hagedorn, Ch.-L. von, *Réflexions sur la Pein-
ture*, Leipzig 1775 (first published as
Betrachtungen über die Malerei, 1762).

Hautecœur, L., *Littérature et Peinture en
France du 17e au 20e Siècle*, Paris 1963.

Hogsett, Ch., 'Jean Baptiste Dubos on Art as
Illusion', *Studies on Voltaire and the Eight-
eenth Century*, LXXIII, 1970, pp.147–
164.

Hübschen, H., 'Der Harmoniebegriff im Mit-
telalter', *Studium Generale*, 19, 1966,
pp.548–554.

Jouanny, Ch., (ed.) *Correspondance de Nicolas
Poussin*, (Archives de l'Art français, nouv.
per. vol. 5), Paris 1911.

Jouin, H., *Conférences de l'Académie Royale
de Peinture et de Sculpture*, Paris 1883.

Kauffmann, G., *Poussin-Studien*, Berlin
1960.

Kemp, W., 'Disegno. Beiträge zur Geschichte
des Begriffs zwischen 1547 und 1607', *Mar-
burger Jahrbuch für Kunstwissenschaft*, 19,
pp.219–240.

Knabe, P.E., *Schlüsselbegriffe des kunsttheo-
retischen Denkens in Frankreich von der
Spätklassik bis zum Ende der Aufklärung*,
Düsseldorf 1972.

Koch, G.F, *Die Kunstausstellung. Ihre Geschi-
chte von den Anfängen bis zum Ausgang des
Achtzehnten Jahrhunderts*, Berlin 1967.

Köhler, E., '''Je ne sais quoi'' – Zur Begriffs-
geschichte des Unbegreiflichen', *Esprit und
Arkadische Freiheit. Aufsätze aus der Welt
der Romania*, Frankfurt/Bonn 1966,
pp.230–286.

Lacombe, J., *Dictionnaire portatif des Beaux
Arts*, Paris 1752.

La Font de Saint-Yenne, *Réflexions sur quel-
ques causes de l'état présent de la Peinture en
France. Avec un examen des principaux
ouvrages exposés au Louvre le mois d'Août
1746*, The Hague 1747.

La Font de Saint-Yenne, *Sentiments sur quel-
ques ouvrages de Peinture, Sculpture et Gra-
vure, écrits à un particulier en province*,
Paris 1754.

Lamy, B., *La Rhétorique, ou l'Art de Parler*,
fourth edition, Amsterdam, 1694 (first ed.
1675).

Lanson, G., *Corneille*, sixth ed. Paris 1922.

Laugier, Abbé M.A., *Jugement d'un amateur*

sur l'exposition des tableaux. Lettre à M. le Marquis de V . . . , Paris 1753.

Laugier, Abbé M.A., *Manière de bien juger des ouvrages de Peinture*, Paris 1771 (edited and annotated by Ch.-N. Cochin).

Lausberg, H., *Handbuch der literarischen Rhetorik*, Munich 1960.

Lausberg, H., *Elemente der literarischen Rhetorik*, second ed., Munich 1963.

LeCoat, G.G., *The Rhetoric of the Arts* (1550–1650), Seattle, Washington 1973.

Lee, R.W., 'Ut Pictura poesis: The Humanistic theory of painting', *The Art Bulletin*, XXII, 1940, pp.197–269, republished separately New York 1967.

Leonardo da Vinci, *Trattato della pittura di Leonardo da Vinci, novamente dato in luce con la vita dell'estesso autore scritta da Raff. du Fresne*, Paris 1651.

Leonardo da Vinci, *Das Buch von der Malerei*, ed. H. Ludwig, Vienna 1882.

Leonardo da Vinci, *The Literary works of Lionardo*, ed. J.P. Richter, London 1883.

Leonardo da Vinci, *The Notebooks of Leonardo da Vinci*, ed., I.A. Richter, paperback ed., Oxford, New York etc. 1980.

Levesque, see: Watelet.

Litman, T.A., *Le Sublime en France (1660–1714)*, Paris 1971.

Lomazzo, G.P., *Trattato dell'Arte della Pittura, Scultura ed Architettura*, Rome 1844 (first ed. Milan 1584).

Lombard, A., L'Abbé Du Bos, *Un initiateur de la pensée moderne (1670–1742)*, Paris 1913.

Mahon, D., *Studies in Seicento Art and Theory*, London 1947.

Mahon, D., 'Eclecticism and the Carracci: Further Reflections on the Validity of a Label', *Journal of the Warburg and Courtauld Institutes*, 16, 1953, pp.303–341.

Mahon, D., 'Poussin au carrefour des années trente', *Nicolas Poussin, Actes du Colloque Poussin*, 1960, pp.251.

Mahon, D., 'Poussiniana. Afterthoughts Arising from the Exhibition'. *Gazette des Beaux-Arts*, 1962, II, 60, pp.1–138.

Mambrun, P., *Dissertatio peripatetica de epico carmine*, Paris 1652.

Marin, L., 'La Lecture du Tableau d'après Poussin', *Cahiers de l'Association Internationale des Etudes Françaises*, 24, 1972, pp.251–266.

Mavromihali, E., *Pictorial Unity in Turner and Roger de Piles' Theory of Art*, M.A. dissertation, University of Essex, 1981.

Messerer, W., 'Die *Modi* im Werk von Poussin', *Festschrift Luitpold Dussler*, Deutscher Kunstverlag 1972.

Mirot, L., *Roger de Piles, Amateur, Critique, Membre de l'Académie de Peinture (1635–1709)*, Paris 1924.

Missirini, M., *Memorie per servire alla Storia della Romana Accademia di San Luca*, Rome 1823.

Montaiglon, A. de, *Procès-Verbaux de l'Académie Royale de Peinture et de Sculpture, 1648–1793*, Paris 1875 ff.

Nicole, P., *Traité de la vraie et de la fausse beauté dans les ouvrages de l'esprit et particulièrement dans l'épigramme*, translated into French by Richelet 1698 (first Latin ed. 1659).

Panofsky, E., *Idea. A Concept in Art Theory*, transl. by J.J.S. Peake, Columbia 1968.

Pascal, B., *Œuvres*, ed. Brunschvig, Paris 1921.

Pernety, A.J., *Dictionnaire portatif de Peinture, Sculpture et Gravure*, second ed. Paris 1781.

Perrault, Ch., *Parallèle des Anciens et des Modernes*, Paris 1688–1697.

Pevsner, N., *Academies of Art, Past and Present*, London 1940.

Pietzsch, G., *Die Klassifikation der Musik von Boethius bis Ugolino von Orvieto*, Halle 1929.

Piles, R. de, *Remarques*, see: Dufresnoy.

Piles, R. de, *Dialogue sur le Coloris*, Paris 1673.

Piles, R. de, *Conversations sur la Connoissance de la Peinture*, Paris 1677.

Piles, R. de, *Dissertation sur les Ouvrages des plus fameux Peintres*, Paris 1681.

Piles, R. de, *Abrégé de la Vie des Peintes*, Paris 1699. English edition *The Art of Painting with the Lives and Characters . . . of the Most Eminent Painters*, second edition London 1744.

Piles, R. de, *Cours de Peinture par Principes*, Paris 1708. English edition, *The Principles of Painting*, London 1743.

Pirenne, M.H., *Optics, Painting and Photography*, Cambridge 1970.

Poussin, N., *Correspondance* see: Jouanny, Ch.

Puttfarken, T., *Masstabsfragen. Über die Unterschiede zwischen grossen und kleinen Bildern*, Dr. phil. dissertation, Hamburg 1971.

Puttfarken, T., 'David's *Brutus* and Theories of Pictorial Unity in France', *Art History*, IV, 1981, pp.290–304.

Rapin, P.R., *Œuvres diverses concernant les belles-lettres*, Amsterdam 1728.

Reynolds, Sir J., *Discourses*, ed. S.O. Mitchell, Indianapolis, New York, Kansas City 1965.

Richardson, J., *The Connoisseur: An Essay on the whole Art of Criticism as it relates to Painting*, London 1719.

Richardson, J., *Traité de la Peinture et de la Sculpture*, Amsterdam 1728 (original English edition 1715).

Roskill, M.W., *Dolce's 'Aretino' and Venetian Art Theory in the Cinquecento*, New York 1968.

Saisselin, R.G., 'Some Remarks on French Eighteenth Century Writings on the Arts', *Journal of Aesthetics and Art Criticism*, 25, 1966–67, pp.187–195.

Schlosser Magnino, J., *La Letteratura Artistica*, Florence, Vienna 1864, third edition, updated by O. Kurz (first edition, *Die Kunstliteratur*, Vienna 1924).

Schöne, W., *Über das Licht in der Malerei*, Berlin 1954.

Spencer, J.R., 'Ut Rhetorica Pictura', *Journal of the Warburg and Courtauld Institutes*, 20, 1957, pp.26–44.

Stein, K.H. von, *Die Entstehung der neueren Ästhetik*, Stuttgart 1886.

Sterling, Ch., in: *Exposition Nicolas Poussin*, exhibition catalogue Paris 1960.

Testlin, H., *Sentimens des plus habiles peintres sur la pratique de la peinture et sculpture, mis en tables de preceptes* Paris s.d.

Teyssèdre, B., *Roger de Piles et les débats sur le coloris au siècle de Louis XIV*, Paris 1957.

Teyssèdre, B., 'Une collection française du Rubens au XVIIe siècle: Le Cabinet du Duc de Richelieu décrit par Roger de Piles (1676–1681)', *Gazette des Beaux-Arts*, 1963, II, pp.241–299.

Teyssèdre, B., *L'Histoire de l'Art vue du Grande Siècle* Paris 1964.

Teyssèdre, B., 'Peinture et musique: La notion d'harmonie des couleurs au XVIIe siècle français', *Stil und Überlieferung in der Kunst des Abendlandes. Akten des 21. Internationalen Kongresses für Kunstgeschichte in Bonn*, 1964, vol. III, Berlin 1967, pp.206–214.

Vignola-Danti, *Le due regole della prospettiva. pratica de M. Jacomo Barozzi da Vignola*, ed. Danti, Rome 1583.

Varwig, F.R., *Der rhetorische Naturbegriff by Quintilian*, Heidelberg 1976.

Watelet, C.H. and Levesque, P.C., *Dictionnaire des Arts de Peinture, Sculpture et Gravure*, Paris 1792.

Wittkower, R., *Architectural Principles in the Age of Humanism*, London 1967 (first ed. 1949).

Wittkower, R., *Art and Architecture in Italy, 1600–1750*, London 1958.

Zeitler, R., *Poussinstudien* I, typescript Uppsala 1963 (copy in the Warburg Institute, London).

INDEX